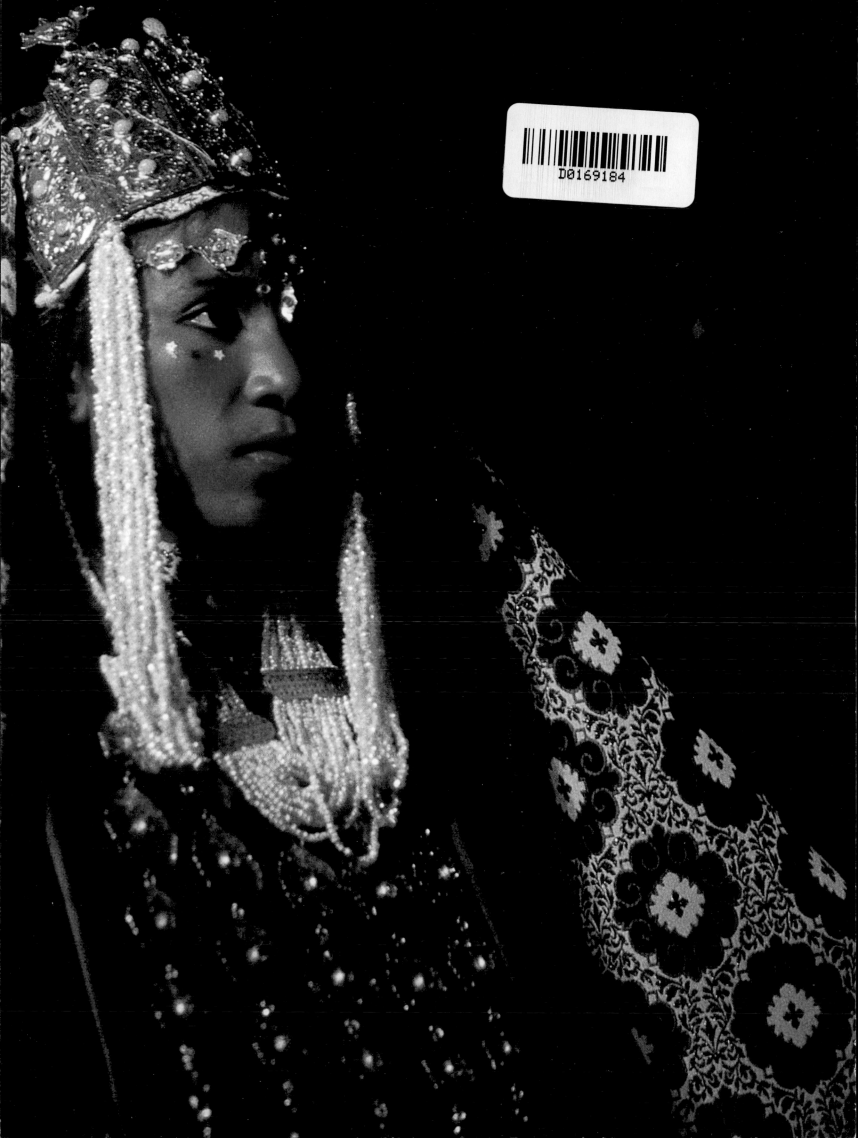

SPLENDOURS OF
MOROCCO

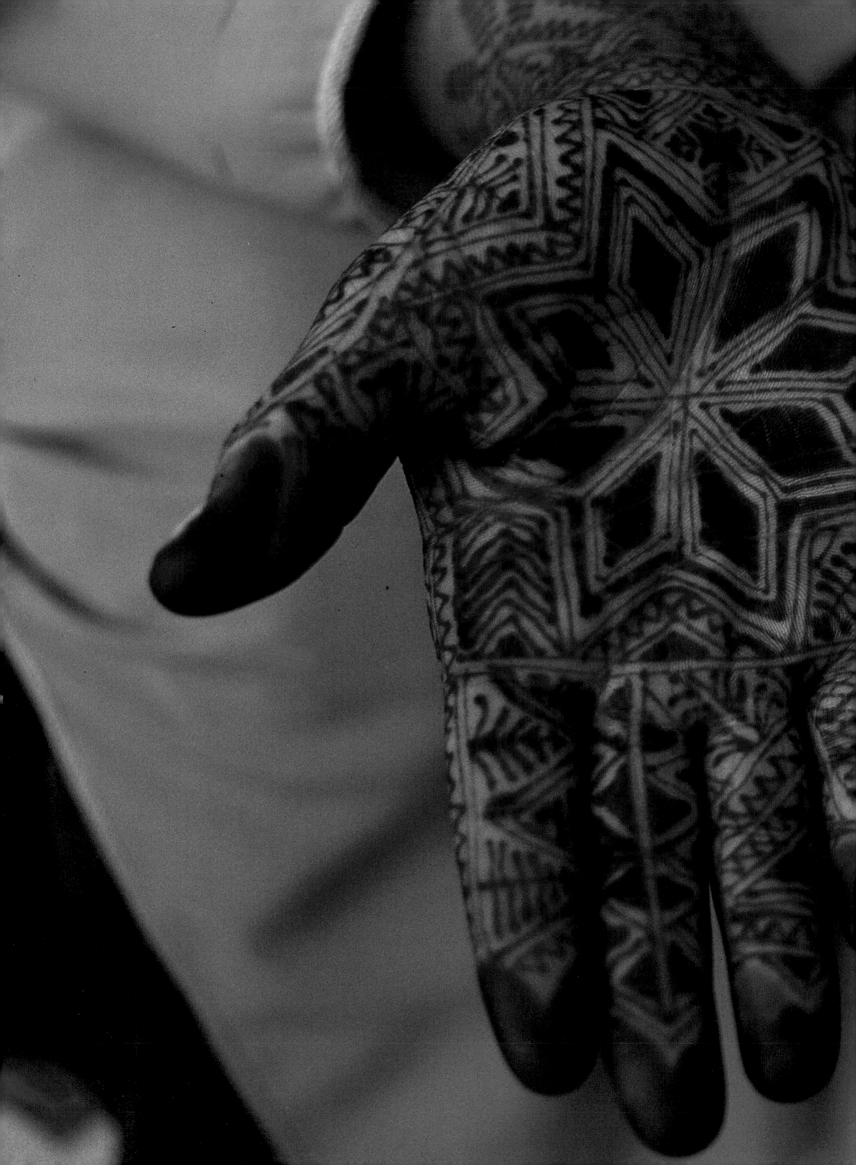

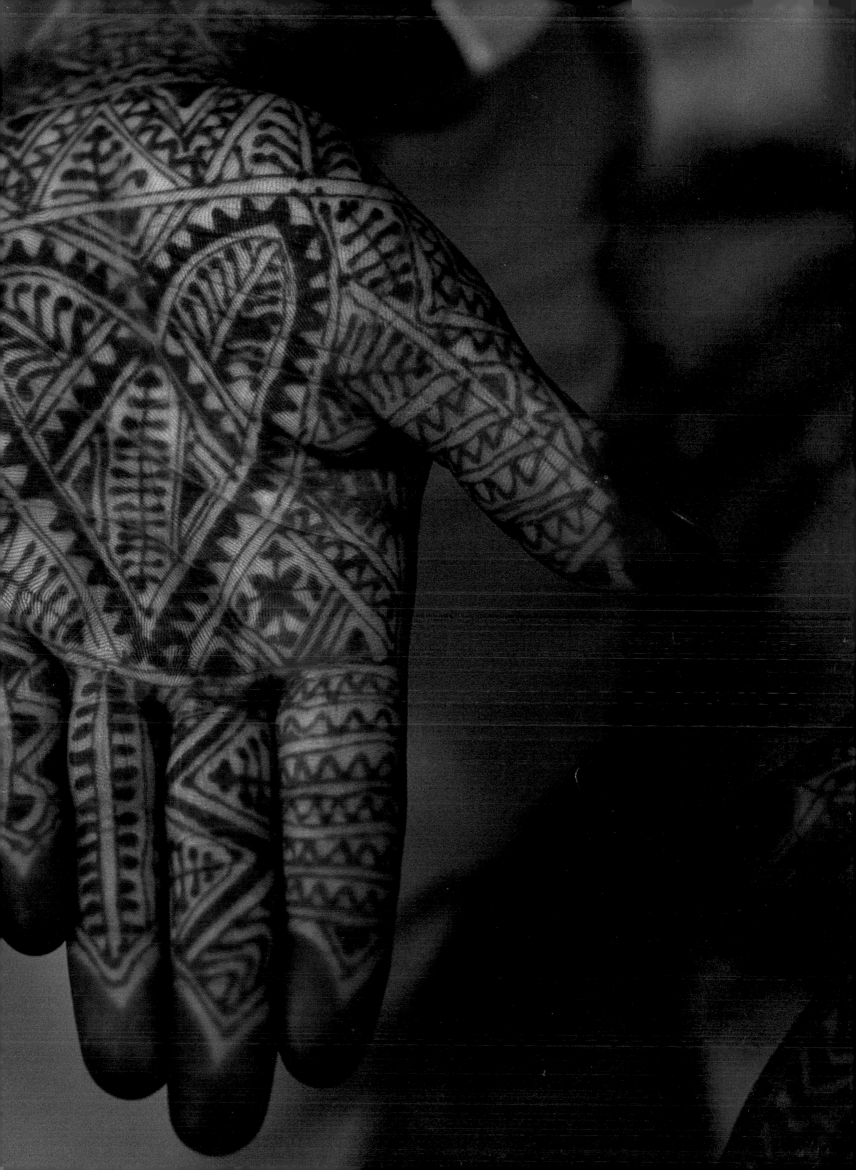

End pages

A bridal costume from Fez.

Pages 2-3

*T*raditional hand decorations in henna.

05
916.4
6-331

Published in 2000 by Tauris Parke Books
an imprint of I.B.Tauris & Co Ltd
Victoria House, Bloomsbury Square, London WC1B 4DZ
175 Fifth Avenue, New York NY 10010
Website: http://www.ibtauris.com

In the United States and Canada distributed by St. Martin's Press
175 Fifth Avenue, New York NY 10010

Copyright © Éditions Plume, 1998
Translation © Éditions Plume

ISBN 1 86064 482 1

A full CIP record for this book is available from the British Library
A full CIP record for this book is available from the Library of Congress

Library of Congress catalog card: available

Printed and bound in Spain by Artes Gráficas Toledo, S.A.U.
D.L. TO: 129 - 2000

SPLENDOURS OF
MOROCCO

Izza Genini

Photography
Jacques Bravo and Xavier Richer

Tauris Parke Books
London • New York

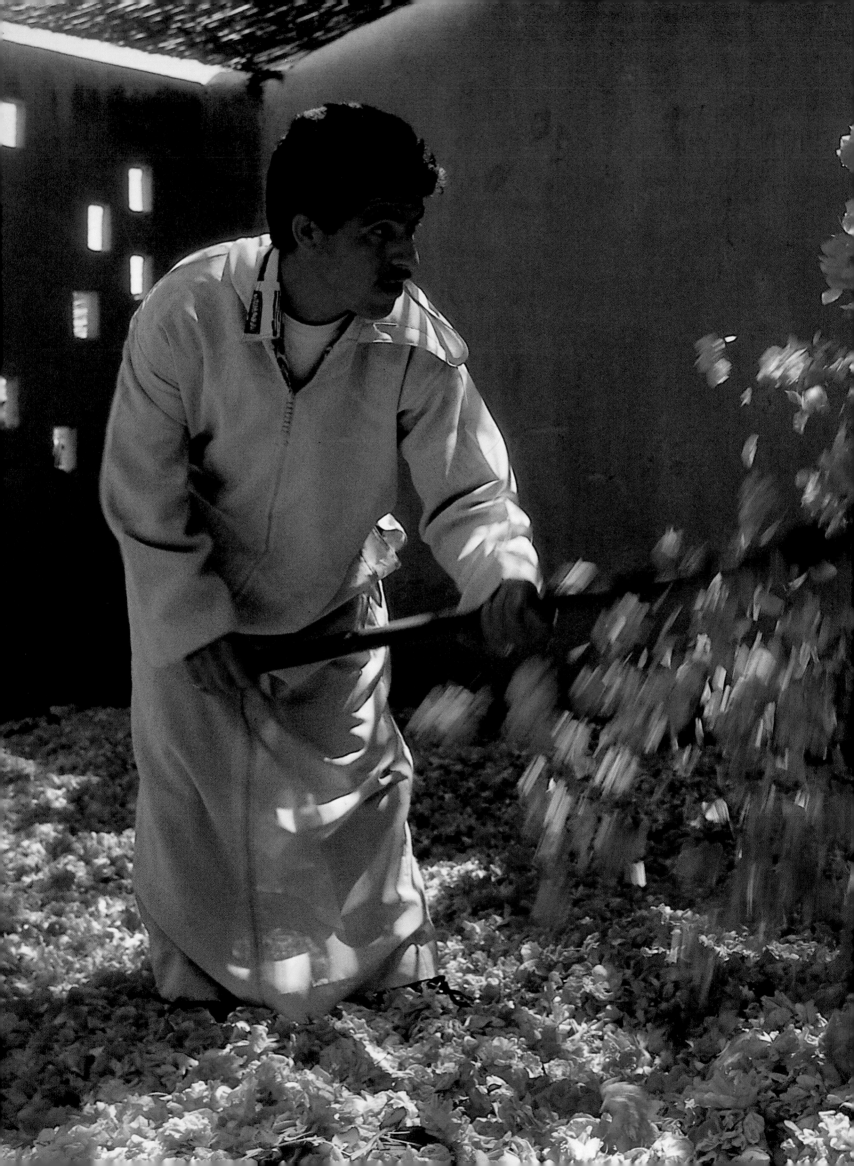

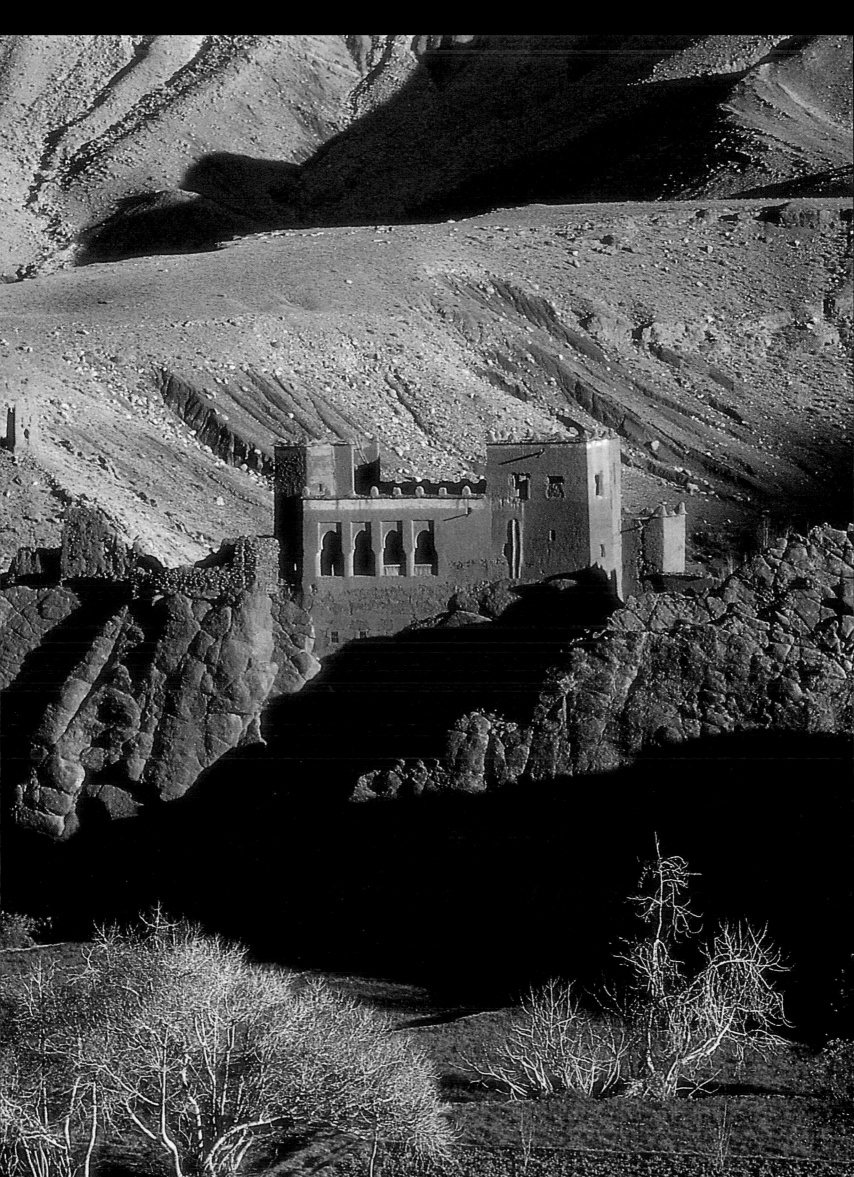

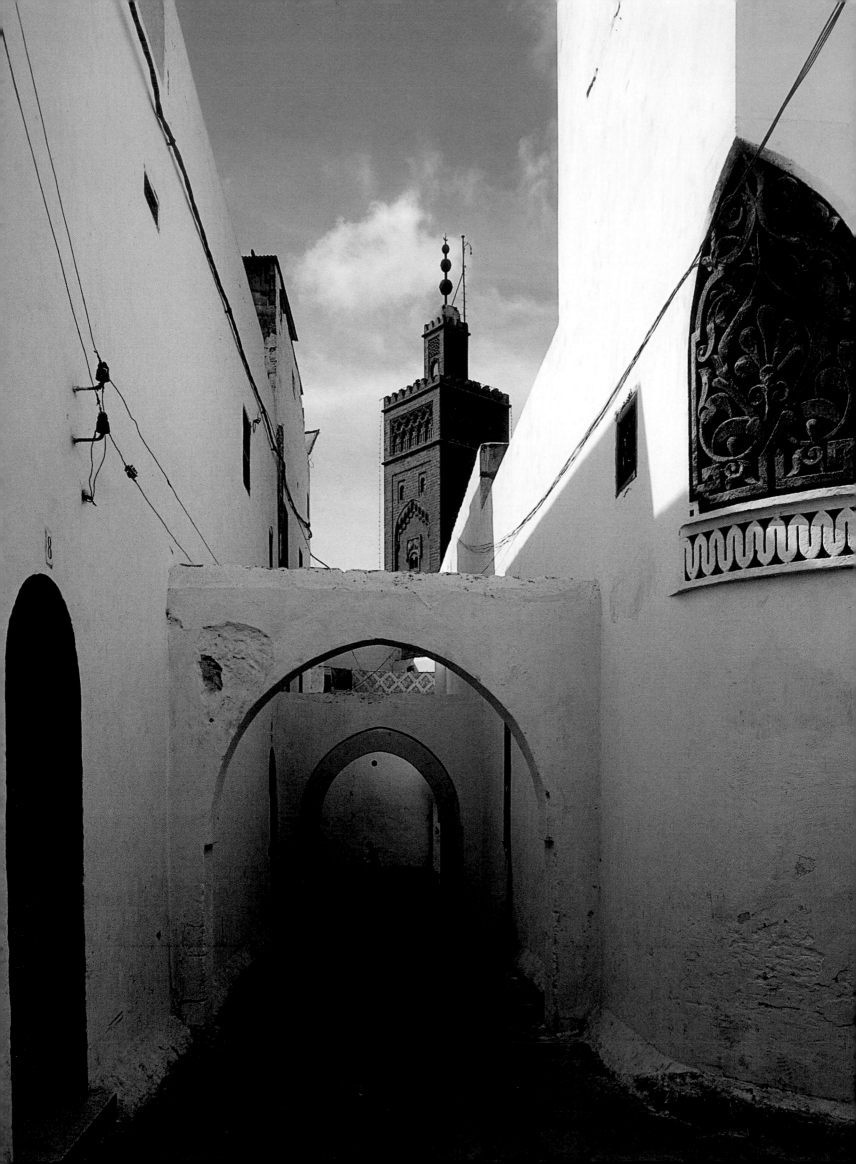

CASABLANCA – RABAT

Less than 100 kilometres, or 60 miles, separate Casablanca from Rabat. No two cities could be so close and yet so different from each other. Casablanca is a teeming, brash metropolis with a population of 3¹/₂ million, half of which is below the age of 20. Rabat, by contrast, is an imposing studious place, a distinguished sedate capital city, with its royal palace, ministries, universities and embassies. Linked together in the minds of Moroccans, Casablanca and Rabat are locked in an embrace both by their geographic proximity and their histories.

Casablanca spreads itself like a fan, and is guarded by its historic city gates: on the south by the "Eye of the Wolf" and the north by the "Eye of the Lion" (Aïn Diab and Aïn Sebaa). The city came into existence when the Beghouata, a Berber tribe, founded the town of Anfa because of squabbling among various Almohad warlords. This was followed by the rise of Sufi mysticism as a way of life, which led to a further decline in state authority.

In 1565 the Portuguese settled in Anfa, which they soon began calling Casa Branca, because of the whiteness of its houses. They were joined by the English and the Spanish, whose attentions had likewise been attracted by the abundant wheat and wool of the Chaouia plain. The Portuguese fled the city after the great earthquake of 1755, abandoning the very fortifications which they had themselves constructed. Several years later, the Sultan Muhammed ben Abdullah changed Casa Branca to the Arabic Dar El Beida, the white city. After the return of the Europeans at the beginning of the nineteenth century, it reverted to Casa Blanca, the Spanish version of its earlier name, eventually becoming Casablanca.

In the first half of the twentieth century, the cosmopolitan character of Casablanca became firmly established when Frenchmen, Spaniards, Arabs, Jews and others flocked to the city to engage in trade, speculation and intrigue. In 1993, King Hassan II dedicated in Casablanca one of the tallest and most immense mosques in the Arab World.

Rabat and its twin, Sale, straddle the banks of the estuary of Bou Regreg, the 'river of reflections', near to where it enters the ocean. Rabat, selected in 1912 as the royal residence by Sultan Mohammed ben Youssef, clearly reflects its thousand-year history. Originally a Phoenician port, established in the sixth century BC, it then became a colony of Carthage. The Almohads, following the trade of Muslim conquest from Arabia and Damascus across North Africa, established themselves across the river from Sale in 1146, in religious fortress-monasteries they called *ribats*, providing the name for the city we know as Rabat. It was from these *ribats* that they launched their attacks, travelling as far as Spain to spread the word of Allah.

The *casbah* of the Oudaïas, despite its romantic overtones to Western ears, is named after a group of fierce rebel tribes. The ruthless and cunning ruler of Rabat, Sultan Moulay Ismaïl, promised to give them his protection in return for their agreement to man his garrison and to assist in the repression of his political enemies. Today the ramparts which encircle the *casbah* and its Andalusian gardens offer a unique setting in which visitors and locals alike can absorb the historical atmosphere of Rabat.

Sale remains faithful to its fervently religious traditions, rooted in its *médina*. In 1627, it was proclaimed to be the independent republic of Bou Regreg. Each May, Sale holds a traditional solemn celebration, where its fishermen and boatmen honour the city's religious patron, Sidi Abdallah ben Hassoun, by marching through the streets in candlelit processions.

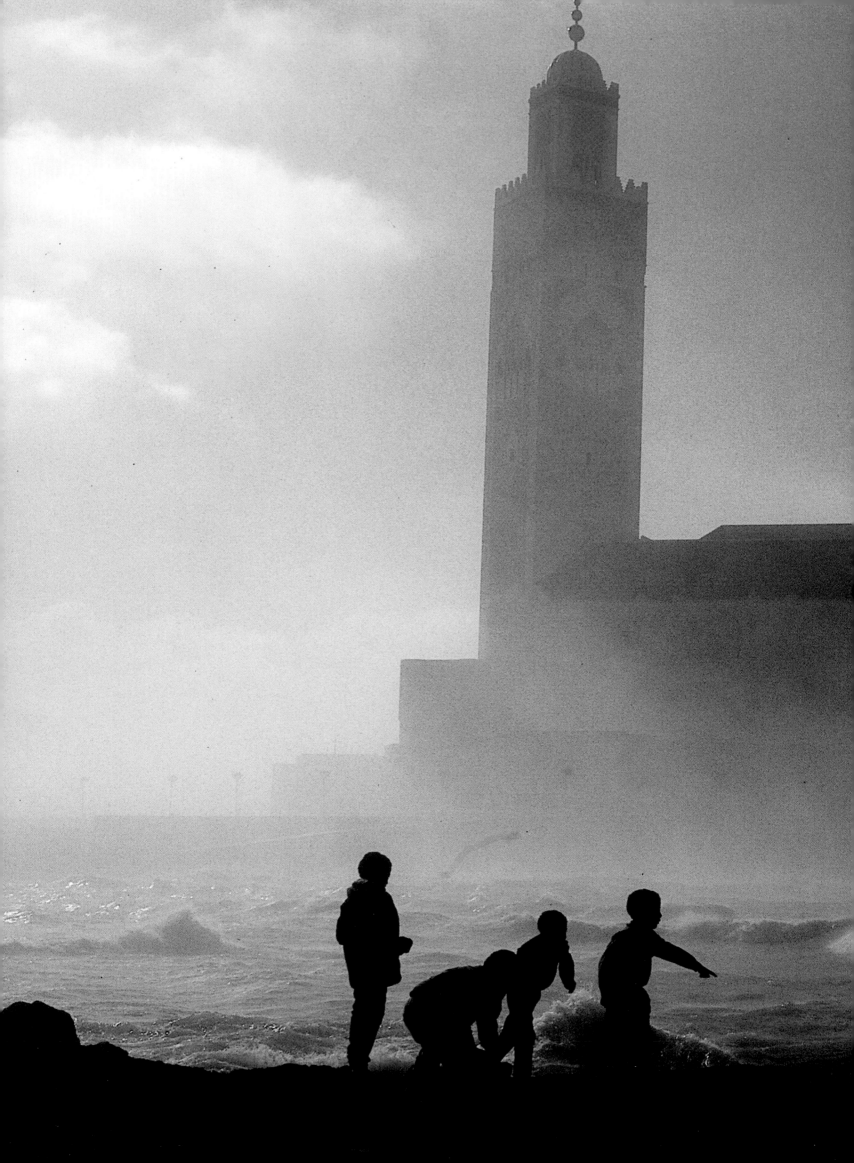

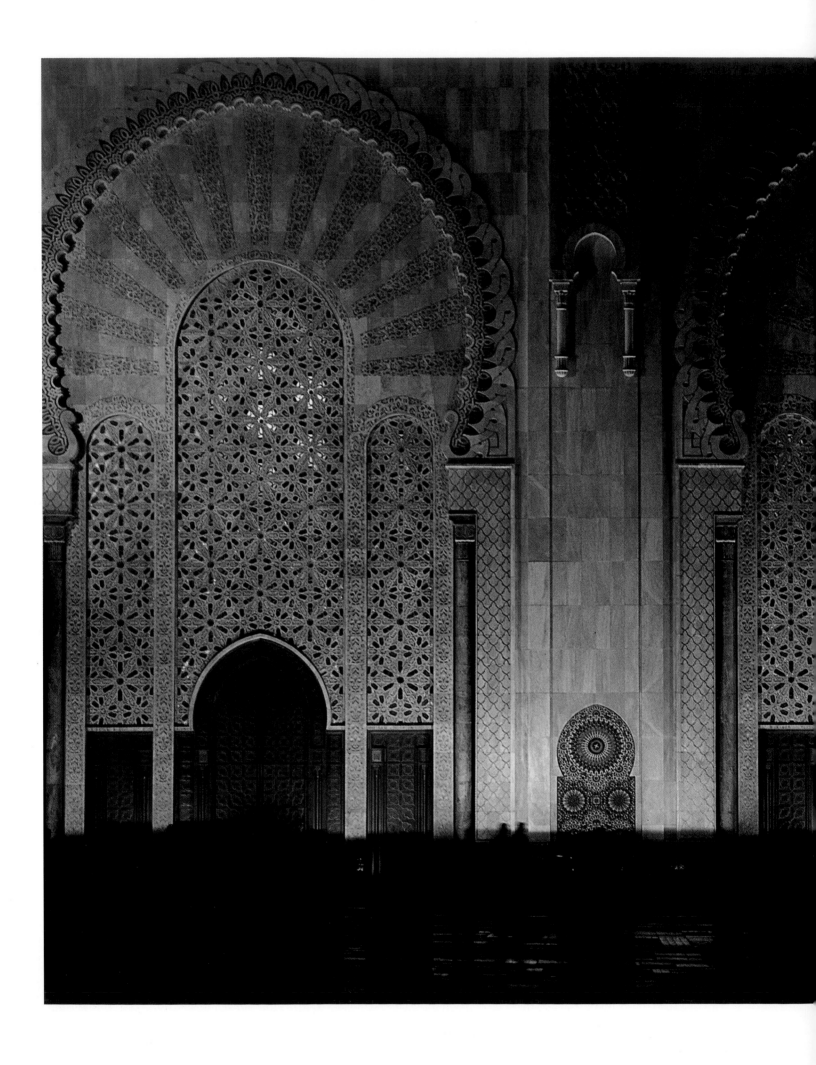

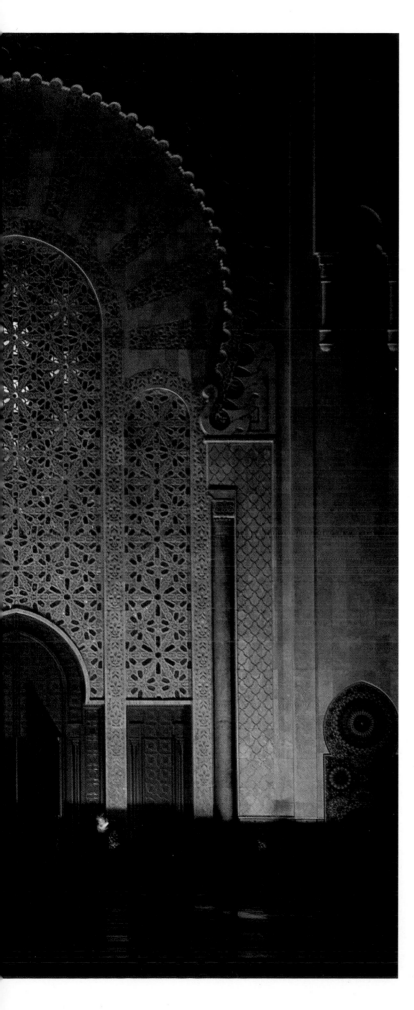

Page 10

*T*he Spanish-Moorish enclave at the heart of Casablanca, the *hablous* district, is famous for its architecture and bazaars. The *hablous*, religious properties bought with donations, make up one of the largest heritage sites in Morocco.

Pages 12-13

*T*he great mosque of Casablanca, very near to the Atlantic Ocean coast, surrounds an esplanade capable of holding 80,000 of the faithful and extends over an area of nine hectares. The great hall can accommodate 25,000 people, of whom 5000 are women who occupy the mezzanine galleries. Designed by the French architect Michel Pinseau, the mosque is the result of almost six years' work by thousands of workmen from Safi, Marrakech and Fez. At the top of the minaret, at a height of 200 metres, a laser beam points in the direction of Mecca and can be seen from a distance of 30 kilometres.

Pages 16-17

*T*he ramparts of the *casbah* of Oudaïa in Rabat. The wall of this *casbah* recalls the Mohammedan period. Built from rubble, to a thickness of 2.5 metres and from eight to ten metres high, it has a walkway all around it. The Oudaïa *casbah* contains a museum, a garden and the Moorish Café.

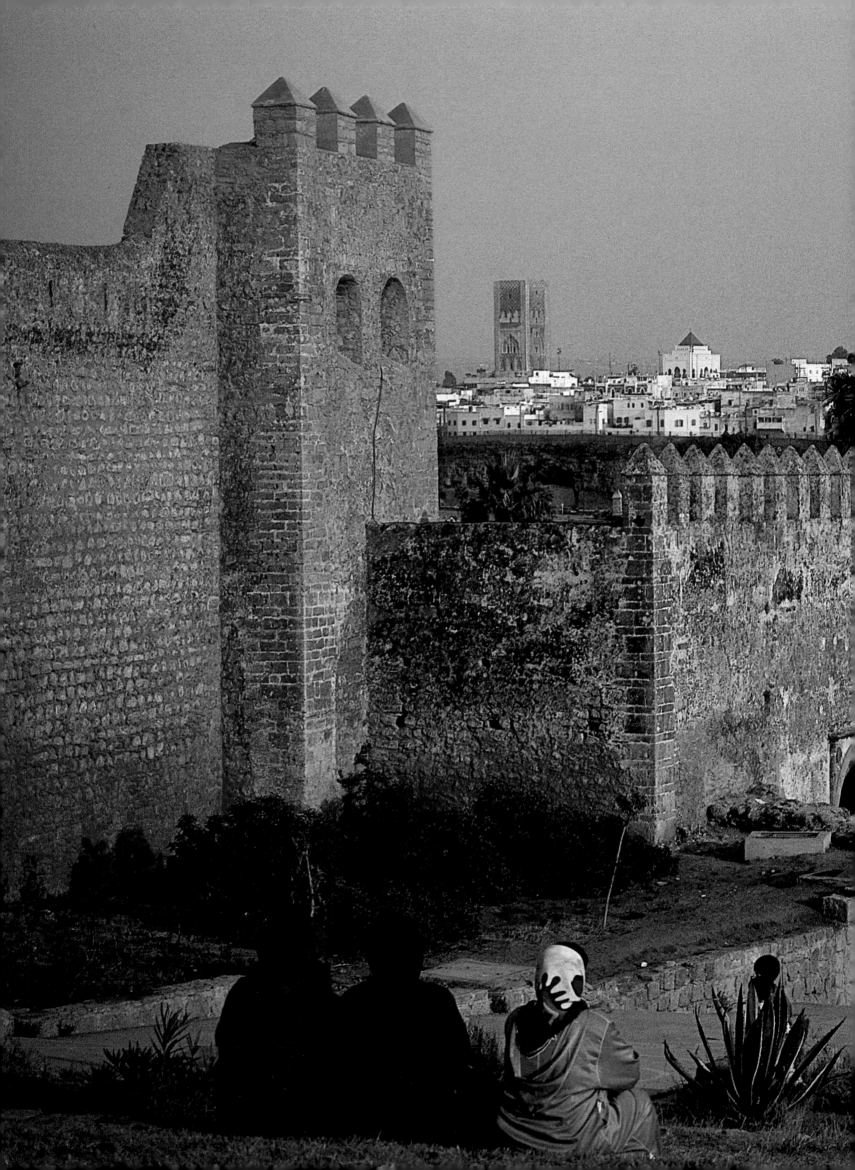

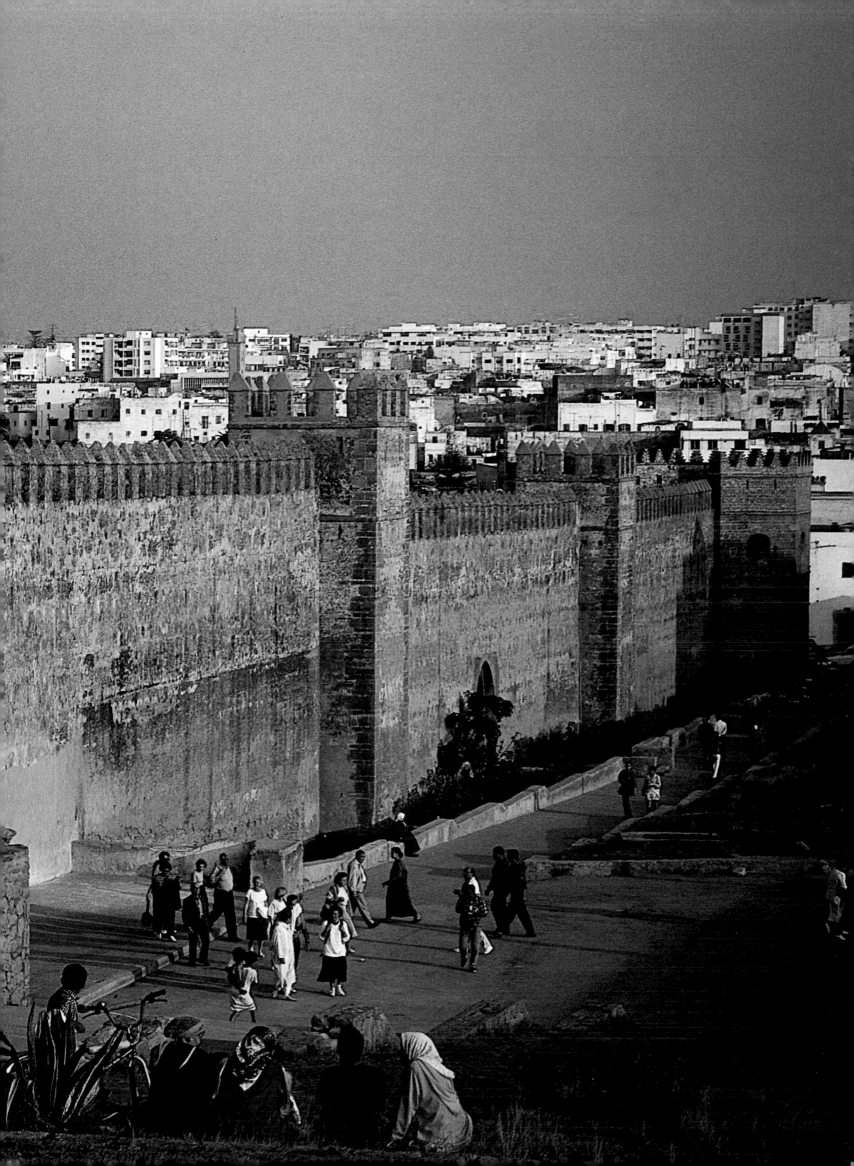

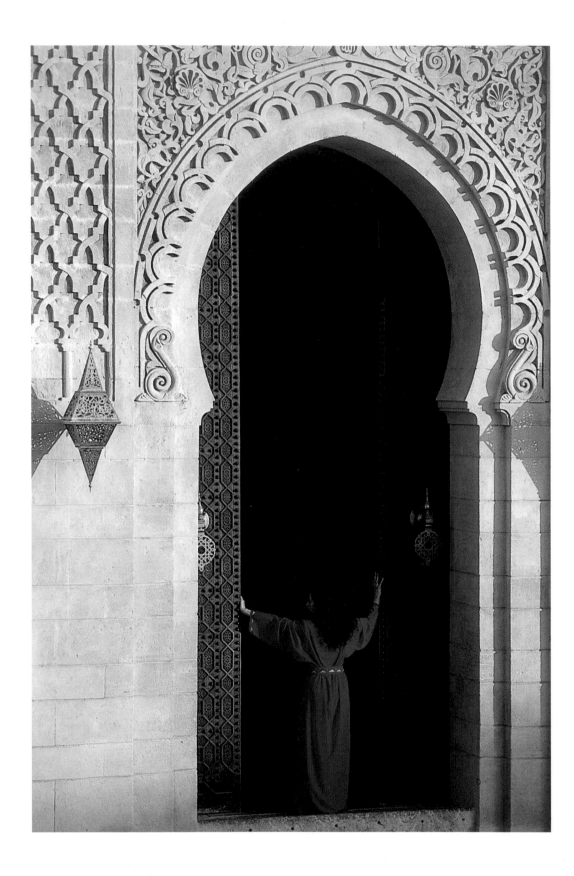

*M*osque of the mausoleum of Mohammed V at Rabat.

To the right :

*T*he fountain of the great mosque of Casablanca.

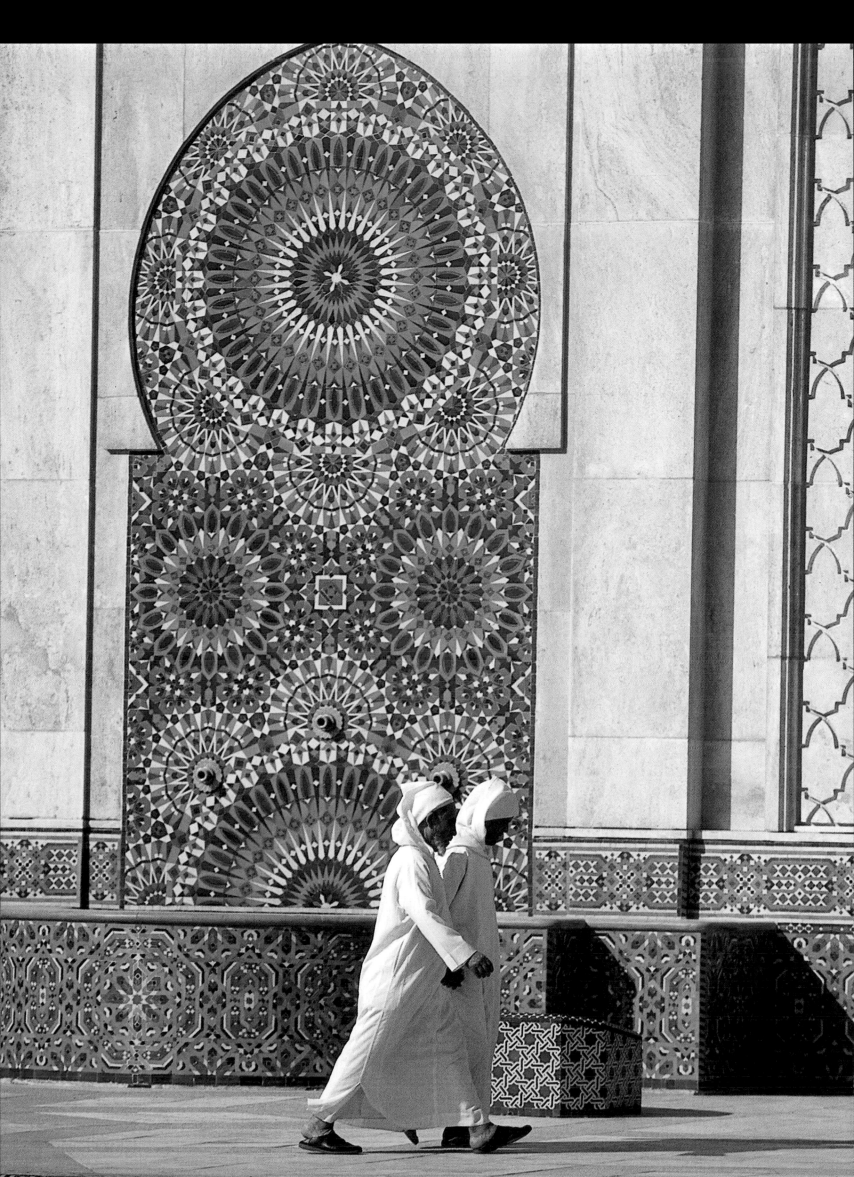

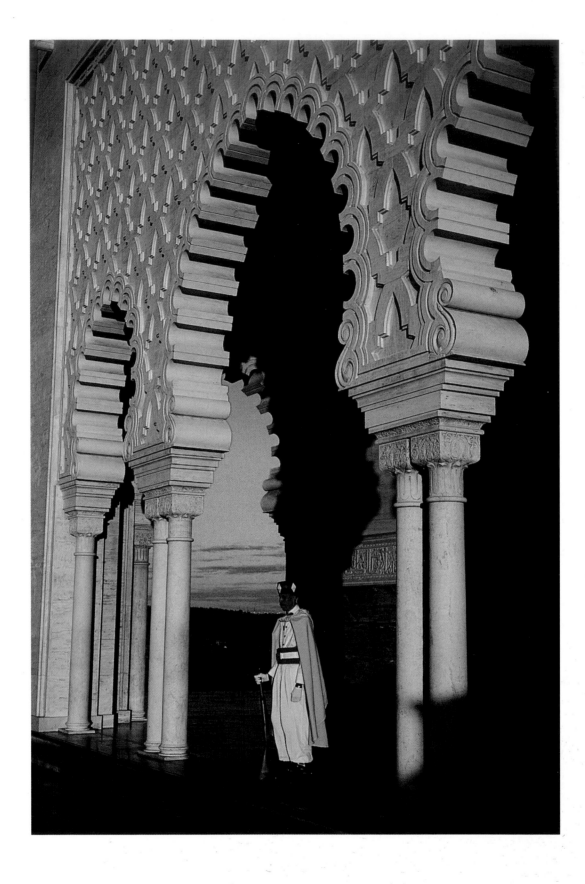

\mathcal{T}he mausoleum of King Mohammed V in Rabat was completed in 1971. Beneath the decorative stone arches stands a royal guard in his traditional costume.

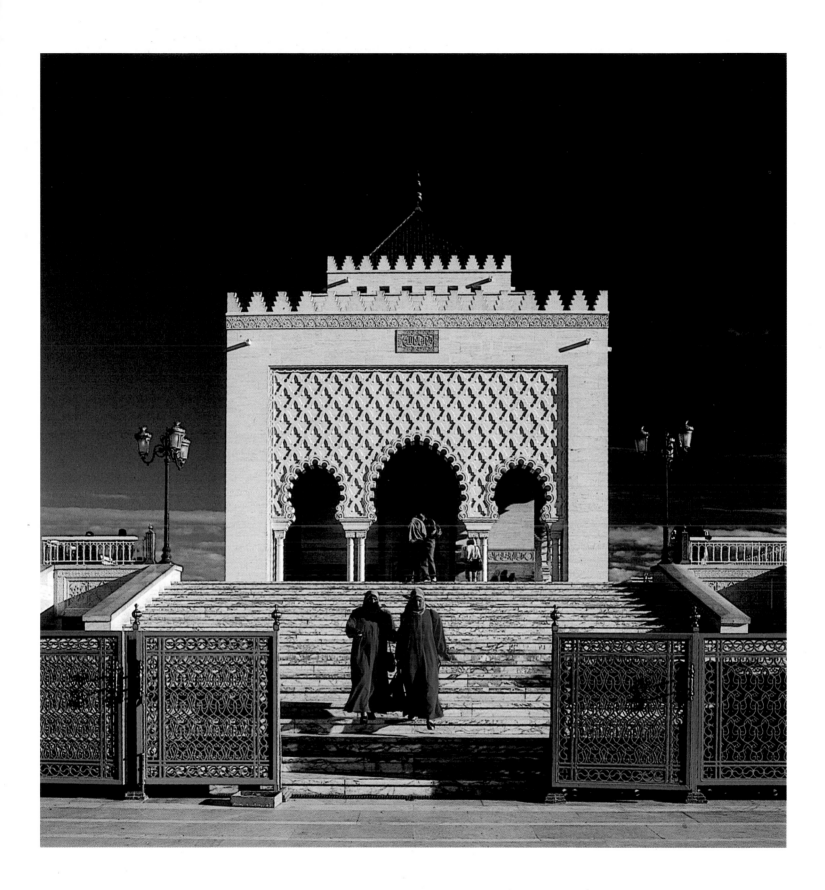

The previous monarch, King Mohammed V, lies in the white mausoleum dedicated to him. He died in November 1961 and was succeeded by his son King Hassan II, who formally ascended the throne the following March.

Pages 22-23

*I*n Rabat, the *casbah* of the Oudaïas, on the estuary of the Bou Regreg river.

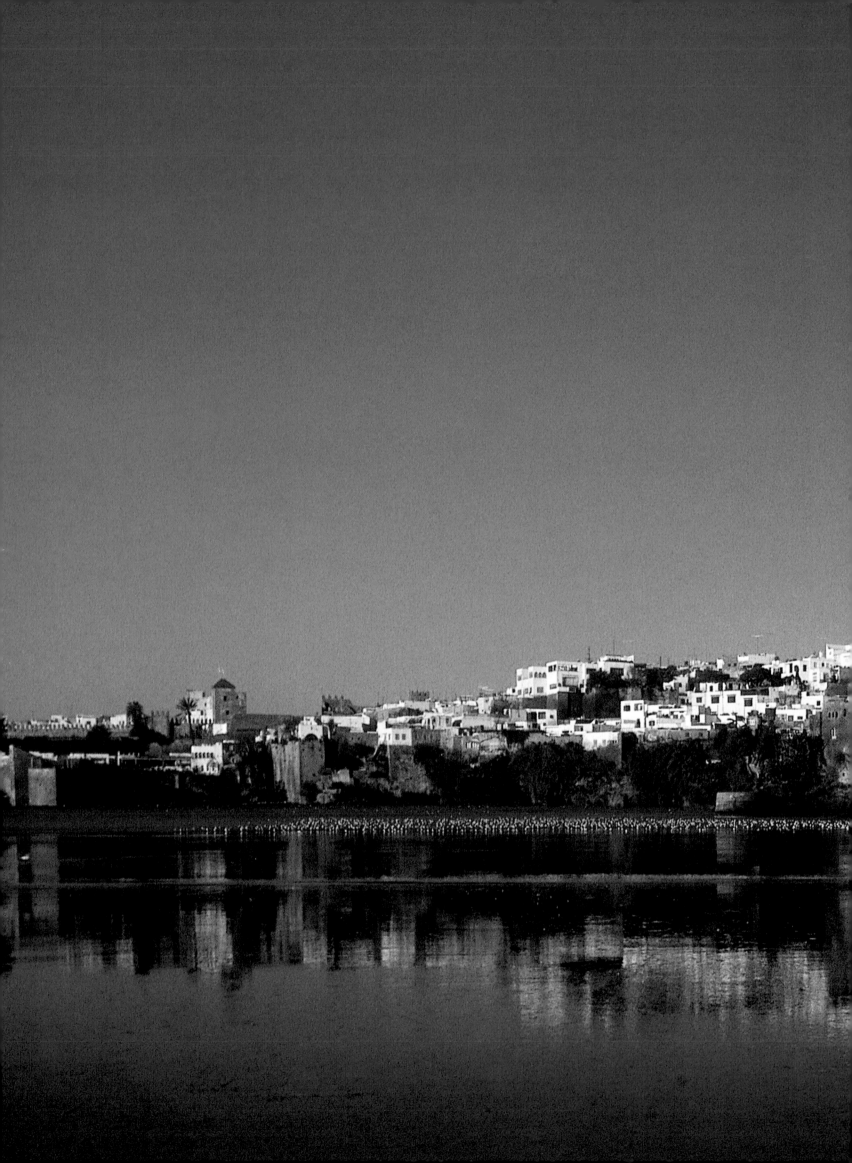

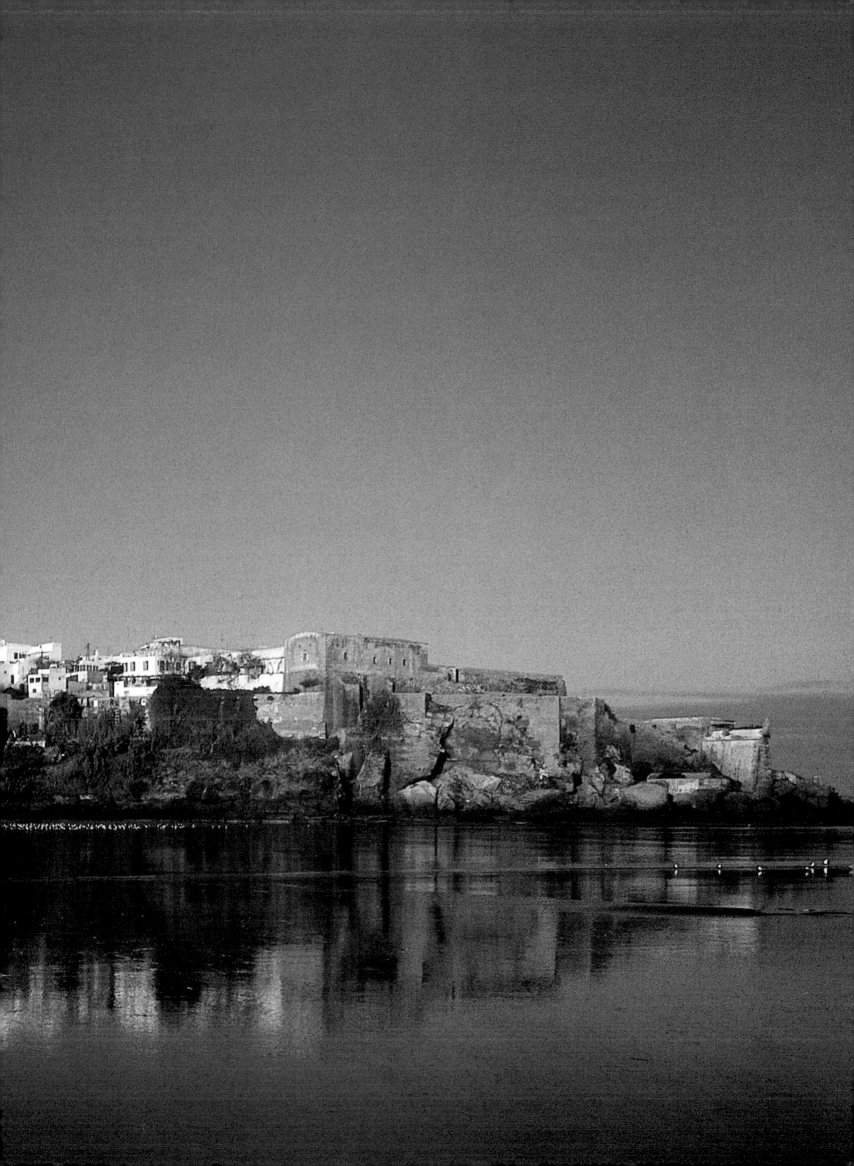

24 ⬚

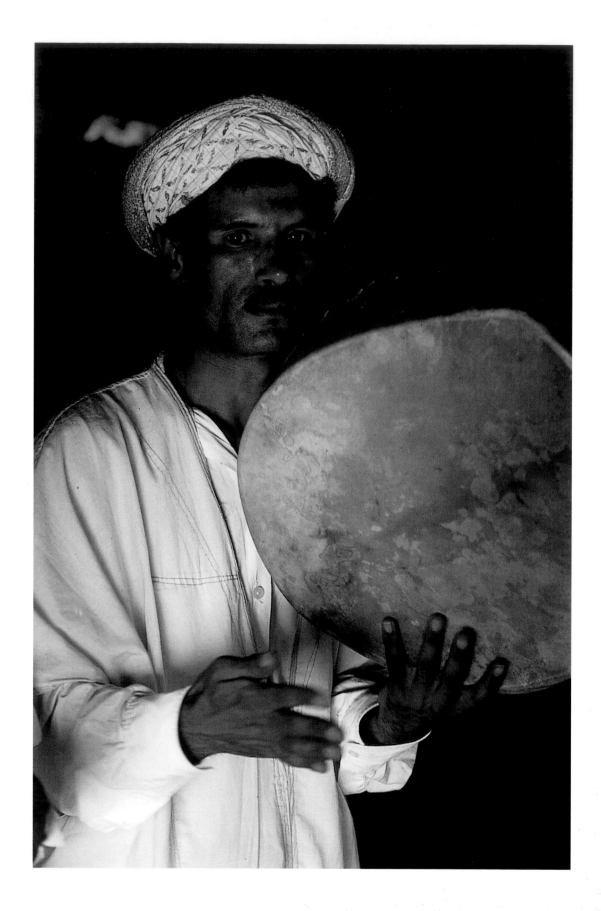

𝒜 bendir player. On festive occasions, the sound of the
bendirs resounds through the narrow streets of the
médina. Children learn the art of playing this tambourine
from an early age.

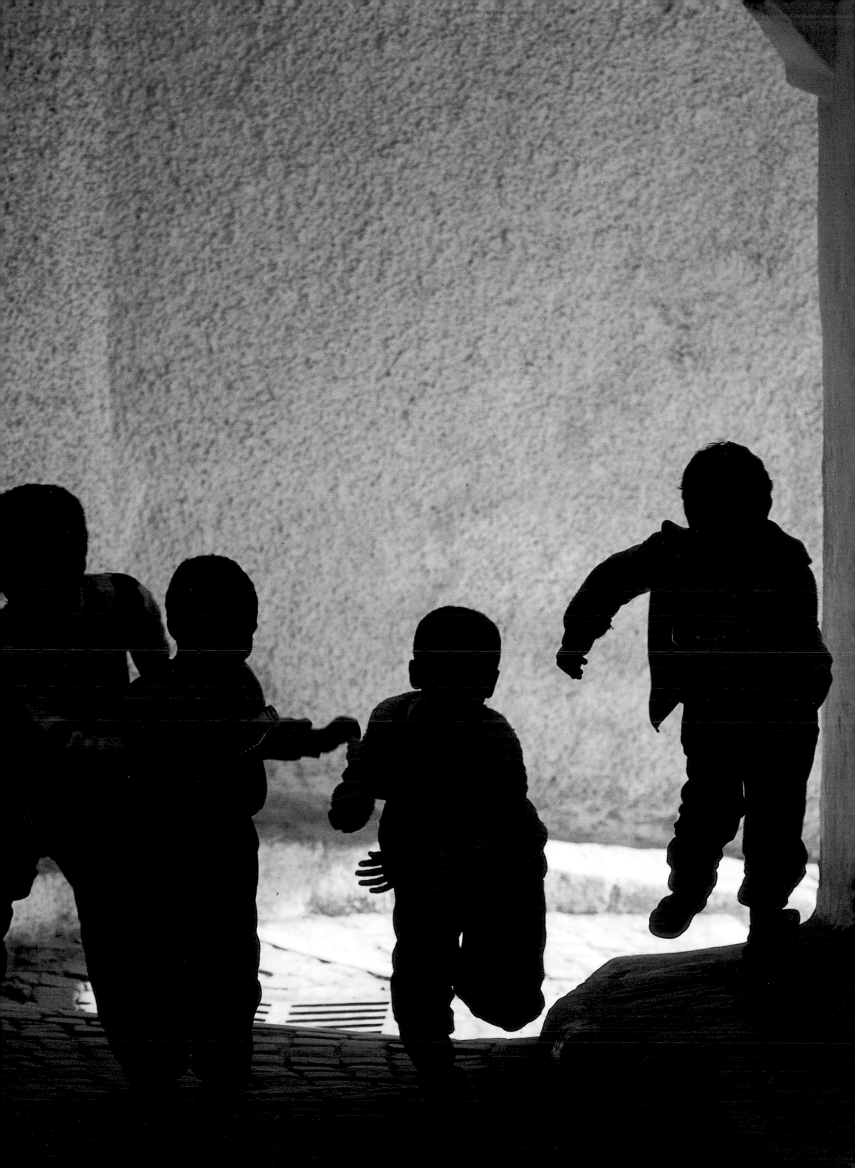

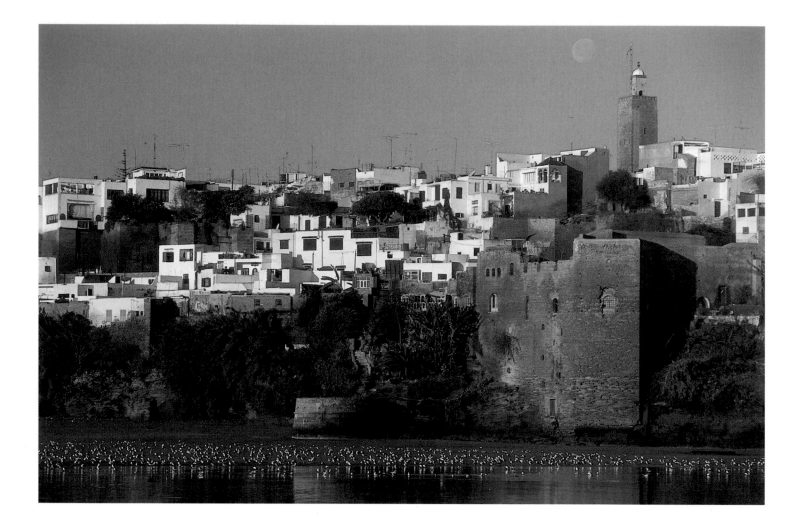

\mathcal{T}he very lovely houses in the *casbah* of the Oudaïas dominate the city of Rabat. Most of them have been restored and are occupied by painters, writers and sculptors.

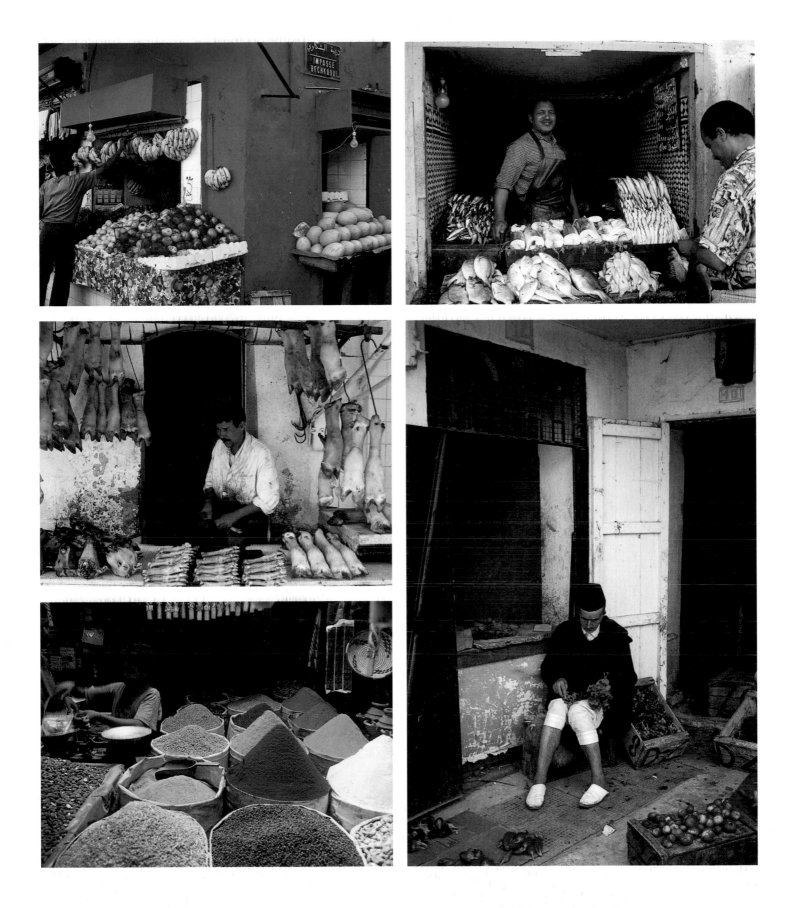

\mathcal{N}ear Rabat's Andalusian wall is a permanent market,
colourful and vibrant in the traditions of the East.

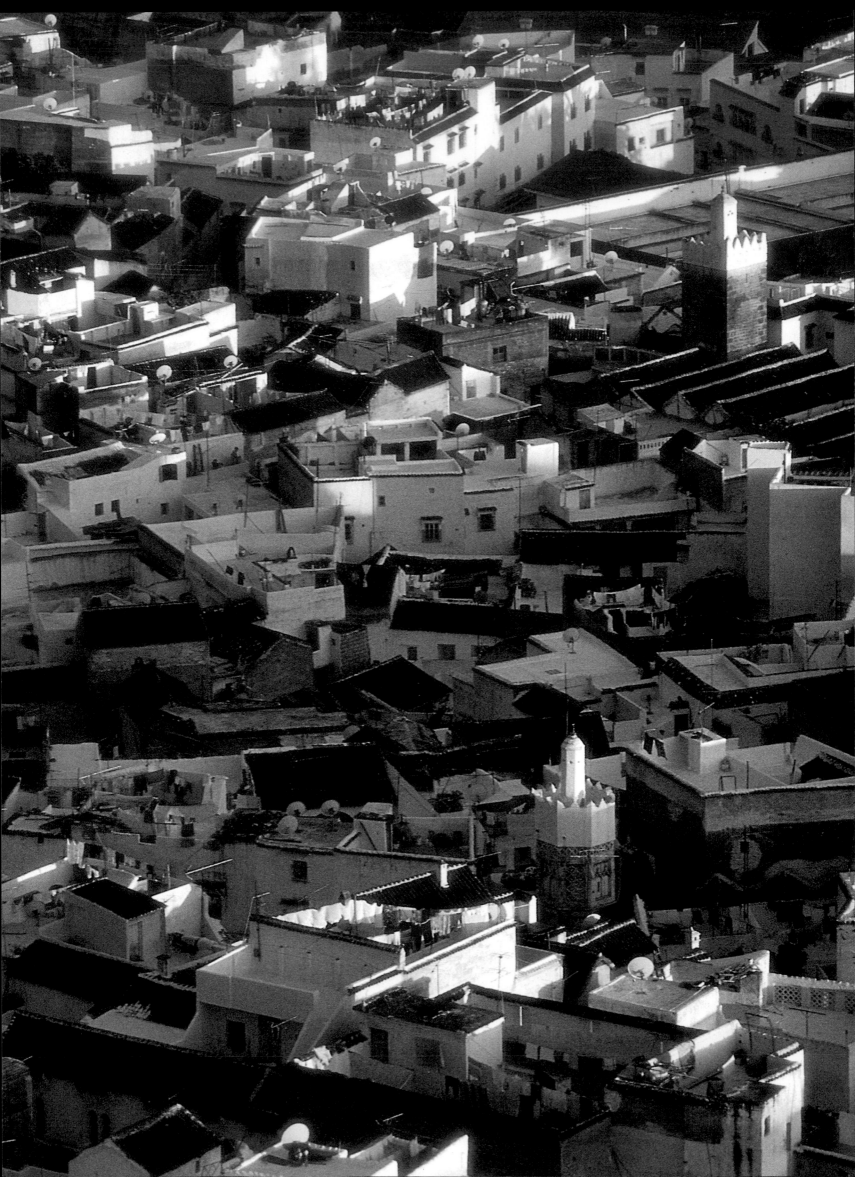

THE REGION OF TANGIER

The geographic features which have most influenced the evolution of northern Morocco are its Mediterranean and Atlantic coastlines and the Rif mountain range. The variety of languages spoken by the population, mainly of Berber and Andalusian origin, reflects a turbulent history, filled with successive invasions which shaped the development of the principal cities of the north: Tangier, Tétouan, Chefchaouen (or Chaouen), Asilah, and Al-Hoceïma.

There are no palm groves or crenellated red and ochre towers, nor are herds of camels to be seen. Instead, gaily coloured flowery slopes descend gradually or steeply to the sea.

Carthage, which had a Phoenician cultural tradition, colonised Morocco's Mediterranean and Atlantic shores for trade in the sixth century BC. Rome, after the three Punic wars fought intermittently against Carthage during three hundred years in order to assert its supremacy over North Africa, completed its conquest in AD 46.

The establishment of Islam in Morocco marked the beginning of an era predominated by a mixture of Berber, Arab, Jewish and Muslim cultures, with important European influences, which created Morocco as it is today. The richness of this civilisation can still be sensed in the everyday life of the cities of the north.

Tangier is Morocco's oldest continually inhabited city, founded around 1000 BC by the Phoenicians. A free port from 1923 to 1956, Tangier has always attracted a variety of adventurers, artists and intellectuals such as Delacroix and Matisse. The composer Camille Saint-Saëns found inspiration here. Later, it was home to writers such as William S. Burroughs, Jack Kerouac, and Paul Bowles, Tangier's most distinguished long-term resident expatriate writer. Situated at the crossroads of Europe and Africa, the city still survives economically on the tourism attracted by its continuing mystique.

Asilah, a town on the Atlantic coast which also had Phoenician origins, was raided by the Vikings in the 10th century. Not far from its decorated walls was fought the Battle of the Three Kings in 1578, between warring Moroccan factions allied respectively with the Ottomans and the Portuguese, and in which three monarchs perished. It marked the coming to the Moroccan throne of the Saadian dynasty king Ahmad el-Mansour.

The city of Tétouan was founded by refugees from Grenada who had fled from Spain in 1484. It is still called "La Grenadine" by its inhabitants, who take pride in its Andalusian past. On festive occasions, inside Tétouan's Hispano-Moorish palaces, orchestras of magnificently costumed women interpret classical *noubas*, musical suites based on the twenty-four hours of the day, which are versions of compositions originally brought to Andalusia in the twelfth century by musical virtuosos who had travelled from the courts of the great oriental potentates of the Middle East.

Chaouen is another magnificent town which, like Tétouan, was built by Andalusian Muslim refugees expelled from Spain during the persecutions of the late fifteenth century during the period known as the *Reconquista*. Beautifully situated on a hillside, it maintains the Andalusian traditions of whitewashed walls, blue doors, flower-filled patios, and a sense of austere pride in its architecture.

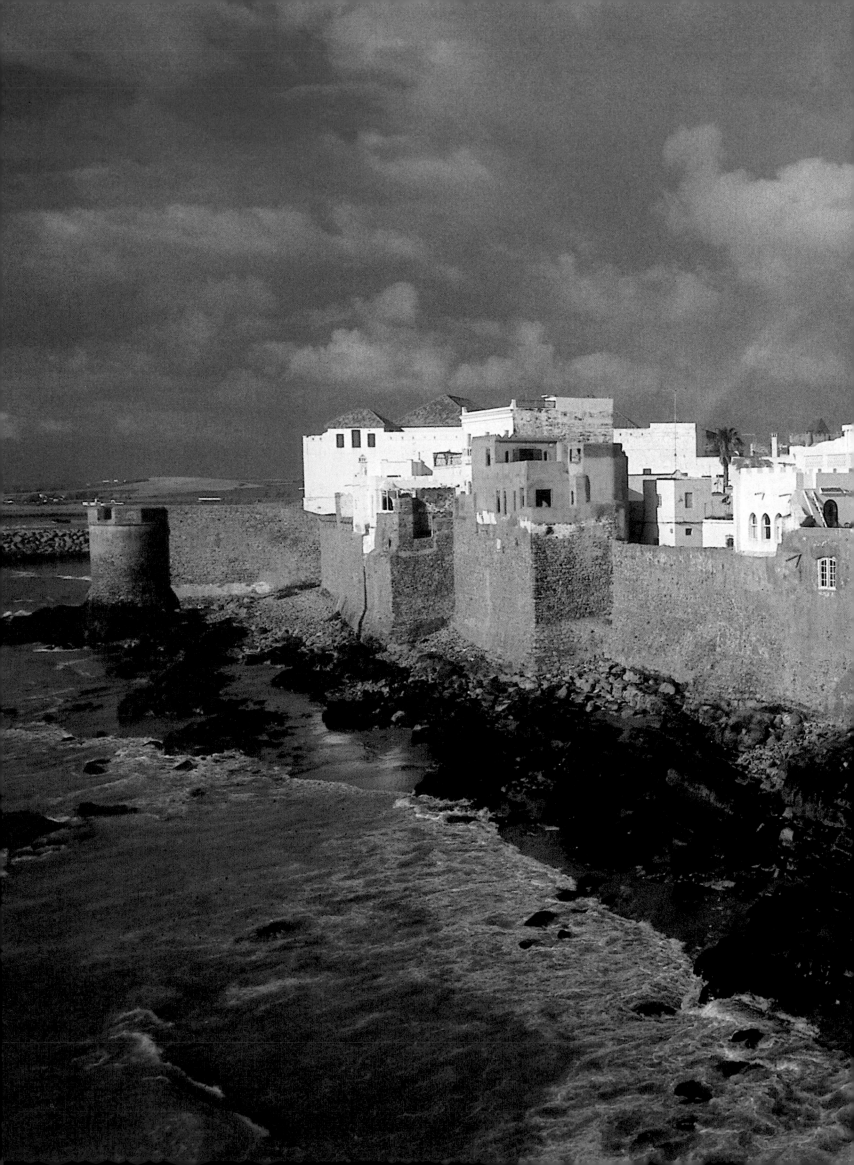

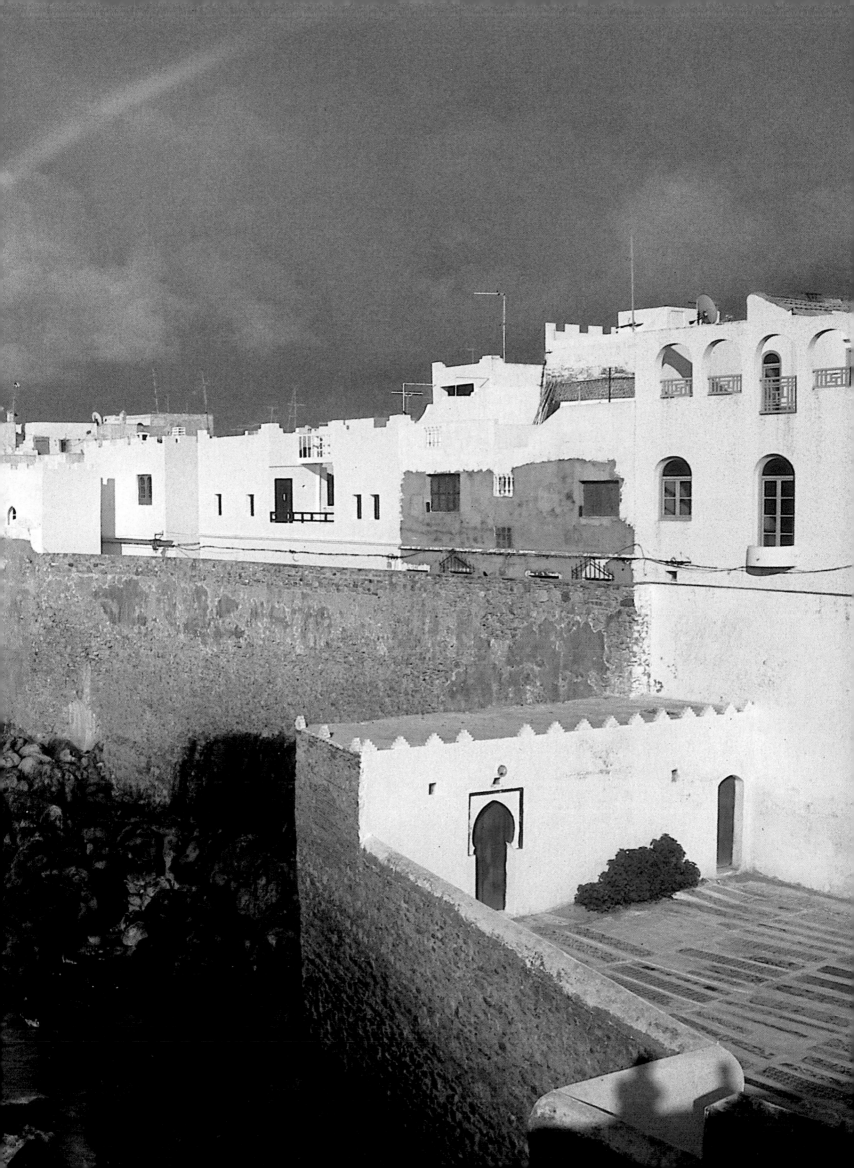

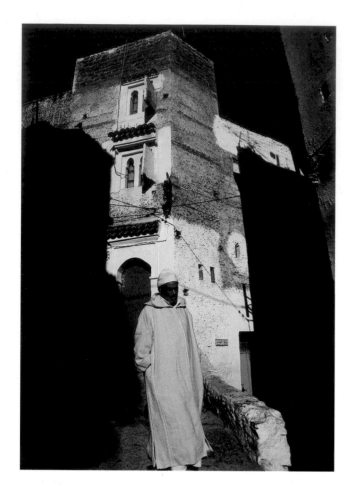

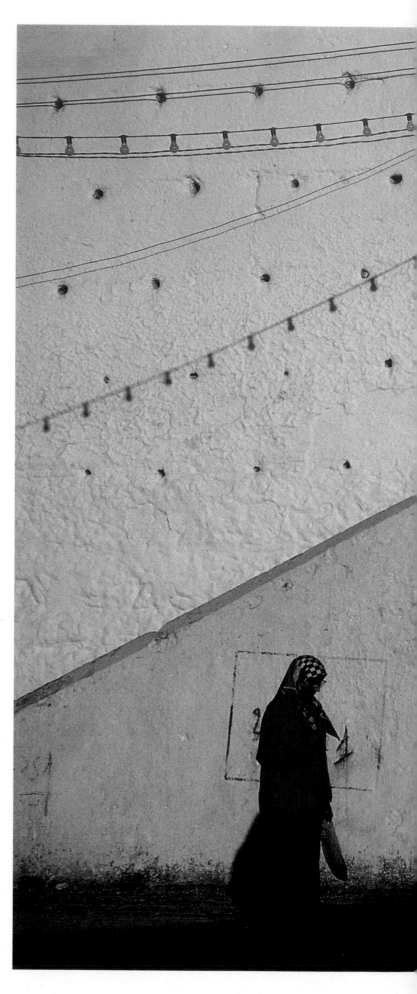

Pages 30-31

The ramparts of the old town of Asilah, dating from the Portuguese period (15th century).
In the lower right corner, a miniscule cemetary containing twenty or so graves covered with enamelled ceramics.

Andalusia, *anda lucia*, 'before the sun'. Romantic poets in Oriental courts celebrated the sun, recalling the lver and his loved one. Interpreters of *ala*, Arab-Andalusian classical music, sing the verse of one *nouba* (musical suite): 'Setting sun, do not go, do not leave me...'.

The mosque of Chefchaouen in the Ulta el-Hamman. Chaouen (or Chefchaouen), founded at the end of the 15the century, is a religious centre containing numerous mosques and the much venerated tomb of its founder, Sidi Ali ben Rachid. Built as a stronghold, huddled at the foot of the mountain of Ech Chaouen (which means 'horns' in the Berber language), the town served as a refuge for Muslims who left Spain just before the *Reconquista*, by the Spanish king in 1492.

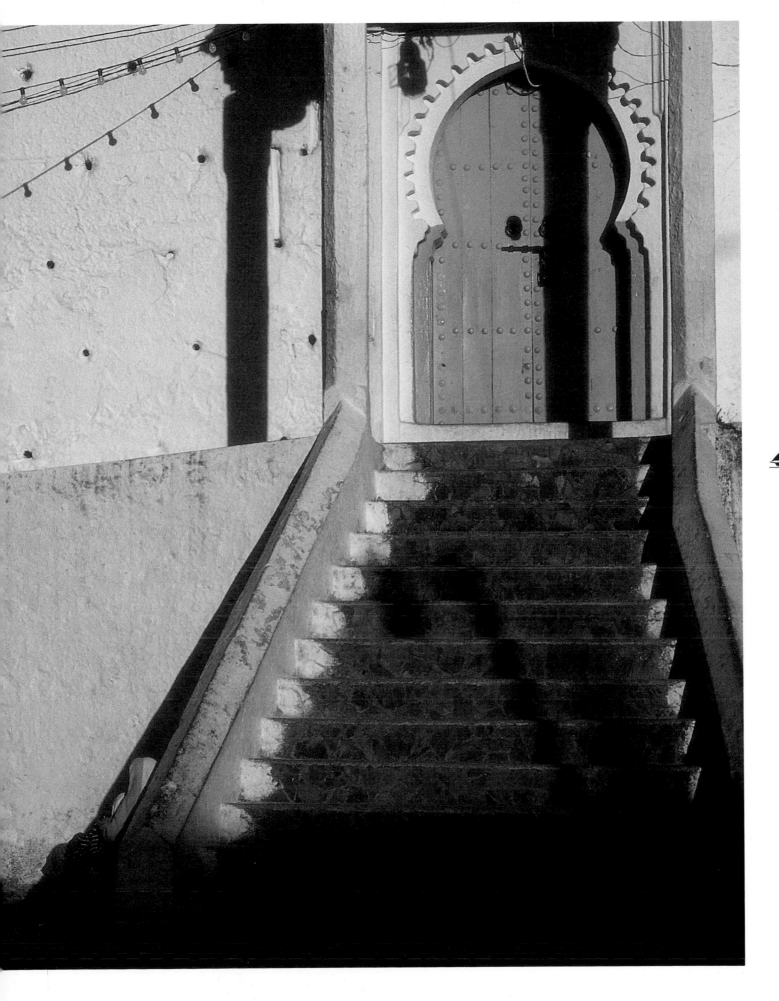

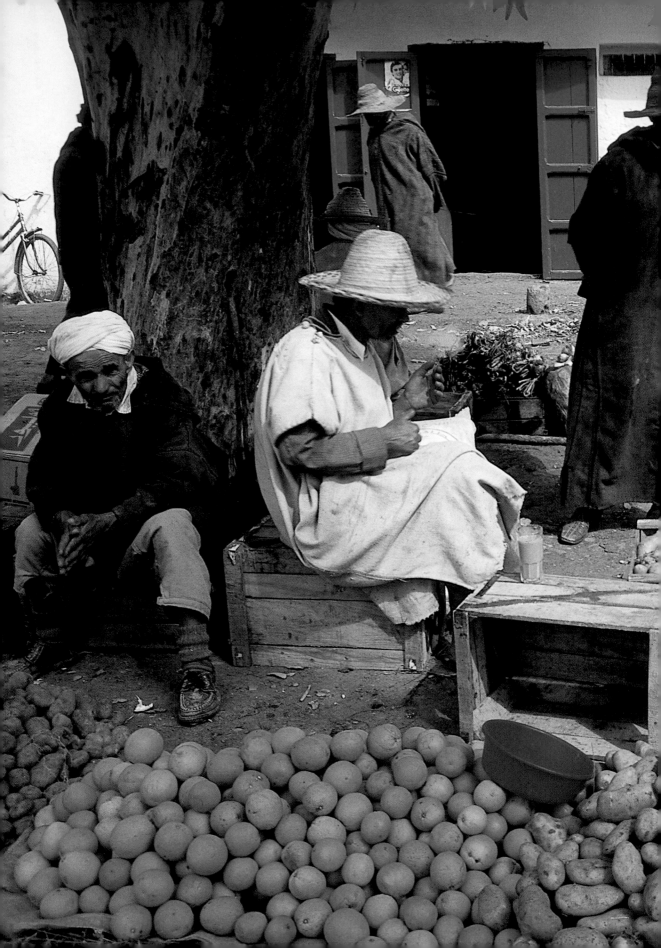

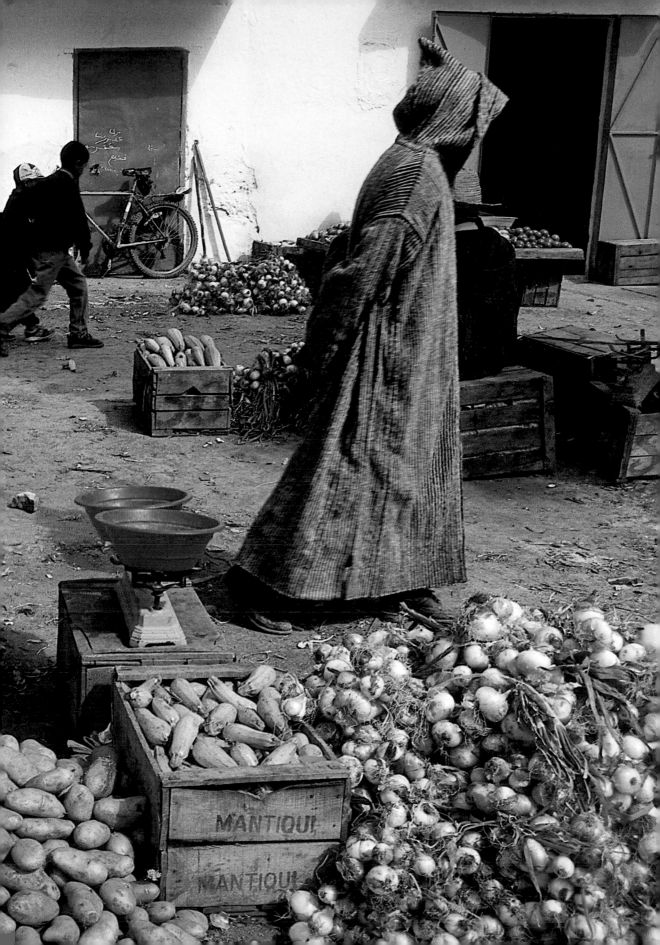

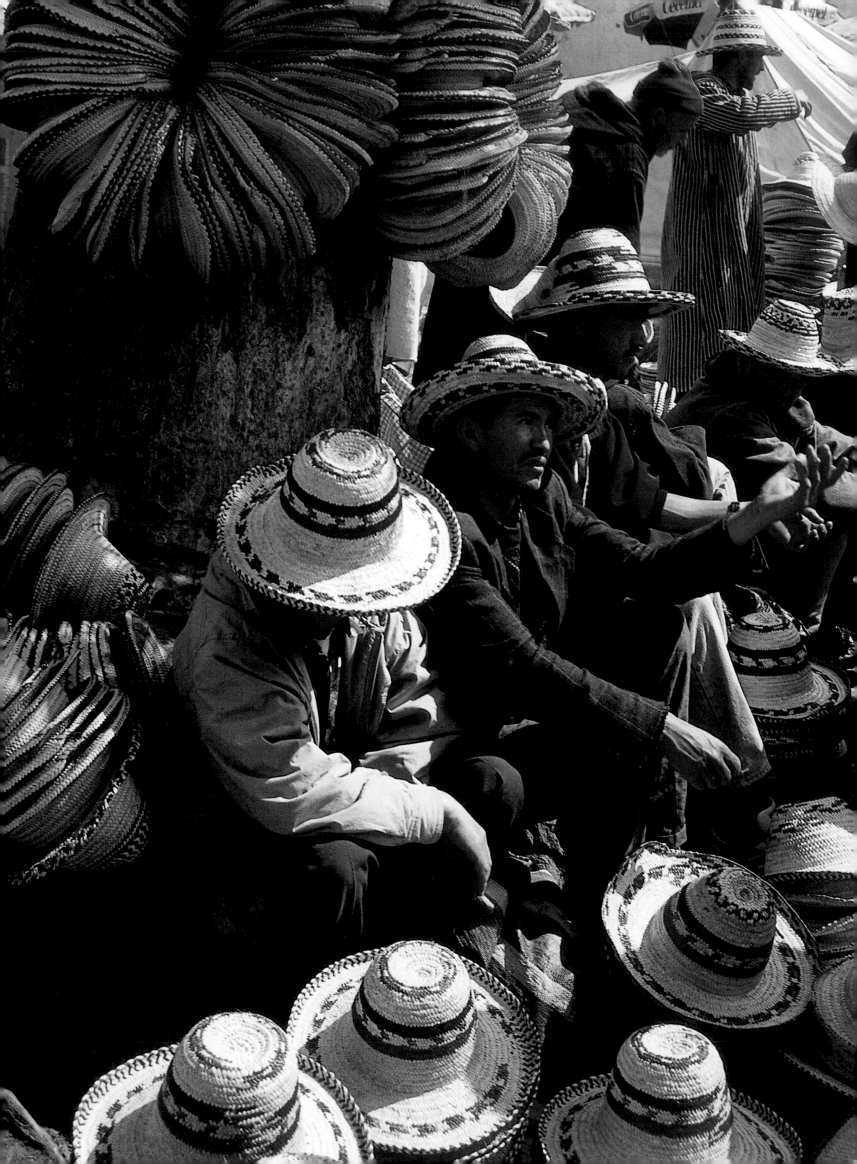

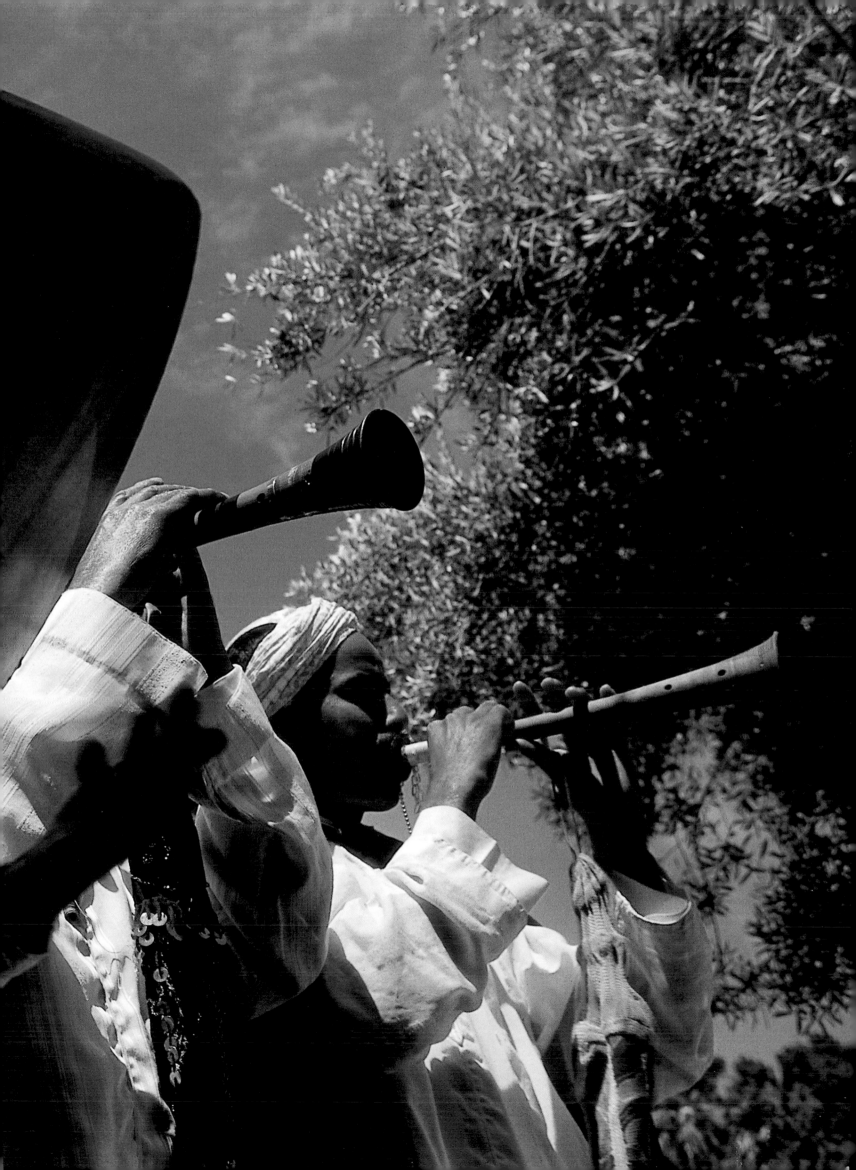

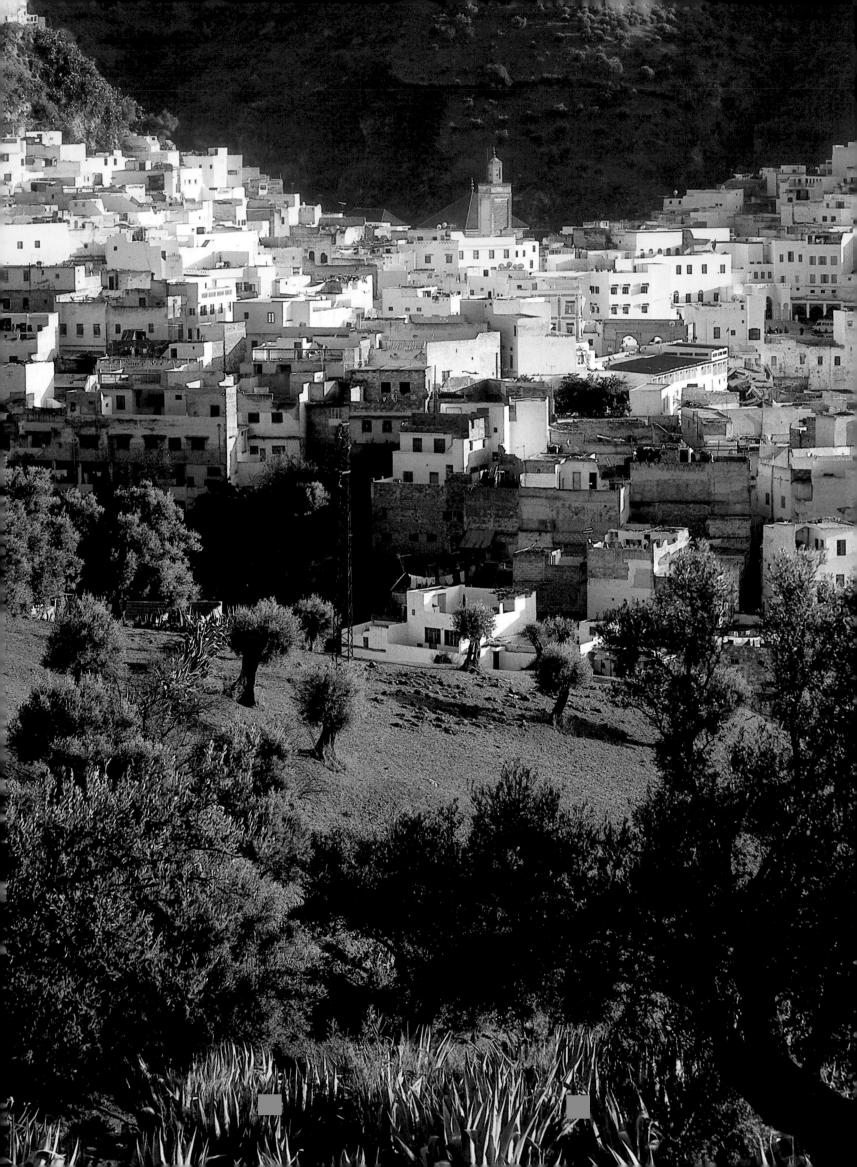

MOULAY IDRISS

The holy city of Moulay Idriss is situated upon a low hill dominating the plain below. It was partly built on the location of Volubulis, a Roman provincial capital, which by the eighth century was known as Walila, a town in which Christians, Jews, and Muslims lived side by side. In 788 the Arab Prince Idris ibn Abdullah sought refuge here, after a journey which had taken him across Arabia and the length of North Africa. He had fled from Mecca, having lost the battle of Fakh there in 786, fighting at the side of his cousin Husayn, the great-great grandson of the Prophet Mohammed, against the armies of the Caliph. He settled, thinking he would be safe in this remote corner of the Arab world, and soon attracted attention for the depth of his Koranic study. Once it became known that he was a sharif, a descendant of the Prophet, he was recognised by the local tribes as their Imam. However, in 791 he was hunted down and slain by an agent of the Caliph, who claimed to be the only legitimate successor of Mohammed. Idris, although unmarried and childless, left behind him a pregnant mistress, who was noticed by Rachid, his faithful slave. She gave birth to a boy who Rachid, while eventually falling victim to an assassin himself, was able to protect, and who was proclaimed Imam Idris II at the age of 11. He founded the city of Fez in 809, which became home to a succession of Idrissid rulers, Morocco's first orthodox Muslim dynasty.

The pointed green dome of the sanctuary dedicated to Moulay Idriss I (as Idris ibn Abdullah is known today) dominates the Roman ruins of Volubulis. The annual moussem in his honour takes place each September. Lasting a week, it is a combination of solemn commemoration, pilgrimage, popular celebration, and commercial fair. There is a festival of liturgical song, poetry, and ritual dancing. Thousands upon thousands of pilgrims, merchants, horsemen, members of religious societies and followers of the Sufi brotherhood flock to the town, setting up a tent city on the side of the hill. In the main square of the city the festival is officially opened by the Alamiyine Society, followers of the holy man and poet from Meknes, Kadour el Alami. He originated the moussem in 1824, by leading a long march of the faithful, praying for relief from a tragic drought. They were rewarded with providential rains, an event which is now recalled in praises addressed to Allah, Mohammed, and Moulay Idriss.

During seven days and nights the city is animated by a continuous succession of processions bringing offerings to the sanctuary, accompanied by the beating of tambourines and the blare of oboes. Velvet relics embroidered with gold, carpets, copper censers and baskets filled with money are carried into the mausoleum, while outside there are stands stocked with food and multicoloured delicacies.

From the edge of the city, near the encampment of large tents belonging to the most prominent visitors, comes the sound of the whinnying of horses being prepared for the fantasia, which will take place on the esplanade dominating the city. It is the week's most spectacular moment, awaited particularly by the children. The caparisoned horses appear, ridden by cavalry warriors in full traditional attire, who mount a great charge, accompanied by war cries and the loud firing of muskets, filling the air with dust and gunpowder smoke. The fantasia marks the end of a week which has been an intensely religious experience

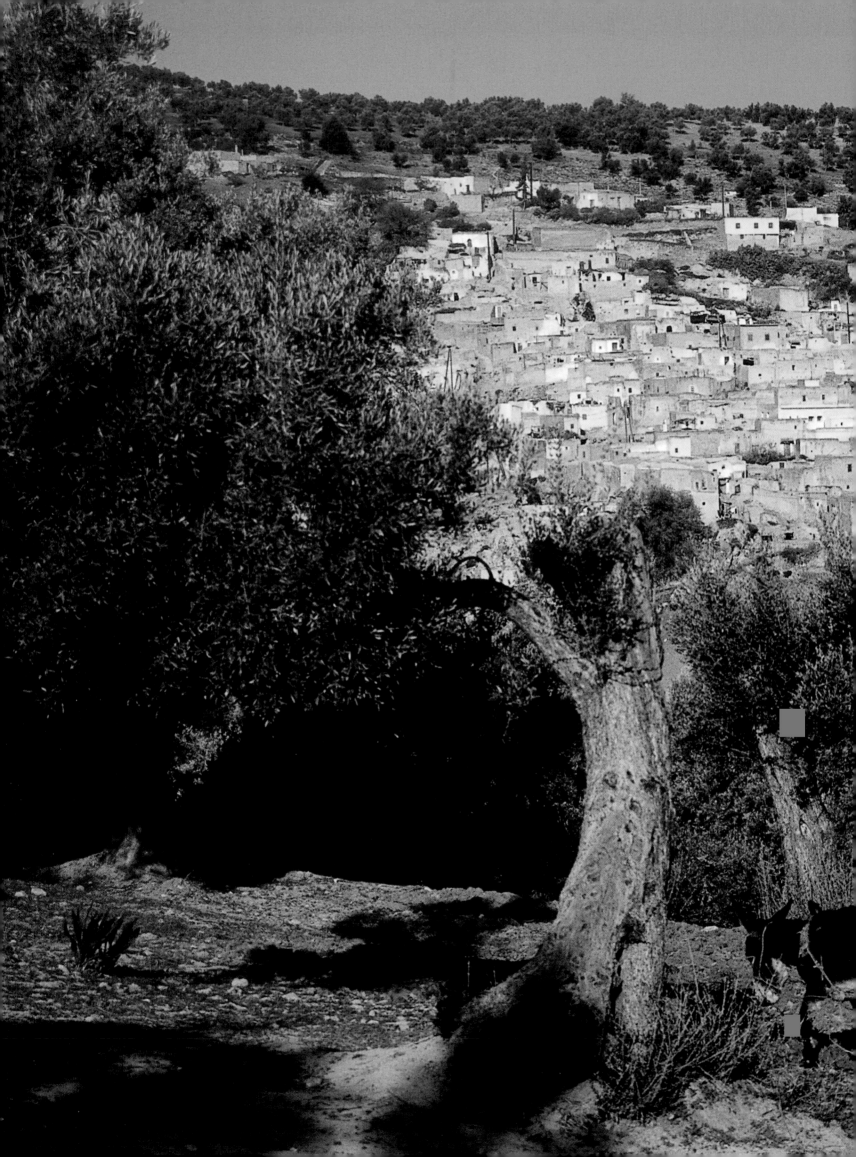

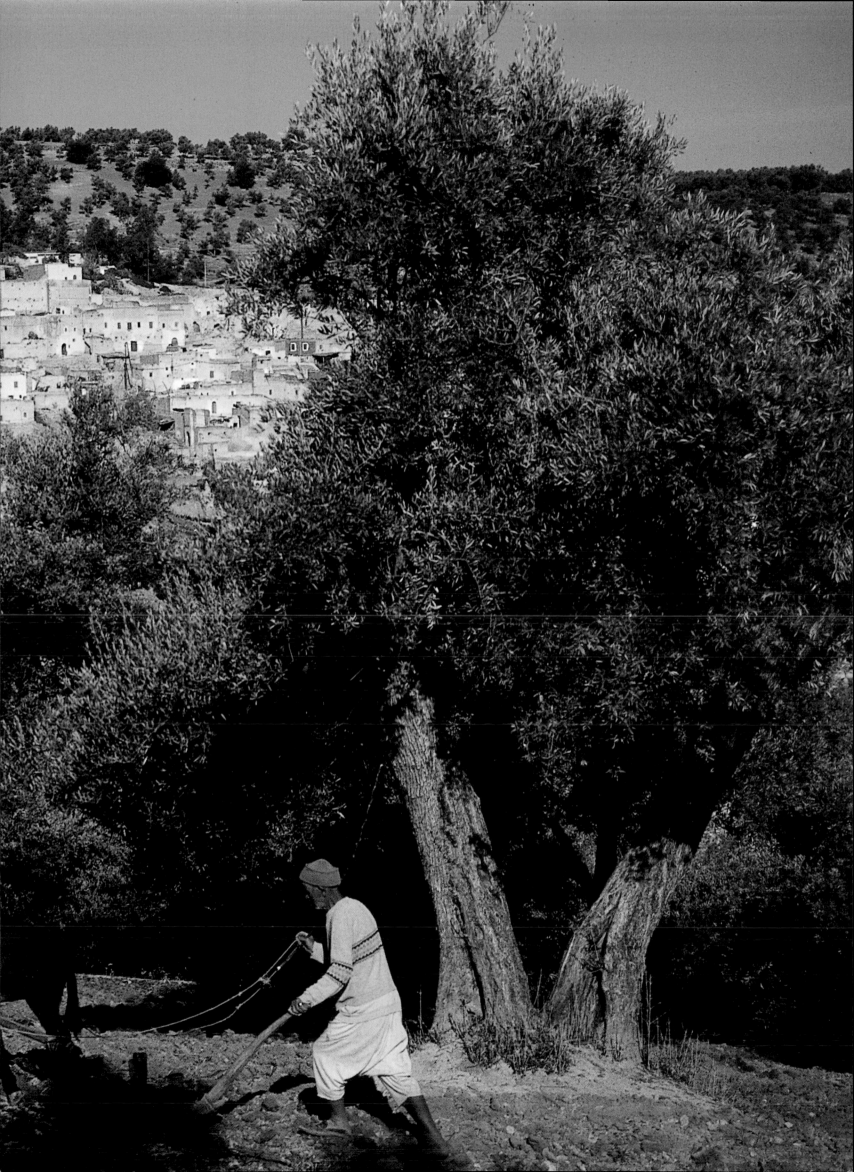

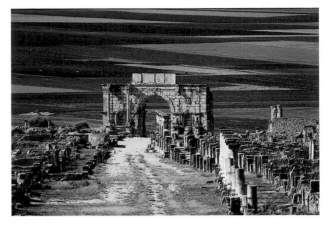

Page 40

\mathcal{T}he only Moroccan city named after its founder, Moulay Idriss is built around its sanctuary. When the time of the *moussem* arrives, pilgrims congregate at the mausoleum of the holy man in the hope of obtaining some of his *baraka*: his good fortune and providential blessing.

Pages 42-43

\mathcal{N}ear Moulay Idriss, a village in the Zerhoun mountain range, surrounded by a forest of century-old olive trees.

Above

\mathcal{A}rch of Triumph of Caracalla at Volubulis, on the Via Decumanus Maximus, built in AD 217 by Marcus Aurelius Sebastenius.

Pages 46-47

\mathcal{F}arm in the region of Khemisset.

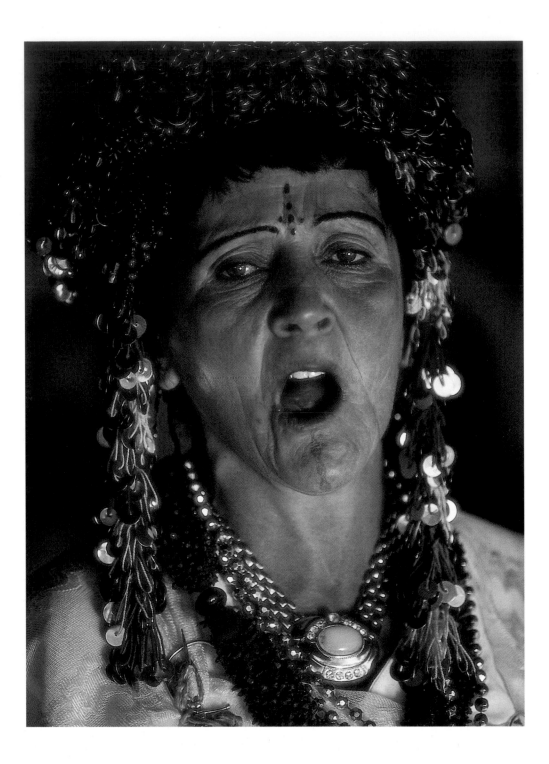

𝒯he *aïta*, a style of music sung by women, is a kind of shrill cry transformed into a supplication. Its singers come from both Berber and Arabic-speaking regions, and this popular art is particularly well-performed in the port cities. Its themes are of love, sorrow and hope. Other songs recount the great moments of Moroccan history.

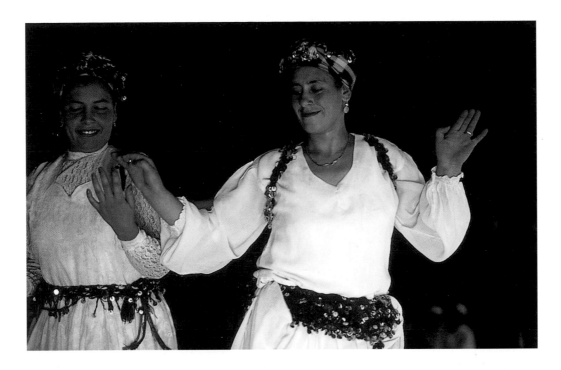

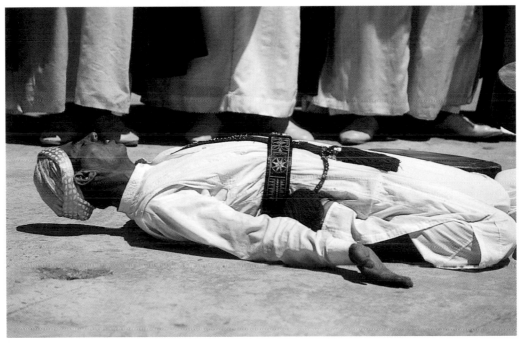

Page 50

𝒯raditional dance is of great importance in Morocco. Each village has its own particular choreographic figures and rhythmic style. Dancers throughout the country miss no occasion to show their skills, for the enjoyment of spectators and for their own pleasure.

𝒯he patio leading to the entrance of the tomb of Moulay Ishmael (1646-1727), a mausoleum carved in arabesque style. A descendant of the Alouite Dynasty of *shorfas* (Muslim dignitaries of Arabian origin), his 54-year reign was marked by the creation of a powerful army and ambitious architectural projects, most famous of which was the the new capital of Meknès.

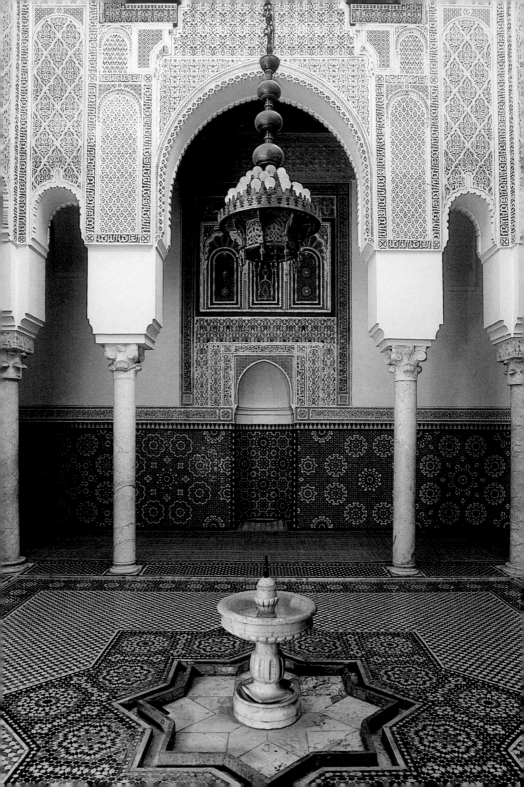

MEKNÈS

Situated on a plateau overlooking the river of Bou Iferkane, the city of Meknès attracts the eye by its sheer grandeur. Its origins go back to the eighth century, when it was built by a Berber tribe, the Mecknessa. Meknès was to reach its pinnacle when the Sultan Moulay Ishmael (1672-1727) chose it as his capital. Because of the grandiose scale of works he undertook, Meknès is often compared to the Versailles of Louis XIV. They included 26 miles of ramparts, complete with bastions and monumental gates, an immense palace, cavalry stables for twelve thousand horses with lodging for seventy thousand men, in which half Moulay Ishmael's army was garrisoned, and a vast ornamental lake. As the Sun King had done when he moved the capital of France from Paris to Versailles, Moulay Ishmael ordered the royal seal of the capital to be taken from nearby Fez and placed on the grand gate of Meknès.

The caravans between Meknès and Ghana and the Sudan prospered during this period, bearing gold and slaves, which counted among the most valuable natural riches of the time. Today, the trade in wool, wheat and olive products give Meknès the character of an important country town. And yet it is also one of the eminent spiritual, intellectual, and artistic centres of Morocco.

The tomb of the venerated Sufi master, Sidi Hadi ben Aïssa, attracts many of his followers, who are called the Aïssaoua. Each year, on the occasion of the Sufi *moussem*, or pilgrimage, members of Sufi Brotherhoods from all over Morocco converge on Meknès. Entranced and intoxicated by the throbbing rhythms of their tambourines, they attract spectators who, incapable of resisting, become mesmerised themselves, joining the Sufi in their frenzied dances.

The poet and holy man Sidi Kadour el-Alami is also buried at Meknès. He became famous in the nineteenth century for his beautiful collection of *malhoun* verses, or sung poetry. Compositions in this style continue to be written by poets inspired by his tradition, verses full of penetration and wit which praise Allah and Mohammed, while also glorifying beauty, love, wisdom, and drunkenness. Until recent times, the *mellah*, or Jewish quarter of Meknès, was a spiritual centre where people of enlightened spirit produced exceptional books and works of art still prized by researchers and collectors. The *mellah* was protected by the ruler, being situated close to his palace, and for centuries many Jews and Muslims coexisted, with common tastes in music and food, and in mutual respect for each other's particular customs. While most of the Jews of Morocco left in the 1950s and 1960s for Israel and for France, one often encounters individuals or families who have returned to visit, walking about the *mellah* or the *medina*, who pause to gaze with emotion and nostalgia at their childhood home. Although Meknès never became as famous among foreign artists and intellectuals as Tangier and Marrakech, it has made a profound impression on those who have taken the time to appreciate it. While its neighbour Fez served as a subject for 19th century writers, Meknès was immortalised by Eugene Delacroix. The dazzling, powerful paintings and drawings he did here depicted the dramatic displays of horsemanship, of Berber origin, which are the pride of Morocco's past. This romantic imagery is celebrated today in the form of the *fantasia*, the definitive version of which is performed in Meknès. Upon a vast esplanade of hard-packed earth, proud, magnificently saddled horses and their riders

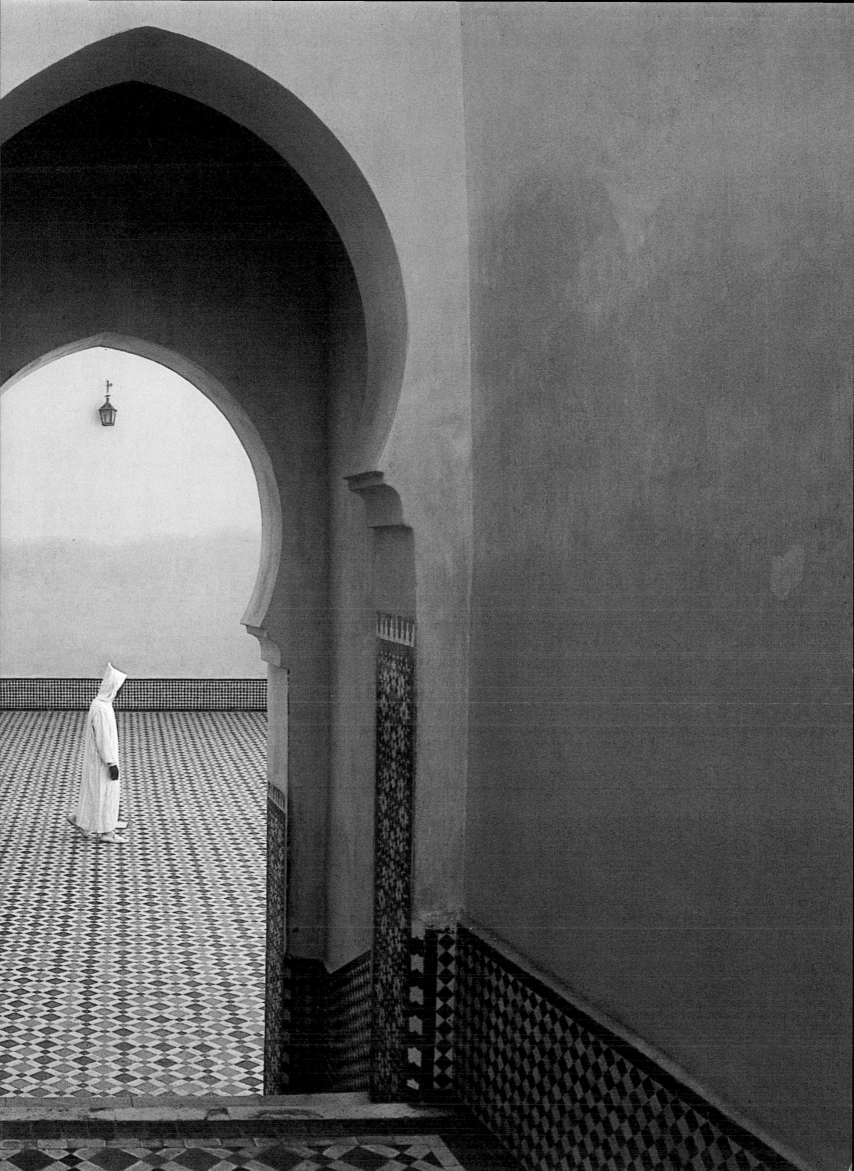

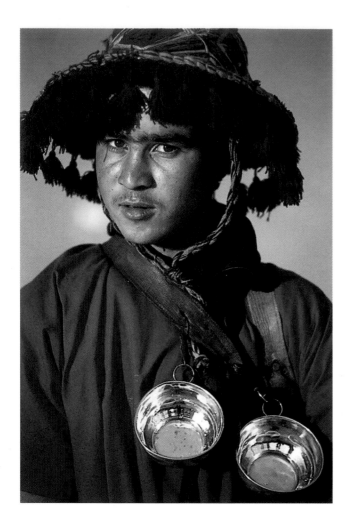

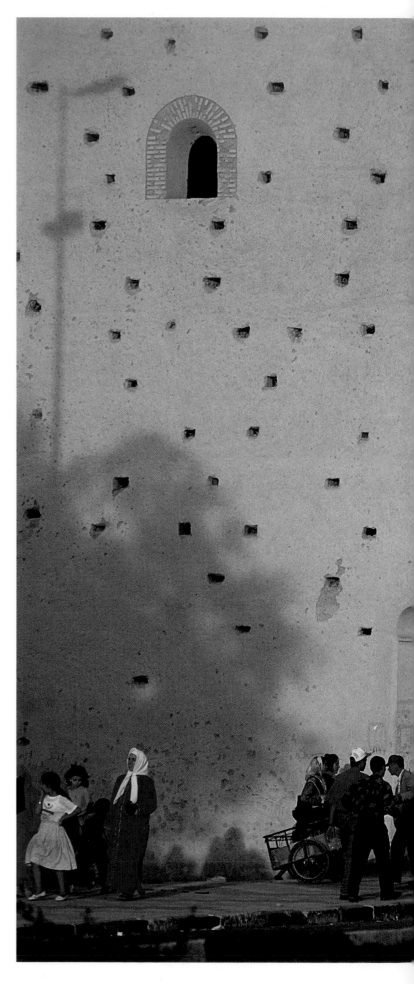

Pages 52-53

*I*n Meknès, in the crypt of Moulay Ishmael's tomb, a Muslim holy place ornamented with glazed enamel mosaics.
The succession of wives in Moulay Ishmael's harem numbered about 600, and gave him almost 700 sons.

*B*efore the great Bab el-Khemis Gate in Meknès, also known as the Thursday Gate, the archway decorated in black, and the gate framed in green enamelled brick.

El guerrab, or water bearer, serves cold water in gleaming copper goblets, which hang on his chest like precious jewels.

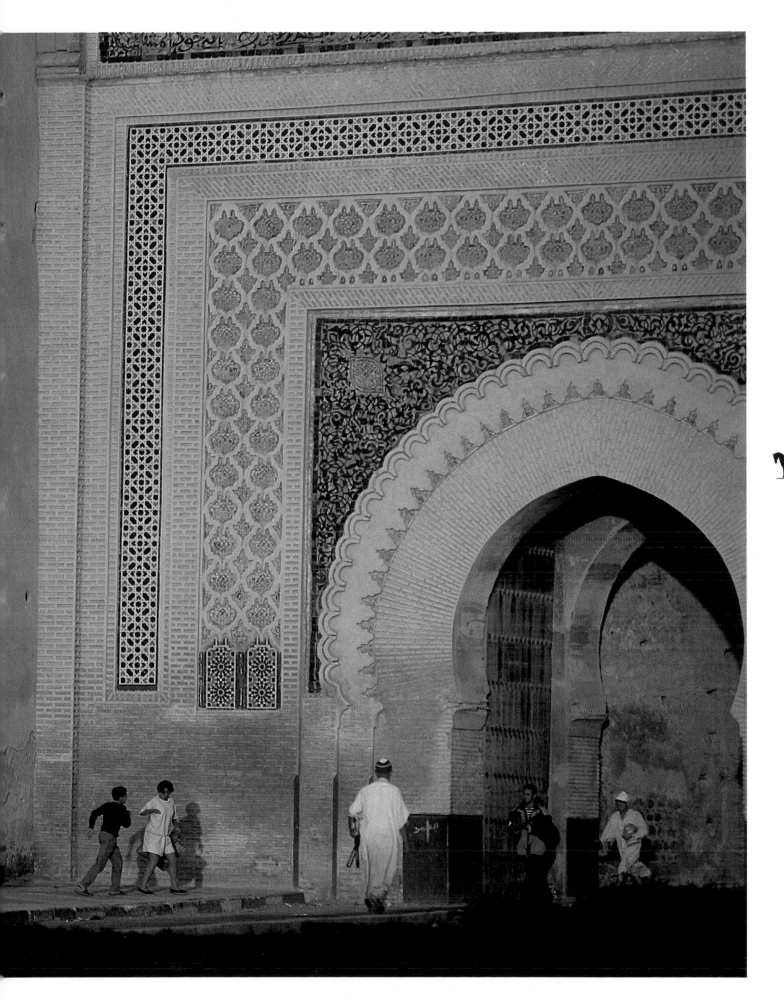

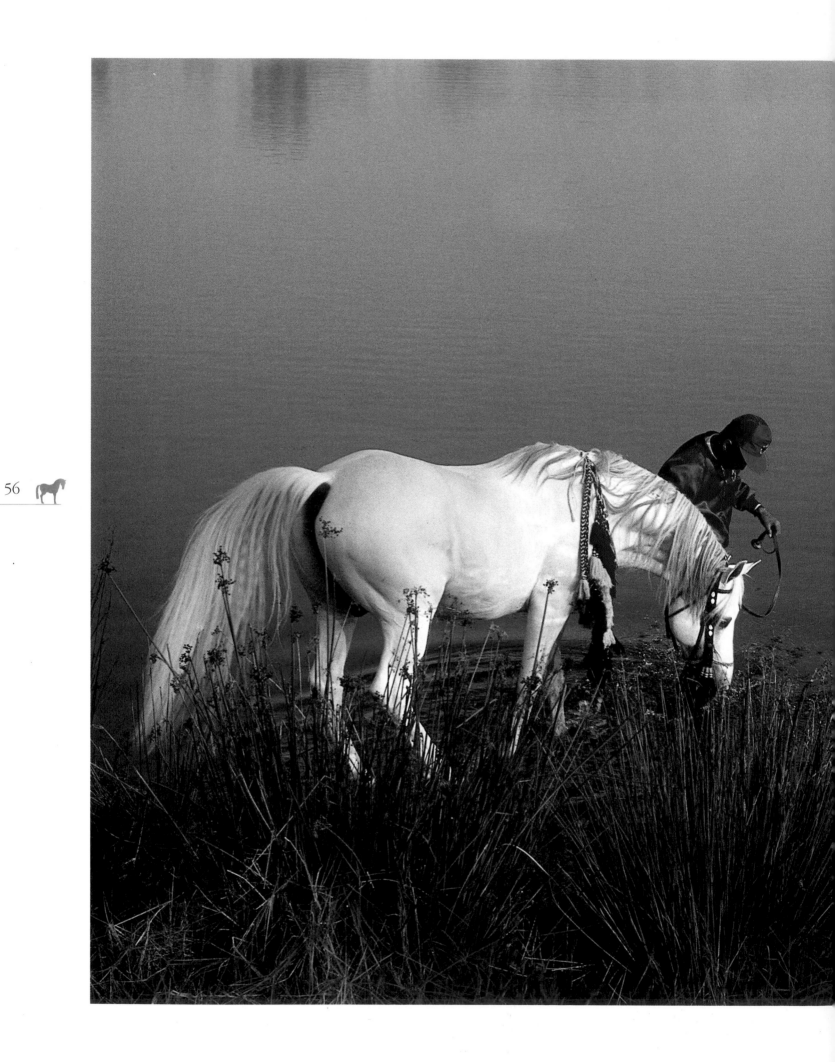

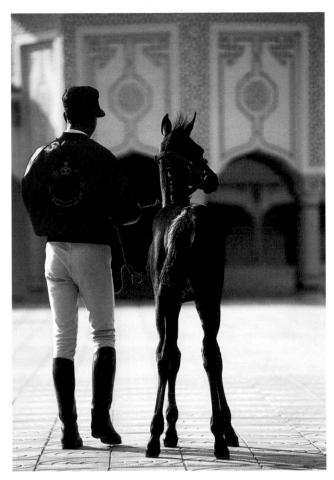

\mathcal{M}eknès retains a passion for horses, and all the traditions associated with them. It is said that Moulay Ishmael possessed twelve thousand. Today, the royal stud farm of Meknès, along with the one of Bouznika, near Rabat, supplies the most beautiful thoroughbreds in Morocco. The horse epitomises the glory of Morocco, most notably, and most nobly, in the *fantasia*.

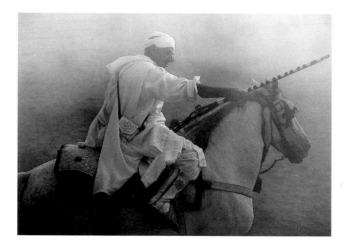

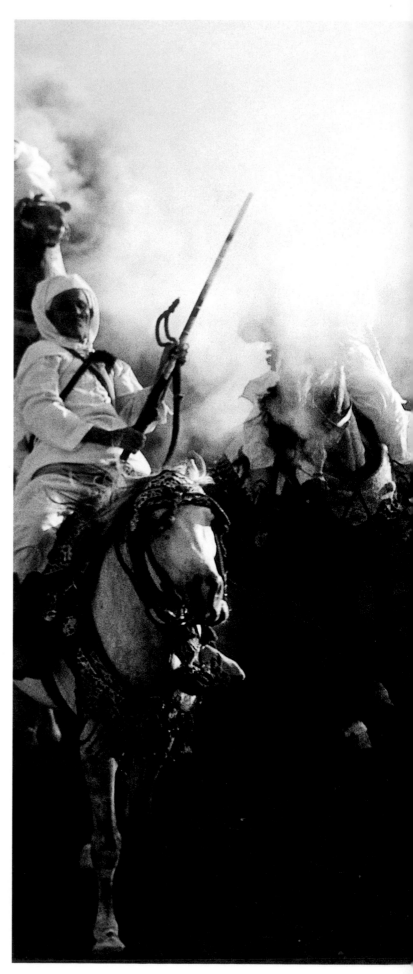

\mathcal{A} salvo cracks out in unison, and a thick cloud of smoke rises. Amid traditional war cries, the horsemen leave the field after pulling up dramatically from their charge in front of the grandstand, to make room for the fresh waves surging up from behind. Hundreds, and at times thousands, of horses, decorated with harnesses of copper and gold, mounted by their proud riders, *burnouses* billowing in the wind, continually replay the glorious cavalry campaigns of the past, in a living tableau based on the paintings of Eugene Delacroix and others, immortalising Morocco's history.

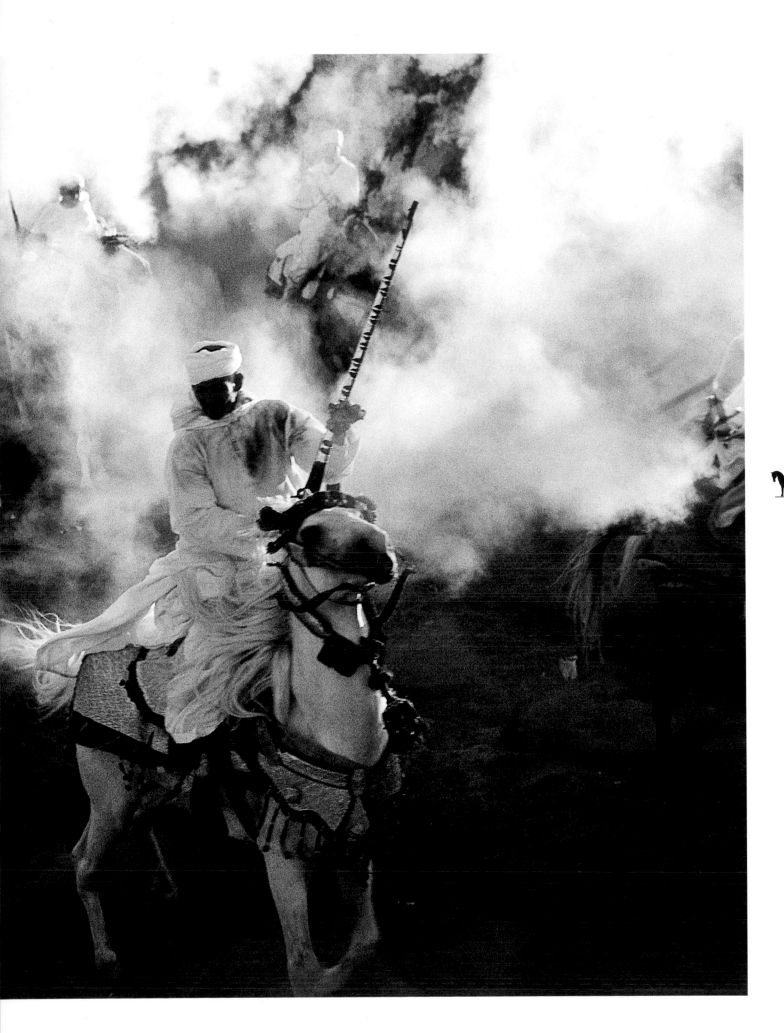

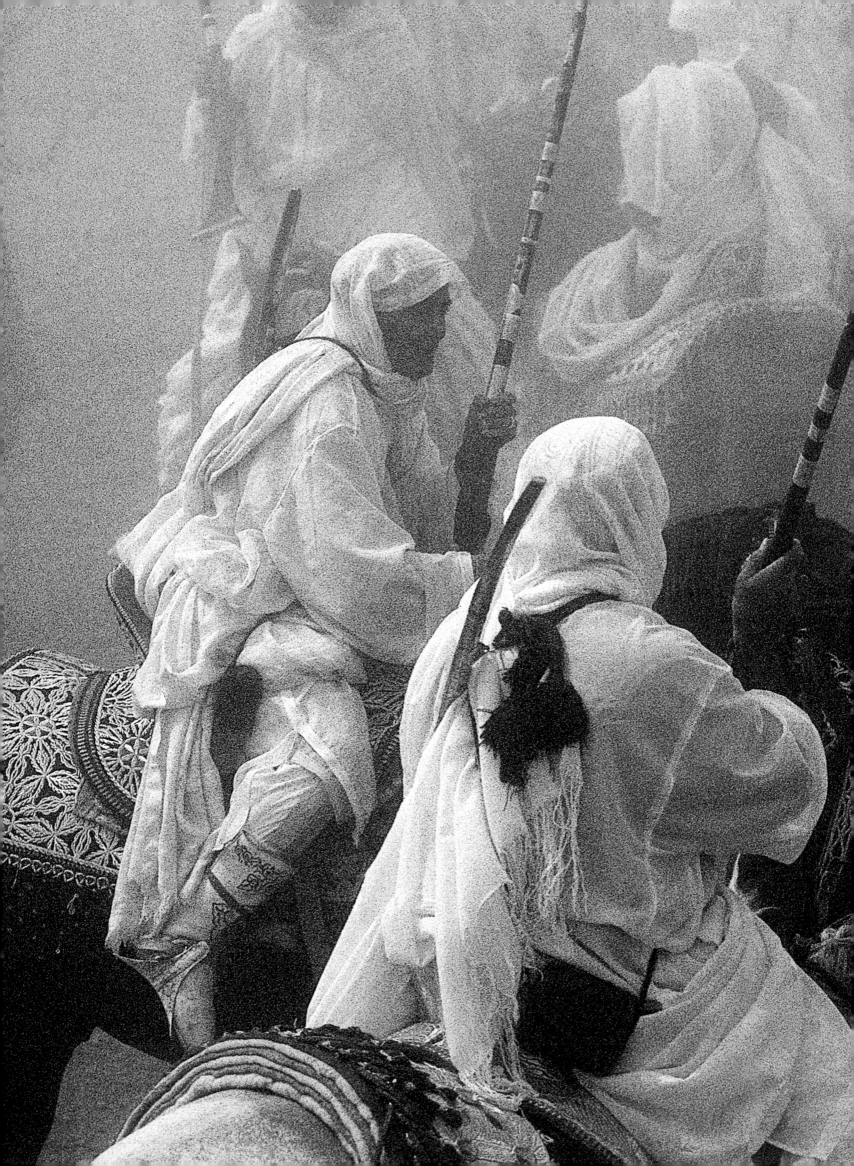

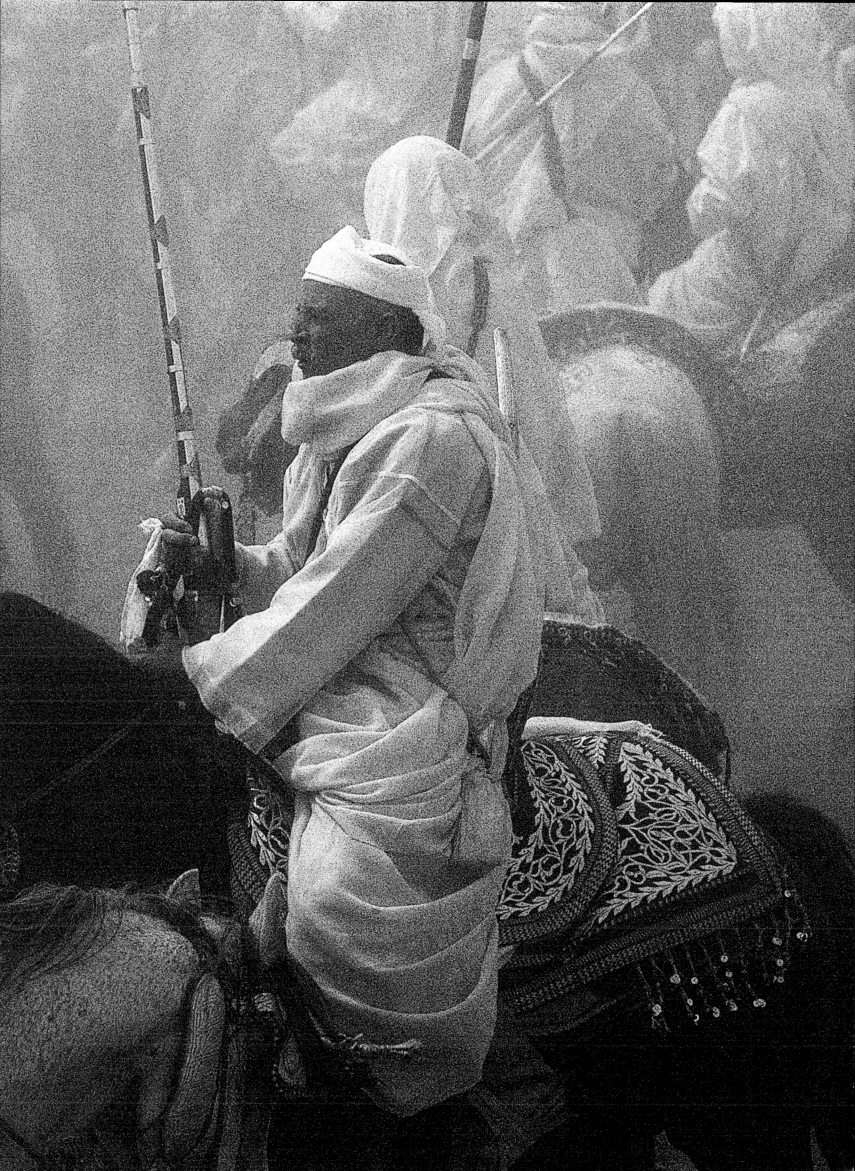

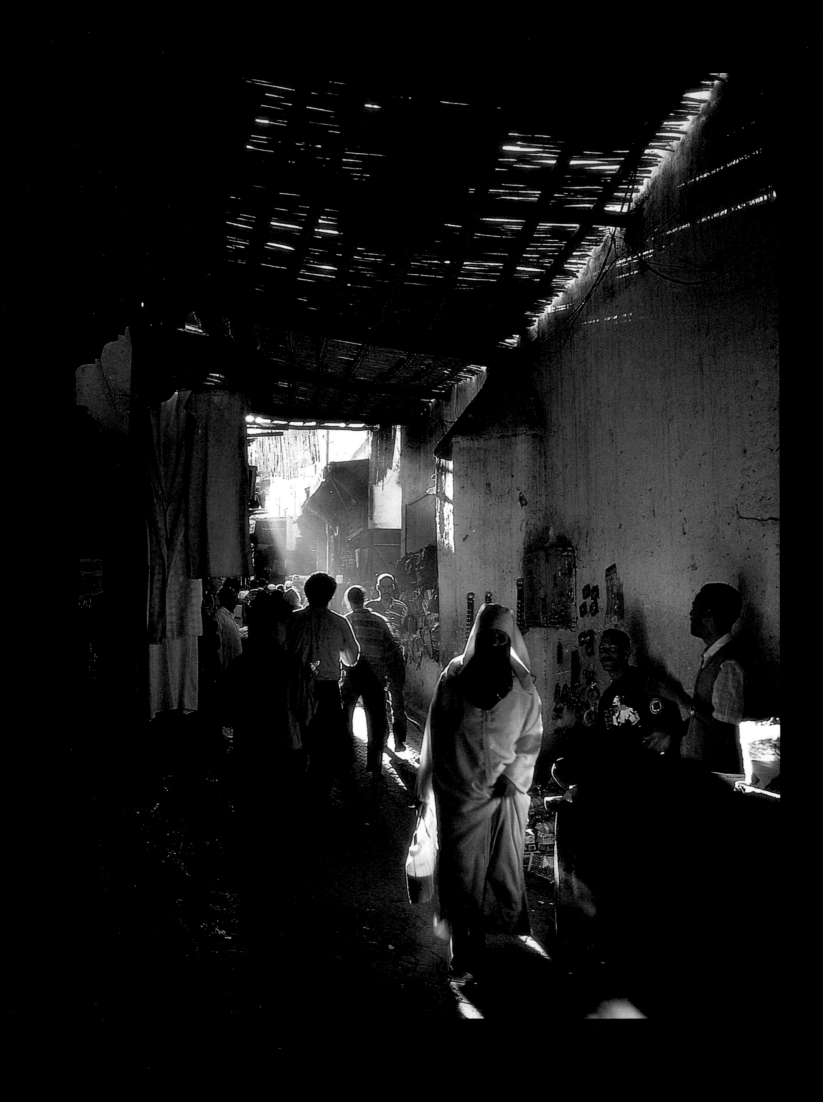

FEZ

ew visitors fall under the spell of Fez immediately. To begin to appreciate it, start by climbing the hill of the Merinides at dawn, to admire the view of the city crowned with towers and minarets at the moment the *muezzin* summons the faithful for the first prayer of the day, evoking the union between man and nature.

Although according to legend, Idris I (see Chapter 3: Moulay Idriss) founded Fez, it was actually his son, Idris II, who in 809 began laying out the original foundations and had canals built along the Fez river. The city eventually was populated by Muslim refugees, one group having fled from Kairouan, in central Tunisia, in the 10th century to escape advancing Bedouin tribes, and a second group having arrived from Cordoba after being expelled in 818 by the Ommayad Muslims during their struggle with the Fatimids. Each group settled on its own side of the Fez river, the migrants from Kairouan (literally meaning "caravan") on the left bank, and the Cordobans on the right. Both, during centuries to come, contributed to making Fez one of the most important cultural centres of the Muslim world. The Kairouine University and its magnificent mosque are among the earliest in existence. Along with the el-Andalous mosque in the Cordoban quarter, with its religious schools, the influence of Fez as a centre of Muslim learning and civilisation was felt as far away as Spain to the north, Constantinople and Damascus to the east, and Senegal to the south.

At various times dominated by Oriental, Andalusian, or Berber influences, Fez served as the capital for several hundred years, interrupted temporarily by Marrakech in the 12th and 16th centuries. Finally, Moulay Ishmael declared Meknès to be the capital at the beginning of the 18th century (see Chapter 4: Meknès). Yet even today, in the heart of the *medina*, Fez's awesome former pre-eminence can be sensed. It is the old city of Fez which can be the most overpowering if you wander through the seemingly inextricable maze of some 4,900 narrow and twisting streets, a veritable labyrinth filled with *souks*, *fondouks* (warehouses), pious Muslim societies and miniscule shops. But the most unforgettable way of experiencing Fez is to be swept along in the swirling movement of the crowd through this medieval setting, in the midst of the varied colours and noises and smells, which range from the aromas of oriental perfumes to the fetid odours of tanning hides to the alluring fragrance of brochettes grilling at an outdoor stand.

As in the *médinas* of other Moroccan cities, each trade has its own particular section of the old city, according to its specialty. The coppersmiths, silversmiths, dyers, weavers, tanners, potters, enamelled ceramic makers and other professions of Fez are generally considered to be among the most skilled in Morocco, often producing remarkable things, as, for instance the *djellabas*, the traditional long North African outer garments, which Fez's craftsmen can weave so finely that they can be fitted inside a slim reed.

Traditional marriage celebrations in Fez are known for their originality. They often take place inside the dozens of Hispano-Moorish palaces, whose discreet doors and entrance passageways are generally known only to people familiar with the city. Established conventions are rigorously followed, with roles strictly assigned to specialists, among whom are women skilled in creating exquisite combinations of jewels and finery, artists specialising in henna and cosmetics, embroiderers, cooks, and many others. They end with the *berza*, in which the bride enters sitting on an opulent palanquin, crowned with an ornamented gold tiara and wearing a belt, the richness of which reflects the size of her dowry. Her entrance sets off a wild reaction of shouting, accompanied by songs of joy, when, like a newly-crowned queen, she is raised above the heads of the guests, while the groom looks on admiringly.

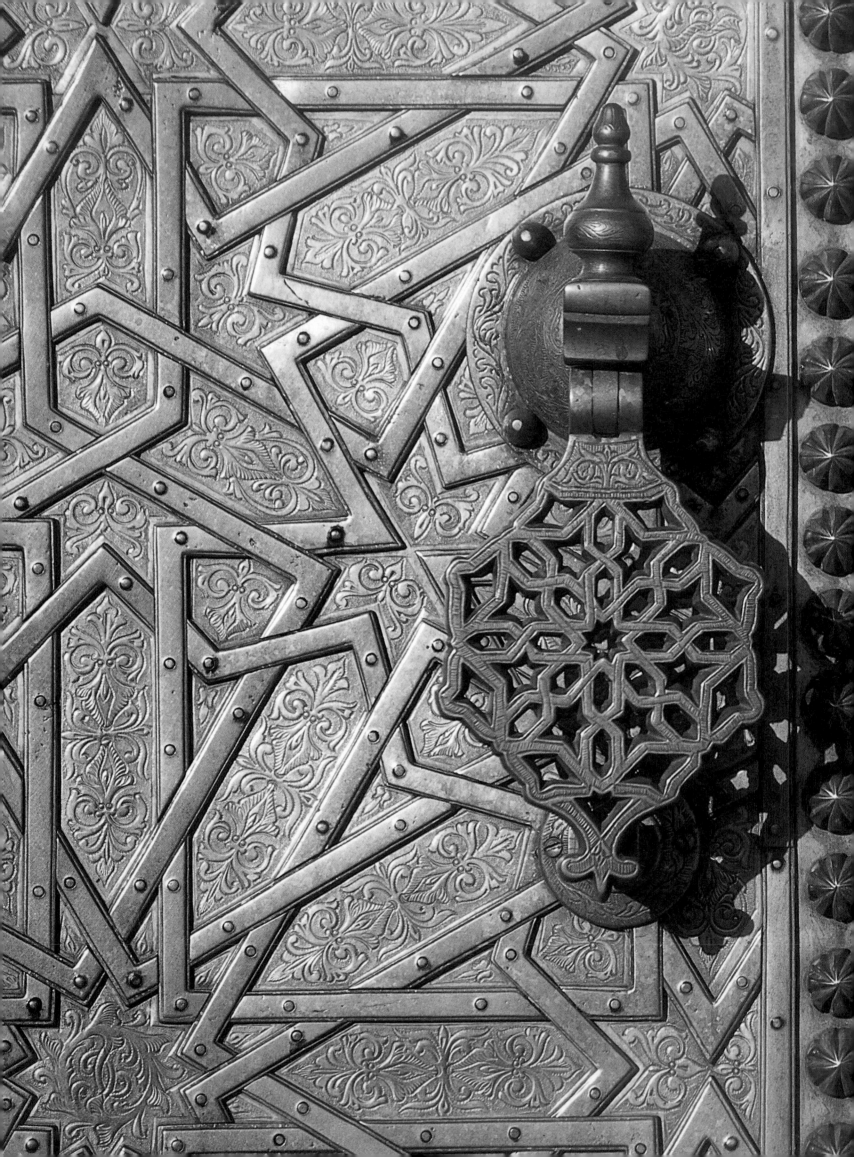

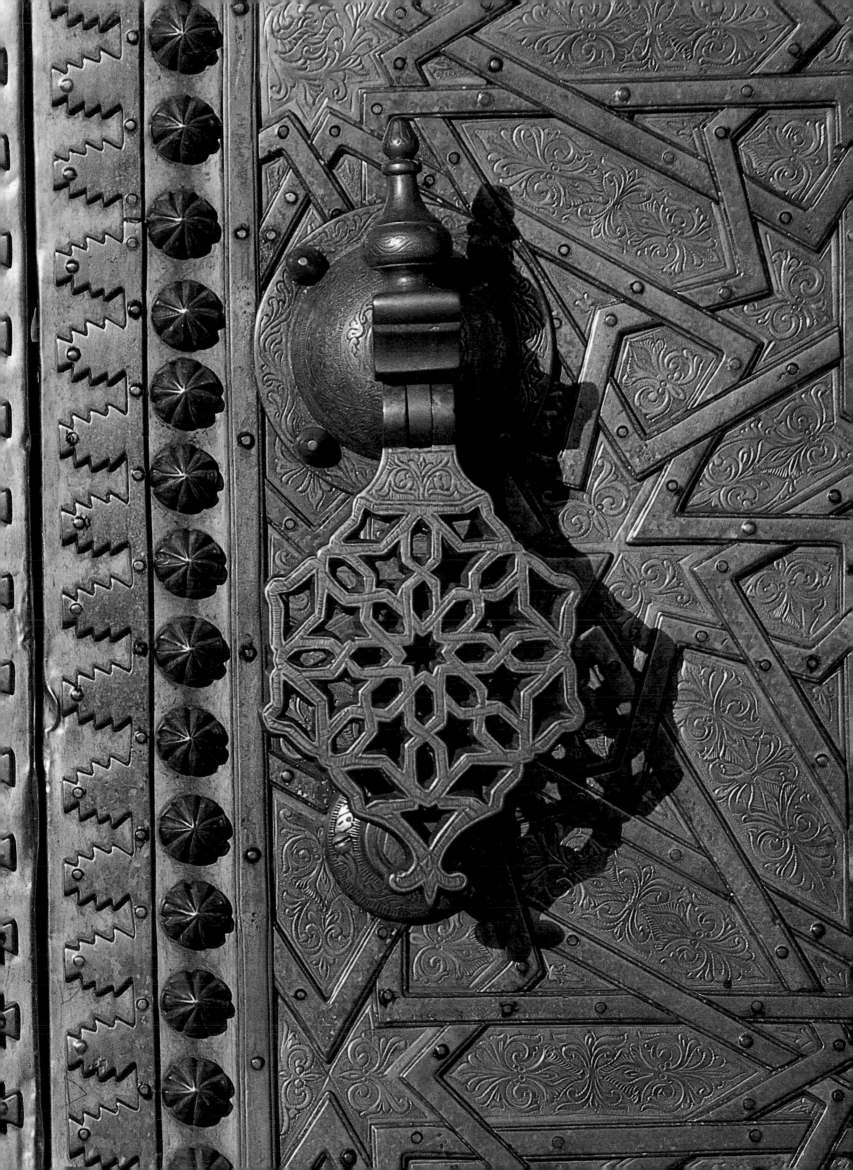

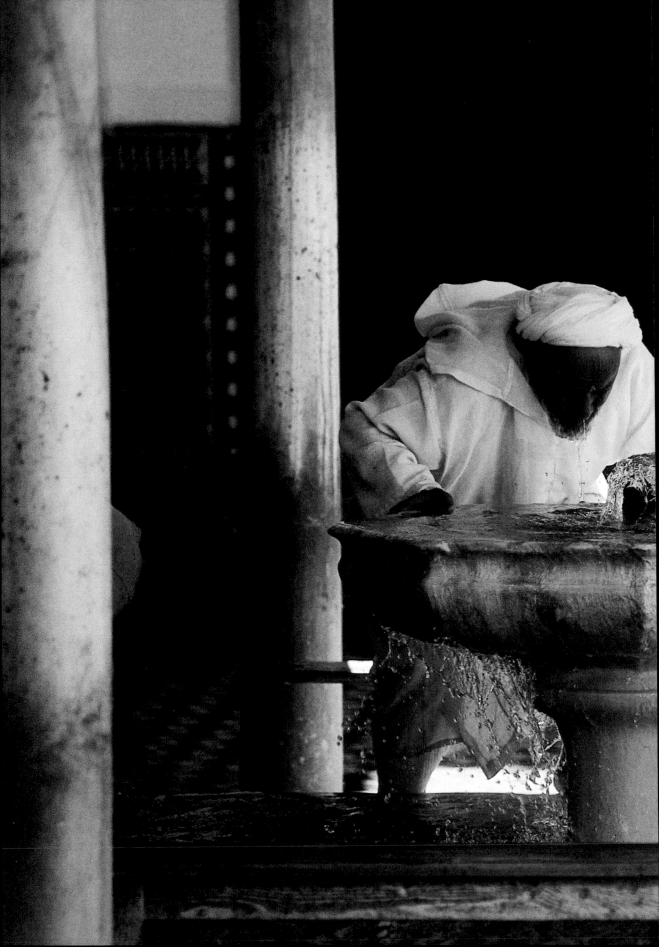

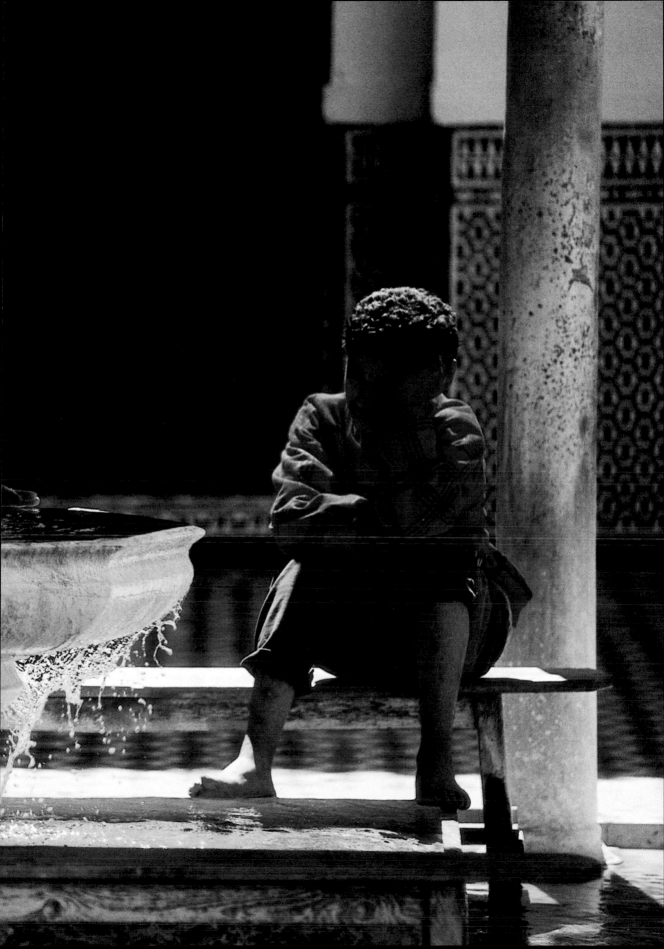

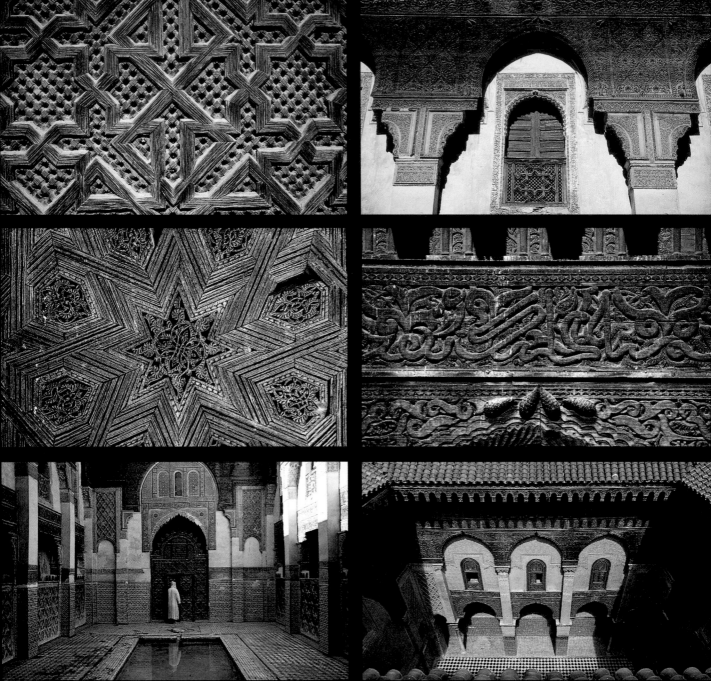

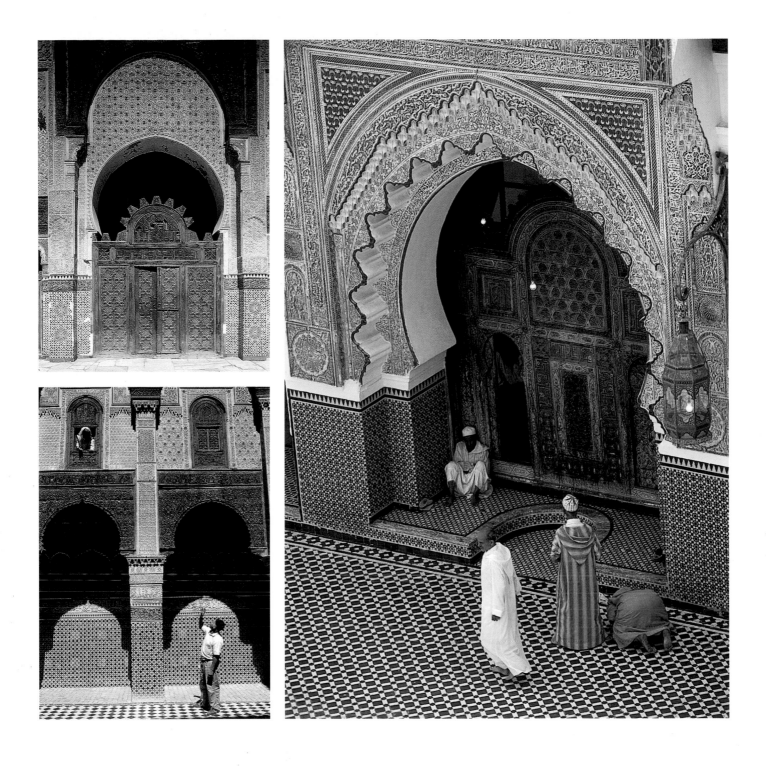

Pages 66-67

*A*blutions in the Kairouine mosque, founded in the 9th centrury, in the Kairouine quarter of the city. It is the largest oratory in North Africa, with a capacity of twenty thousand worshippers. Strictly forbidden to non-Muslims, it is still possible to glimpse some of its riches from the outside, through its numerous doors.

*T*he Kairouine mosque with its *medersas*, or schools: Bou Inania, es Sahrij, and el-Attarine, comprise part of the Kairouine University. From the 9th century onward, a number of famous students came to study here, including Ibn Khaldoun, Ibn Rochd, Maimonides, and Leon the African. The door is decorated in carved cedar, while the patios are ornamented with inlaid glazed tile. Varnished tiles cover the roofs of these jewels of architecture.

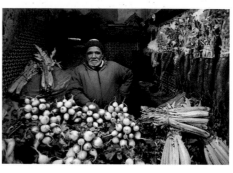

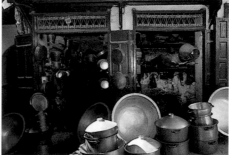

Above, above right, and on following two pages:

*I*n the heart of the *médina*, places of worship and shops exist side by side. Some display food, some are stocked with copper utensils, while others sell multicoloured silk thread.

*T*he people of Fez are exacting when it comes to quality. Whether they be decorative coppersmiths of the Place es-Seffarin or craftsmen who work in the tanners' quarter, these artisans learn from early on how to produce for a public demanding work well done and with respect for tradition.

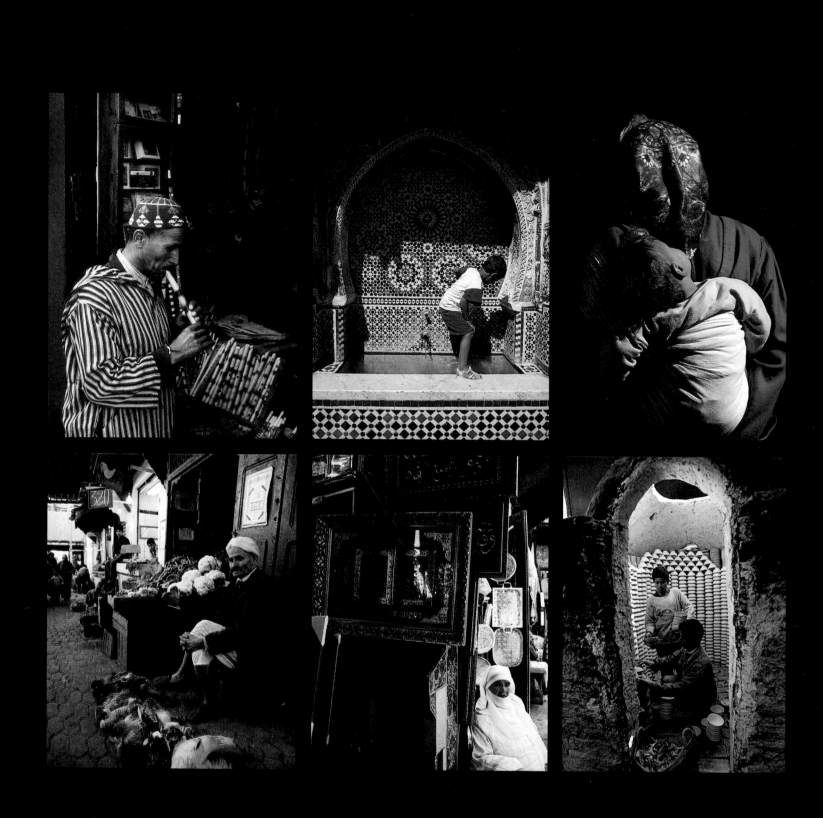

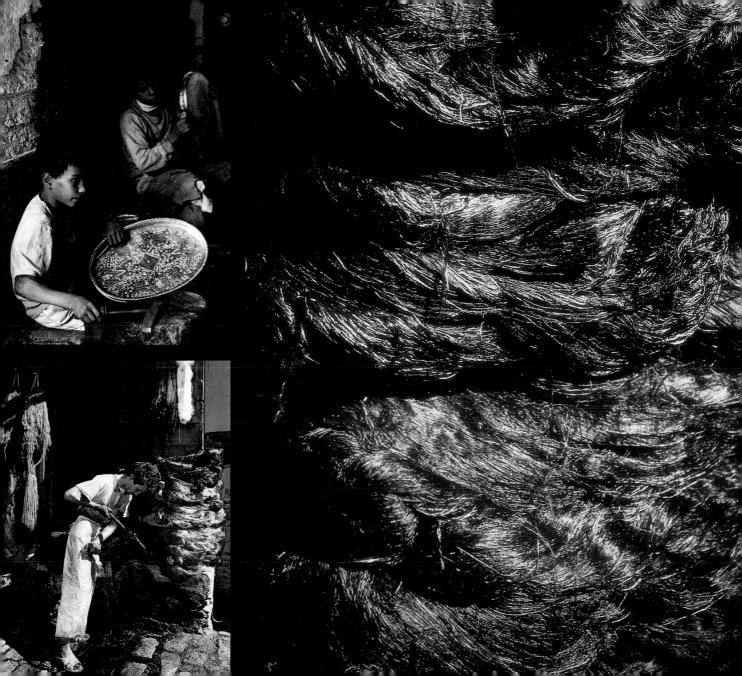

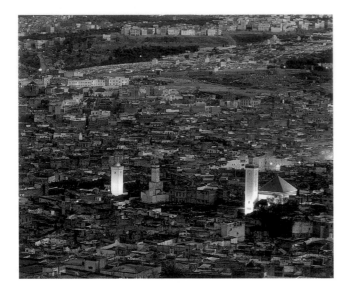

A general view of Fez el-Bali (Old Fez) at sunset. The rooftop terraces are like the cells of a huge beehive, vibrant with life.

*I*n the cool shade of the *kessarias* (merchant galleries) veiled silhouettes and flowing *djellabas* reveal dust dancing in rays of light. The *médina* of Fez is a kind of human sundial: you can judge the time of day by the density of the crowd. When it is most packed, and you must struggle to avoid being pulled along, you know it is 5pm.

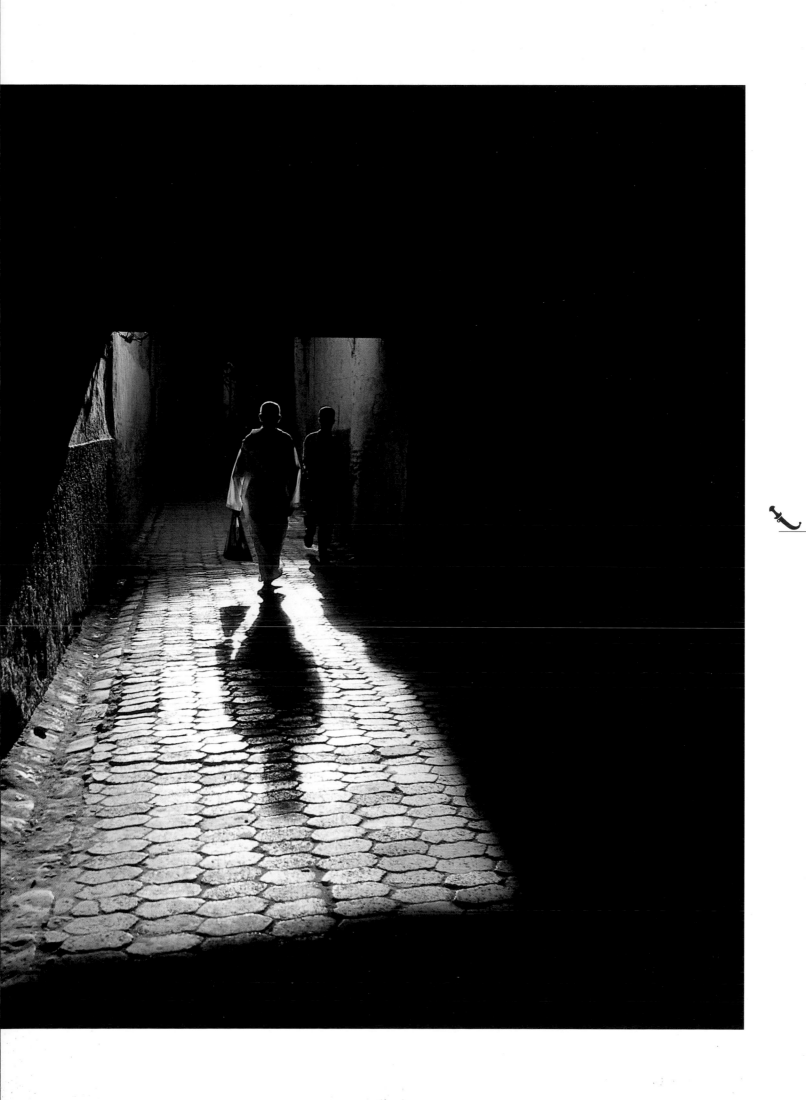

THE ATLAS

The three ranges of Atlas mountains dominate the geography of Morocco. South of Fez, the limestone uplands of the Middle Atlas rise from the plain. South of Marrakech are the jagged summits of the High Atlas, North Africa's highest and most awesome mountain range. Its peak, Mount Toubkal, rises to over 13,000 feet. Of the three roads which cross the passes of the High Atlas, only one is open all year, the Tizi-an-Babaou pass, on the road from Marrakech to Agadir. To the south, the Anti-Atlas, renowned for its splendour, gently descends to the first sands of the Sahara, with contrasting views of plant life, magnificently barren slopes and oases.

The Atlas Mountains are the domain of the Berbers, a name which derives from the Greek word for foreigner, *barbaroi*, and came into use about 1200 BC. They prefer the name *imiazen*, the noble ones. There are few peoples of the world who have occupied the same land continuously for as long as the Berbers, who descend directly from Stone Age people who inhabited the same region. Despite their conversion to Islam from the 9th century onwards, their Arabisation and blending with other populations of different ethnic backgrounds, the Atlas Berbers continue to conserve their languages: Tamazight, in the Middle Atlas, and Tachelhait for the Chleuh Berbers, who live in the western part of the High Atlas, and in the Sous Valley. Containing magnificent scenery, and geographically isolated by being closed off on the north by the High Atlas and on the south by the Anti-Atlas, the population of the Sous has a powerful tradition of self-identity and spiritual singularity.

The lives of the Berbers of the high plateaus are subject to the caprices of the weather. The word for the fundamental necessity, water, is *amane*, signifying confidence, faith, and treasure. It must be drawn several times a day, for crop cultivation, for livestock, or for personal needs. In most Berber religious beliefs, the union of the heavens and the earth is echoed in the legendary union of Islit and Tislit: The Betrothed Couple. The sum and substance of clan life depend on this union. Berber society is hierarchical and interdependent, a contrast to the individualism of modern urban life. The activities of the men of the plateaus revolve around commerce, building houses of *pisé* (packed wet clay, mixed with straw and baked by the sun), and dealing with questions relating to the clan, while the women reign over everything having to do with the organisation of the family. After nursing their children, they are in charge of educating them in the respect for tradition. They must also tend to their ovens, work the fields, spin the wool and weave the blankets, which are the only real protection they and their family have from the mountain cold. Their babies, snugly attached to their backs, accompany them throughout their daily lives.

In the interior of the house, the whole space of the ground floor is reserved for livestock and firewood. The rooms above are used by the women for their household activities. From this level, by means of a small, dark staircase, the men and their guests gain access to the reception room, decorated with wool carpets. The possession of any form of telecommunications is considered shameful, it being felt that the absence of television and telephones preserves the equilibrium of life within the ancestral home, and that there is little place for the superfluous in this harsh existence, in which only necessary and useful news should be transmitted, orally. After a cold winter, each spring brings hopes for abundant crops of barley, potatoes, and walnuts. The annual harvest celebration is an important event in the lives of the villagers. They perform the *ahouach*, the traditional dance in which they form a circle and move around a pole in the centre of the threshing area. The women specially prepare their hair for the occasion, adorning it with colourful wool thread,

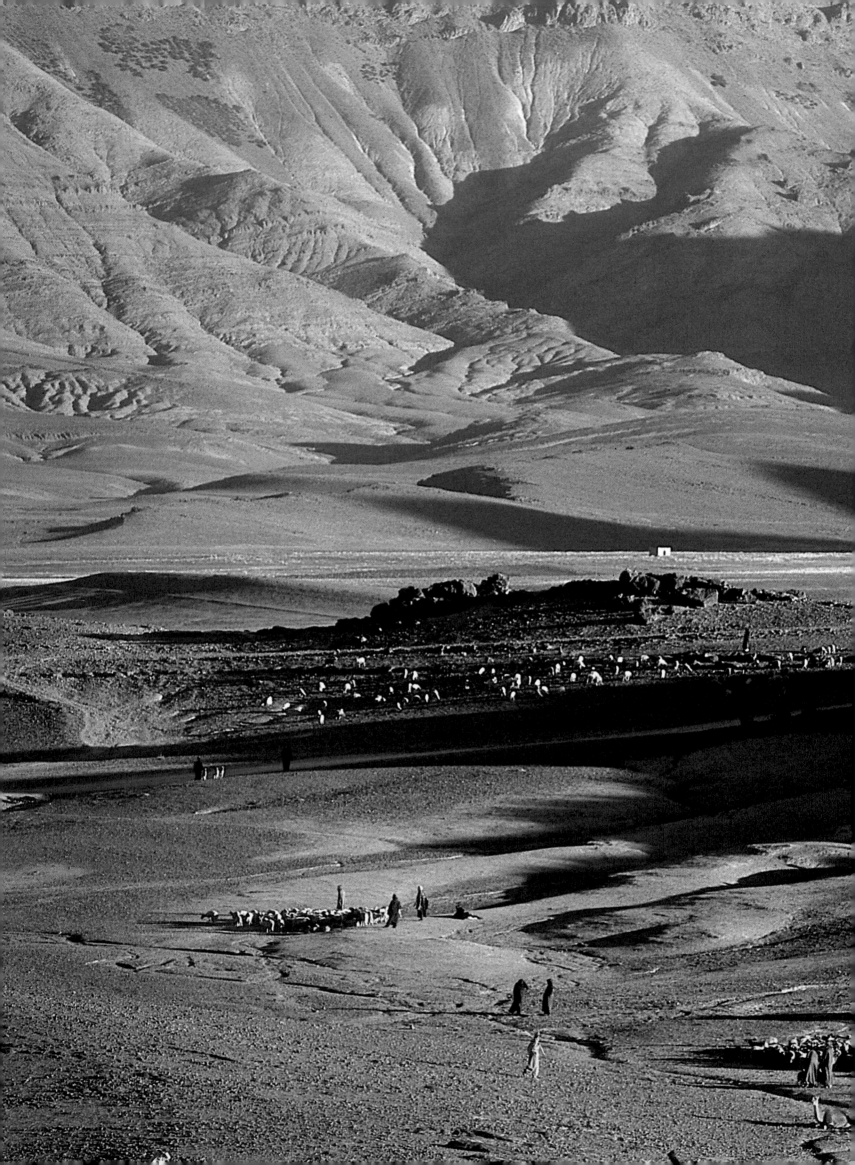

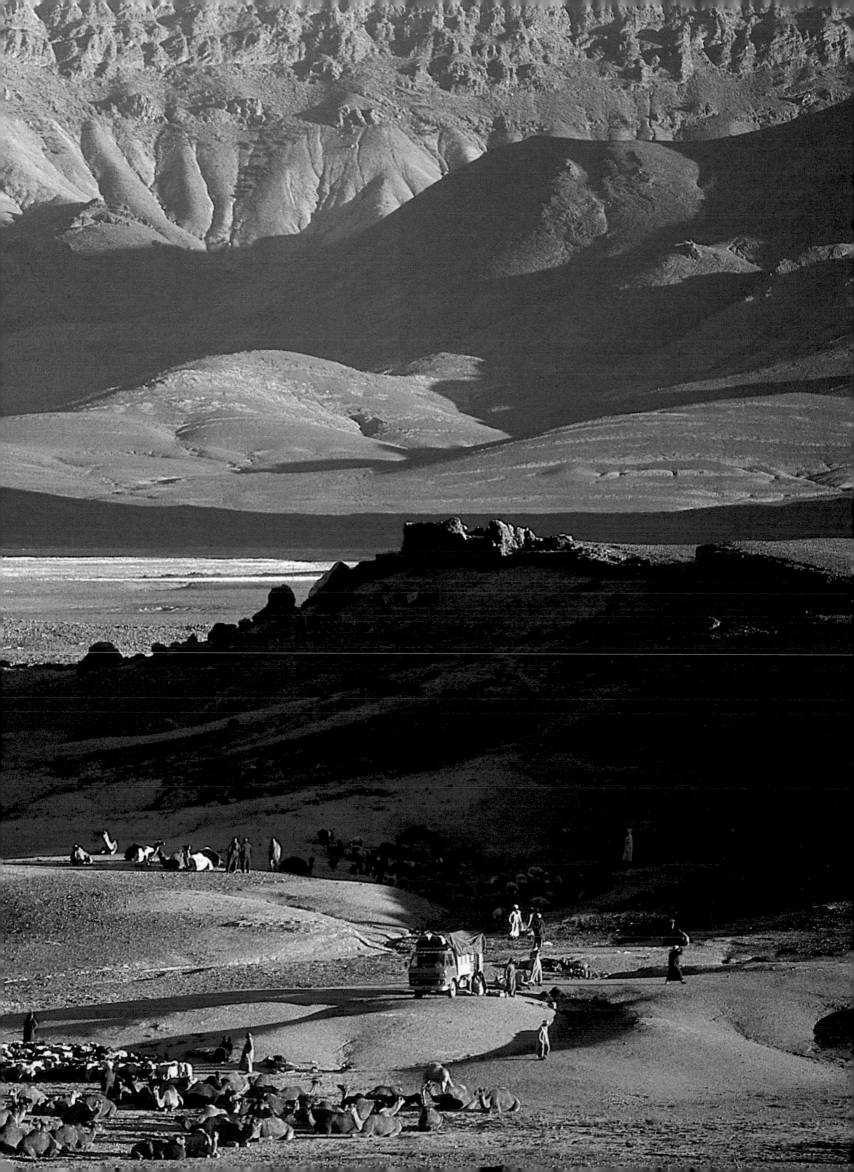

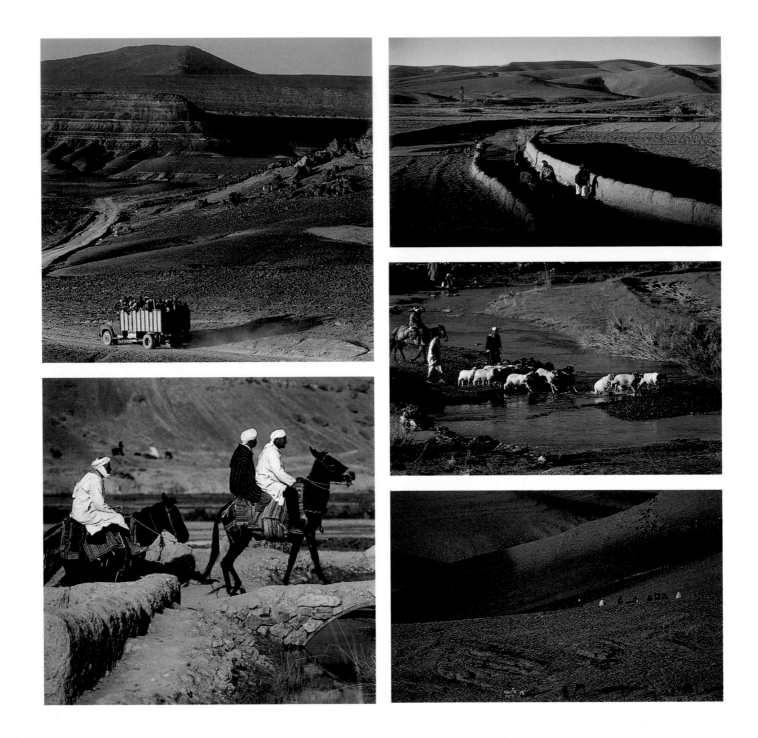

80

Pages 78-79

The Agoudal plateau, in the region of Imilchil, rugged and poor, is the territory of the Aït Haddidou people.

Whether in open country, on a mountain, or in the desert, human activity is always to be seen: a passer-by, a tireless walker, a man mounted on his valuable mule, or a lorry bouncing along one of the rocky dirt roads.

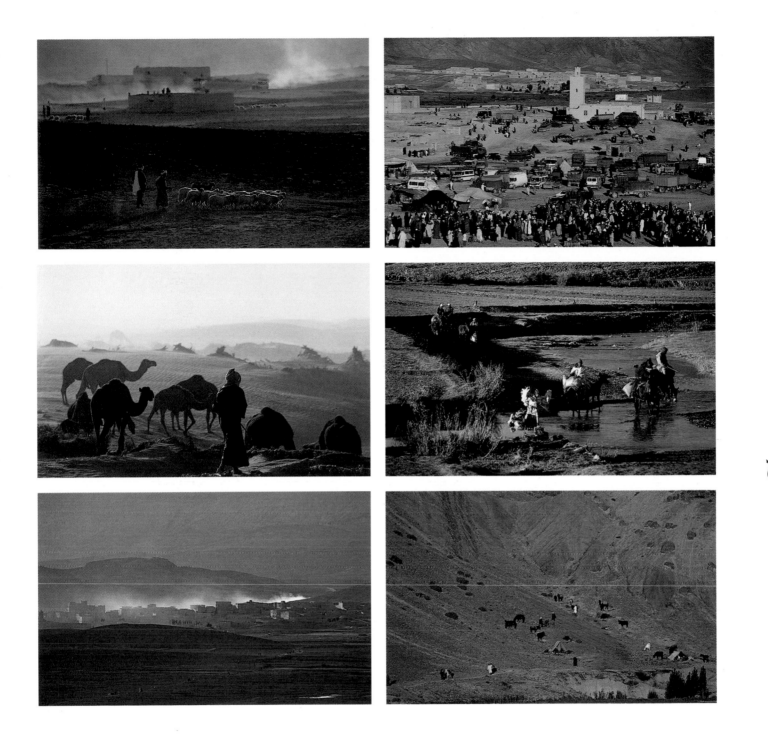

*M*onday is market day at Taliouine, Tuesday at
Iouzioua, Thursday at Taguenzoute, etc. The weekly *souk*
is a vital part of the lives of the people of the Atlas.

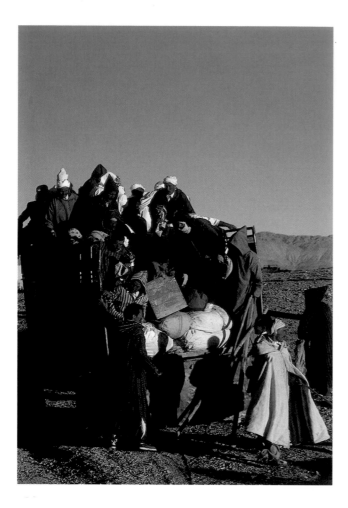

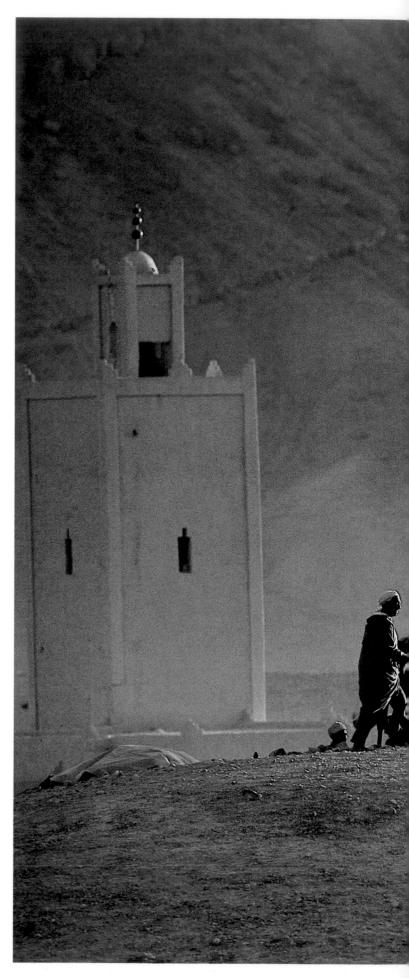

\mathcal{A} patriarchal society, *al jemaa*, "the assembly of sages", is responsible for maintaining the social and economic fabric of the community. It fixes the calendar for the ploughing and the harvests, deals with local expenses, and helps in the organisation of the village festivals. Perhaps its most important role is deciding how the community's most precious possession, water, is to be shared.

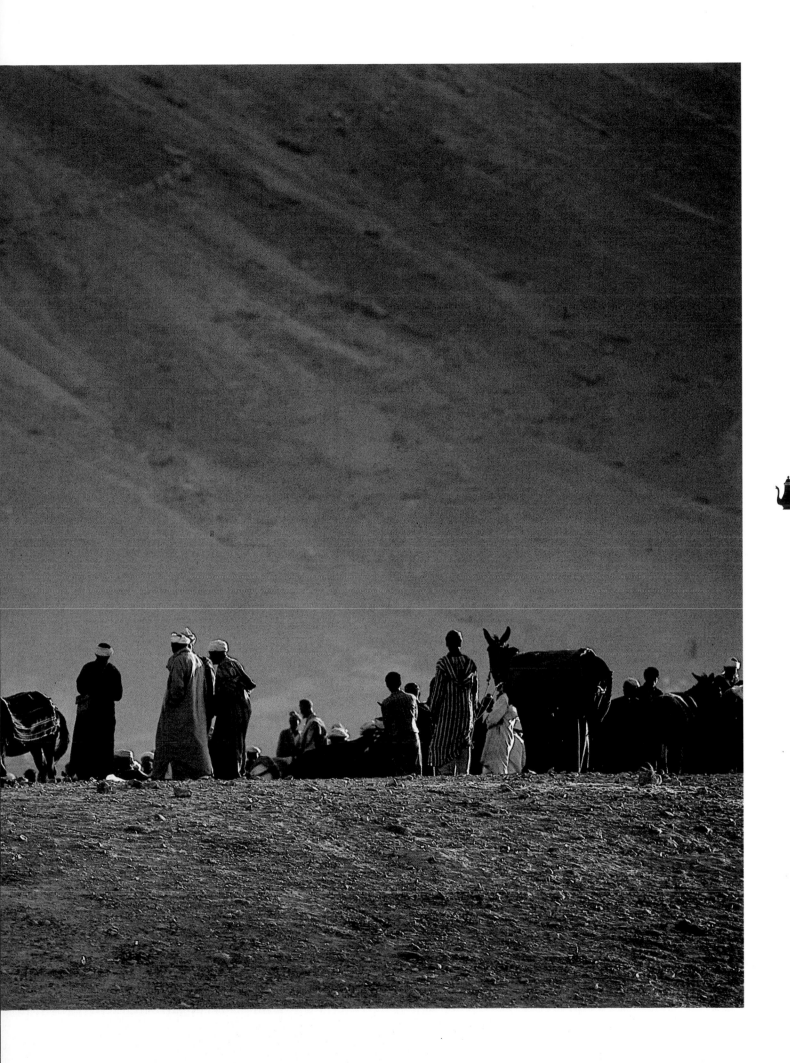

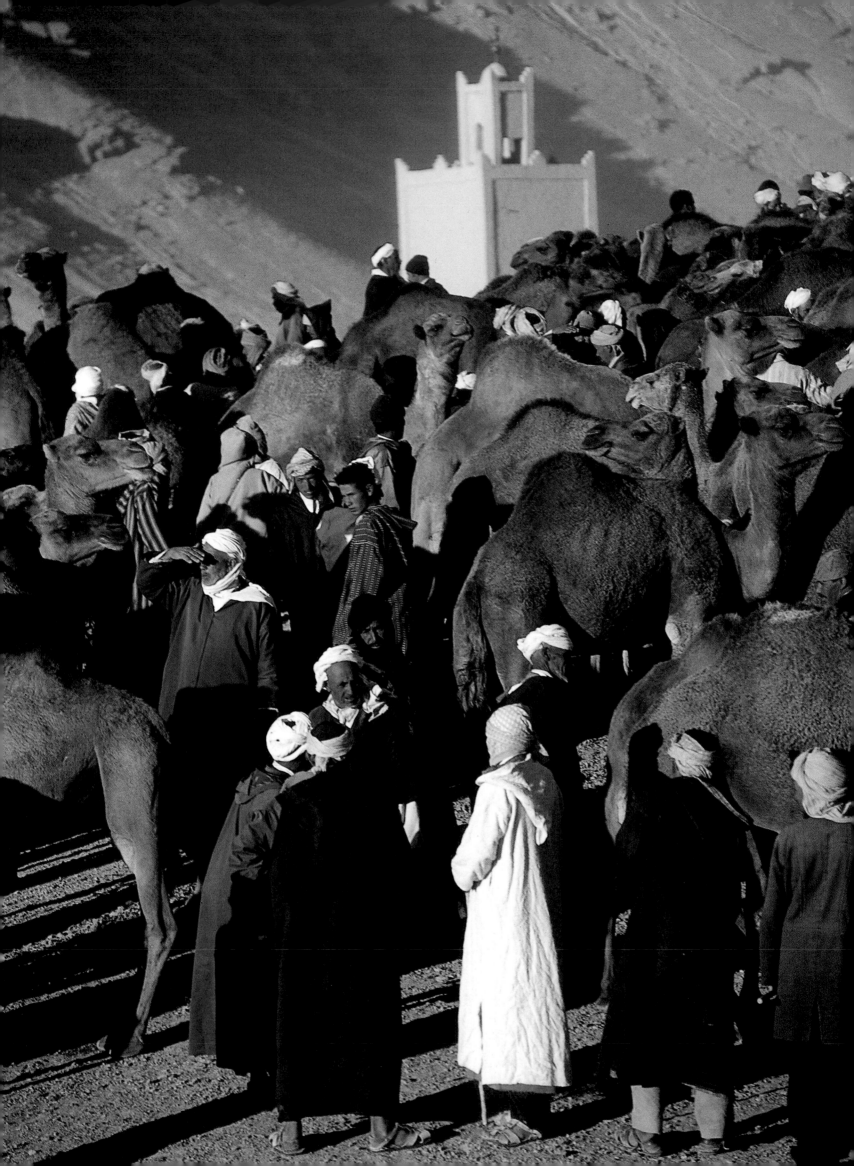

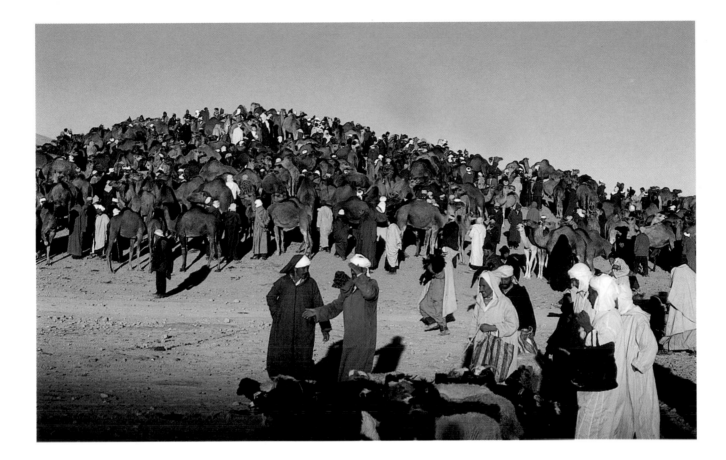

\mathcal{T}he *souk* is the place for commercial bargaining, where everything is negotiated by word and by gesture, under the moral and spiritual protection of the local tribes' religious patron. Bringing a finger to one's mouth, placing a hand on one's heart, and concluding the sale or the purchase with a friendly slap is worth more than any written contract.

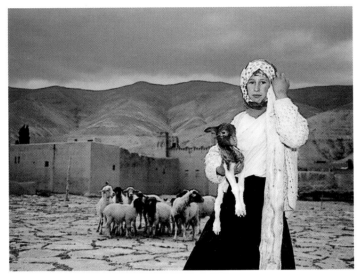

\mathcal{N}othing is inconsequential, nor does egoism have a place in these regions of the High Atlas. The most private ceremonies—birth, circumcision, marriage—are almost always public. In the threshing area, which is sacred, or on the village square, neighbours and outsiders alike are welcome to share a couscous or a mechoui *(see recipe section at the end of the book)*, mint tea and the melodies of the *ahouach*, the Berber circular dance. There are seasonal celebrations of thanksgiving to the sky for its blessings, the Muslim religious holidays of Mouloud-Achoura, Aid-el-Kebir, and family festivities in which the young girls of the high plateaus often play the leading roles. On the twenty-seventh night of ramadan, the Night of Destiny, the girls are adorned like queens. Made-up, festooned with jewels, each crowned with a diadem, timid yet at the same time proud, they march, ending up in the arms of their parents.

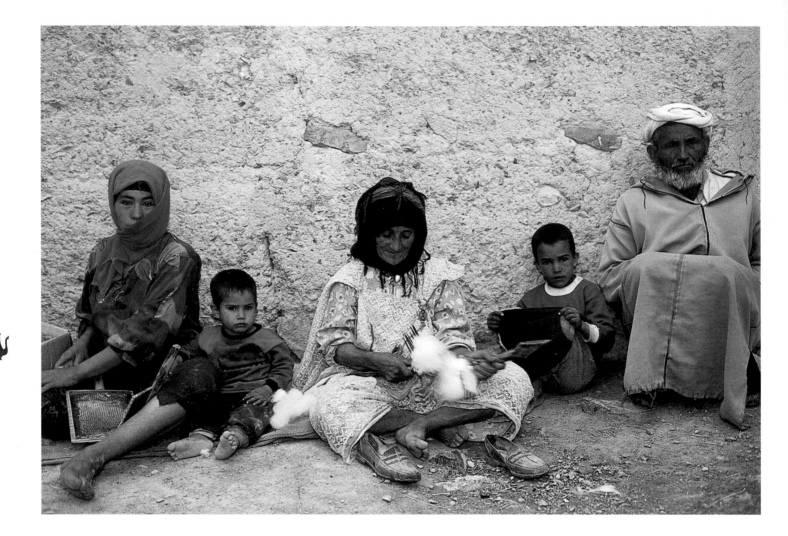

Pages 88-89

The Imilchil Plateau in the lakes region (Lake Tislit, shown here), is a country of legend. Many years ago, two lovers dared to challenge the ban on meeting proclaimed by their rival clans. Their bitter tears formed the lakes of Islit and Tislit, as the lovers were named. Ever since that time, repentant parents of Imilchil allow their children of marriagable age to freely choose their betrothed. Every year, a mass wedding celebration takes place during the *Moussem* (pilgrimage) of the Fiancés.

Although there is still resistance to separation of the community by generation in the Berber villages, the attraction of the big cities is nevertheless emptying them of their young people.

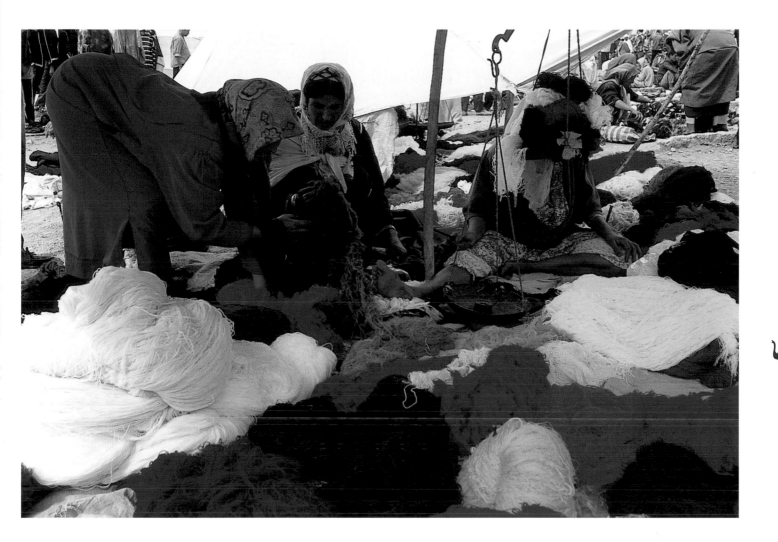

*I*miazighen women do not veil their faces. Some work in the *souk*, selling the products of their weaving, jewels, or feminine accessories. Wool represents capital for Berber women. Throughout their lives they weave and embroider sheets and carpets, embellished with rows of scintillating silver discs.

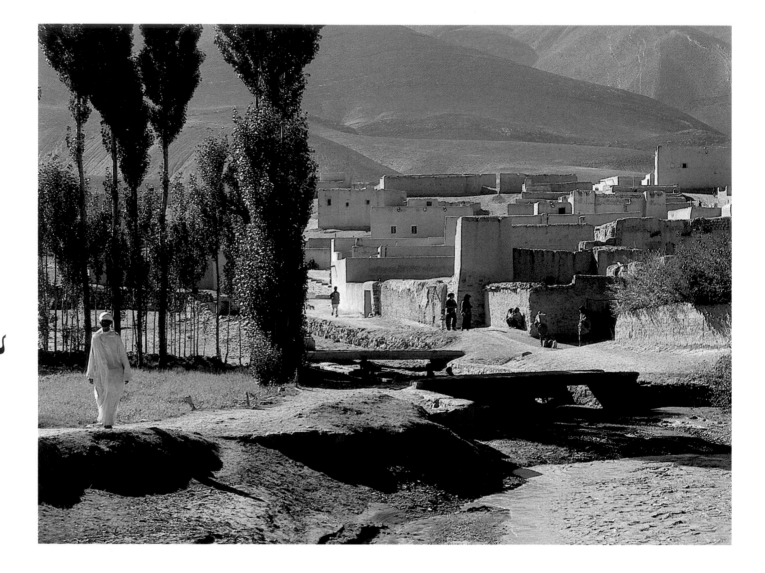

*H*ere, the celebrations take on a sacred importance.
The sky, the wind, the trees and water blend in spiritual
unison.

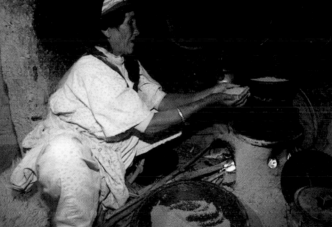

"*Salam alikoum! Alikoum Salam!*" Let peace be upon you! Upon you, let there be peace! Accompanied by a coded choreography of hand kissing, these words of greeting express a way of life preserved in these remote valleys.

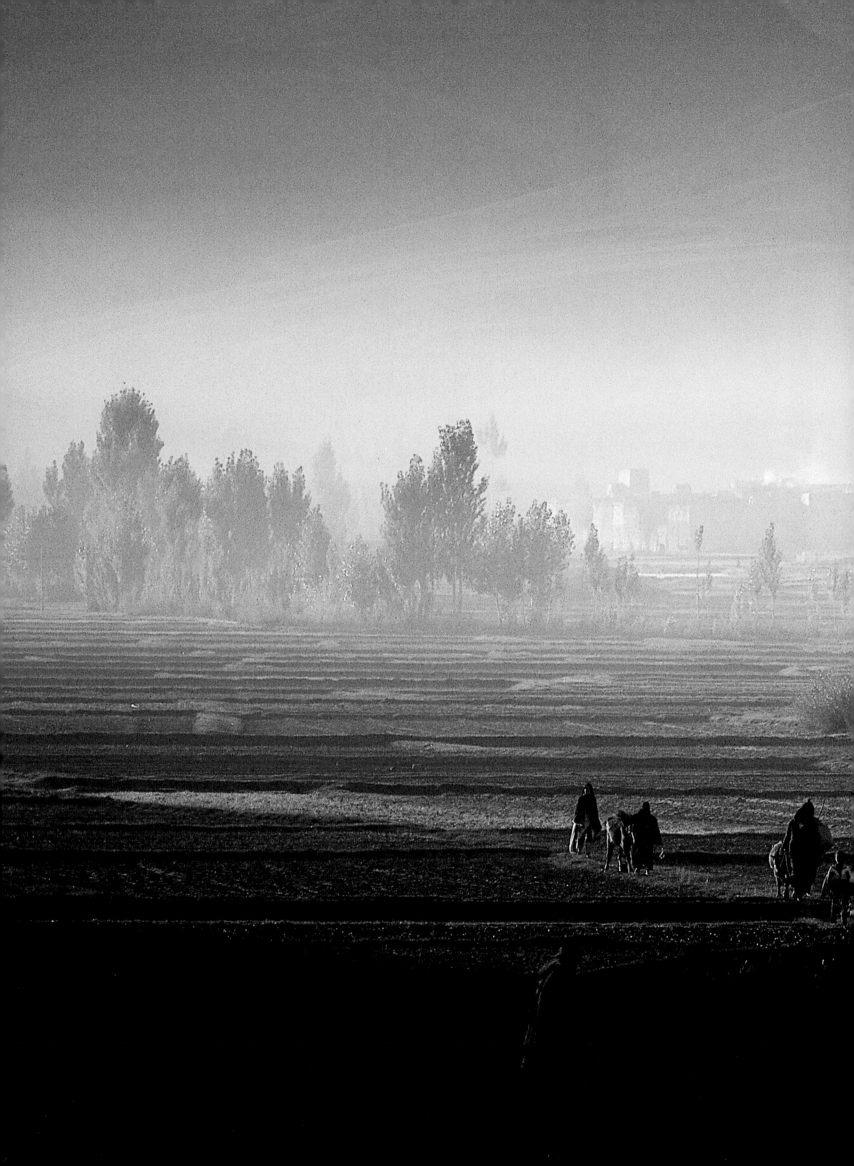

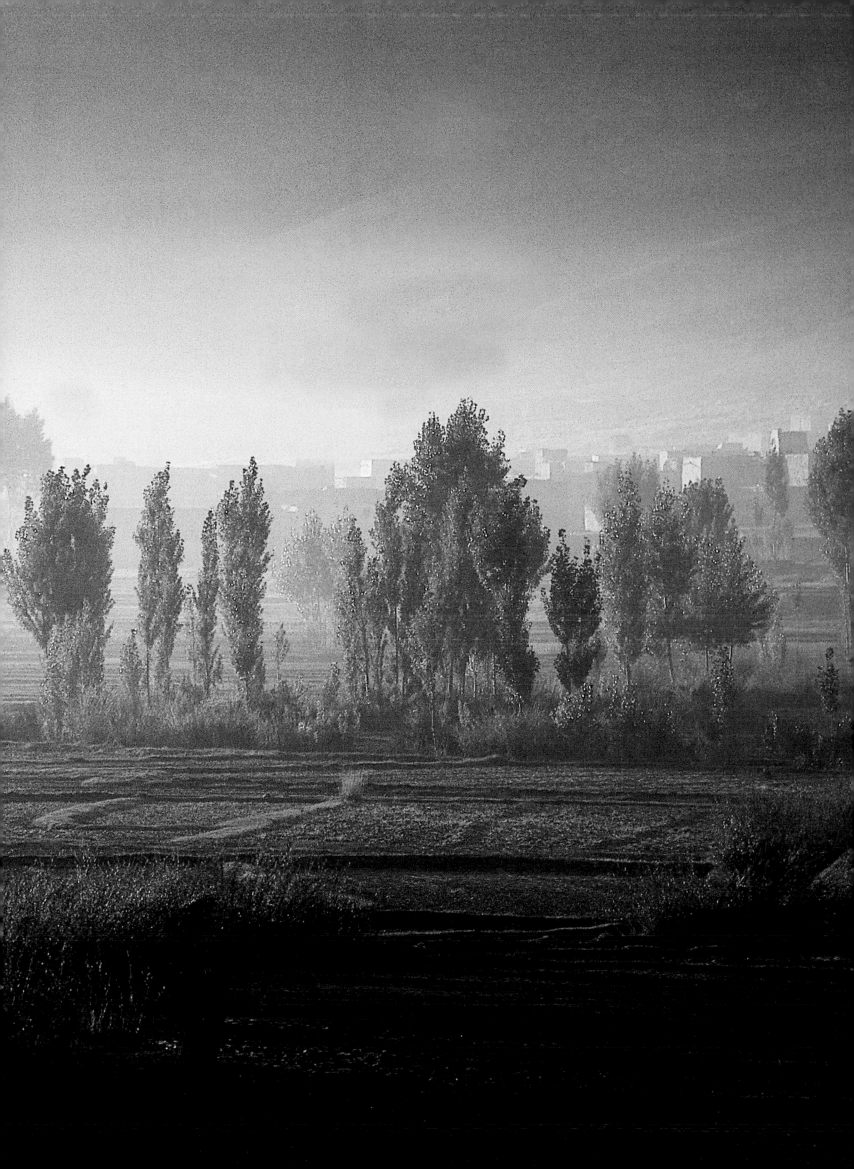

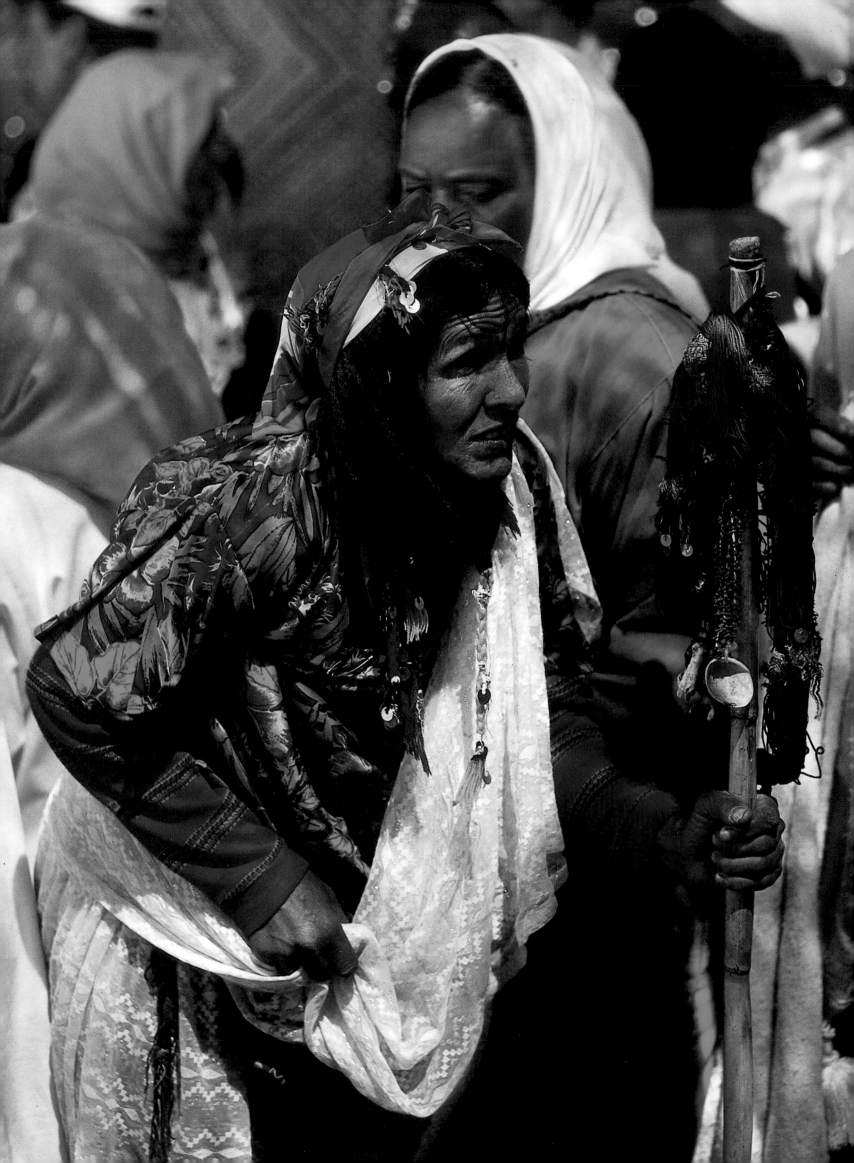

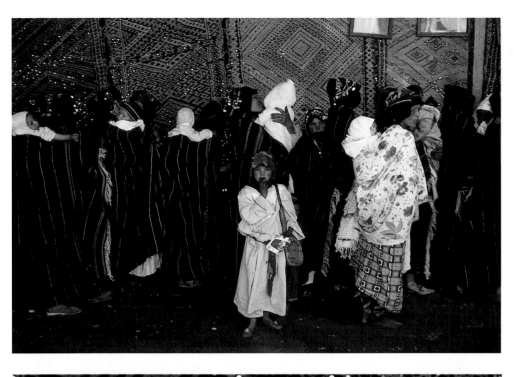

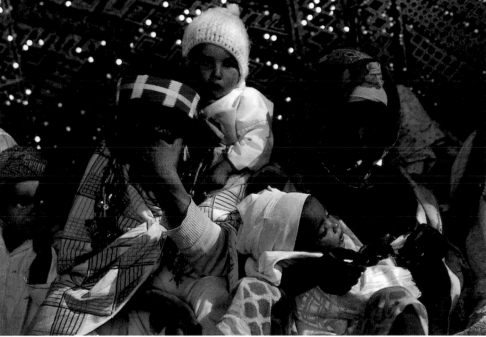

*C*ircumcisions, marriages, religious and national holidays
are among the principal celebrations of the year, moments of
peace and repose in the midst of a harsh life.

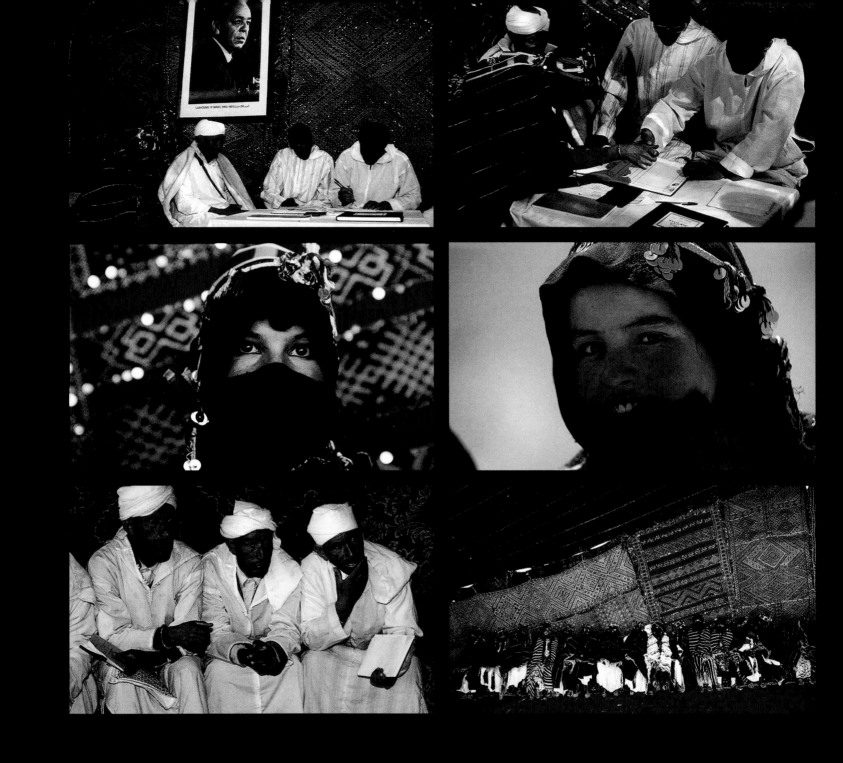

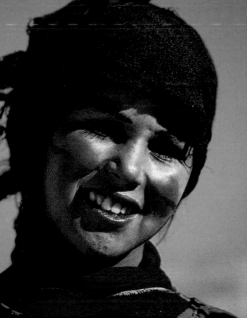
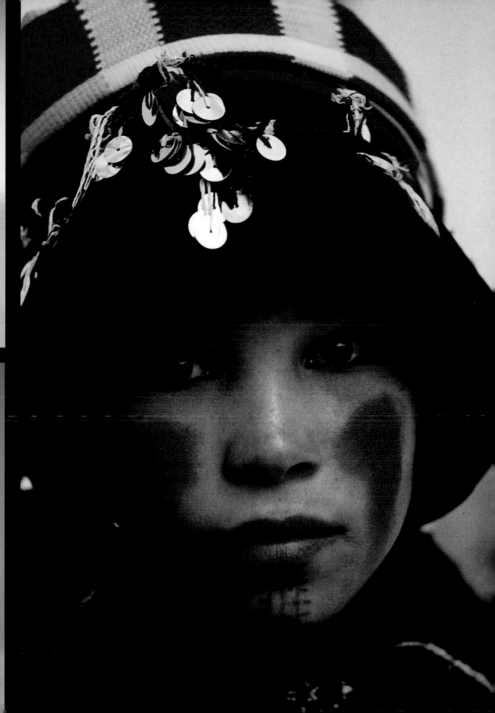

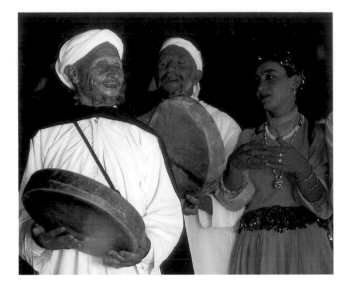

Pages 98-99

*T*he Aït Haddidou tribe, *moussem* (pilgrimage) of Imilchil.

Above:

*T*he famous musician Moha Oul-Houssain, known as "*El Maestro*", has made the trip from Khenifra in the Middle Atlas to join the undulating round dance of the Fiancés of Imilchil. "The day's first light has set upon your cheeks the colour of a bed of roses", says the legend. The young girls of the Aït Haddidou, adorned with jewels and decorations, made up, dressed in their *handira*, a striped woollen cape which they have woven for themselves, prepare to be wed under the symbolic auspices of the legendary wedding of the heavens and the earth.

Page 102

*W*hile the shepherds lead their flocks of goats and sheep toward the grazing land, the women carry wood and fodder.

Pages 104-105

*T*he Ouzoud waterfall in the Middle Atlas. The cascade plunges into a chasm 100 metres deep, There is nearly always a rainbow visible in the mist created by the water falling on the rocks.

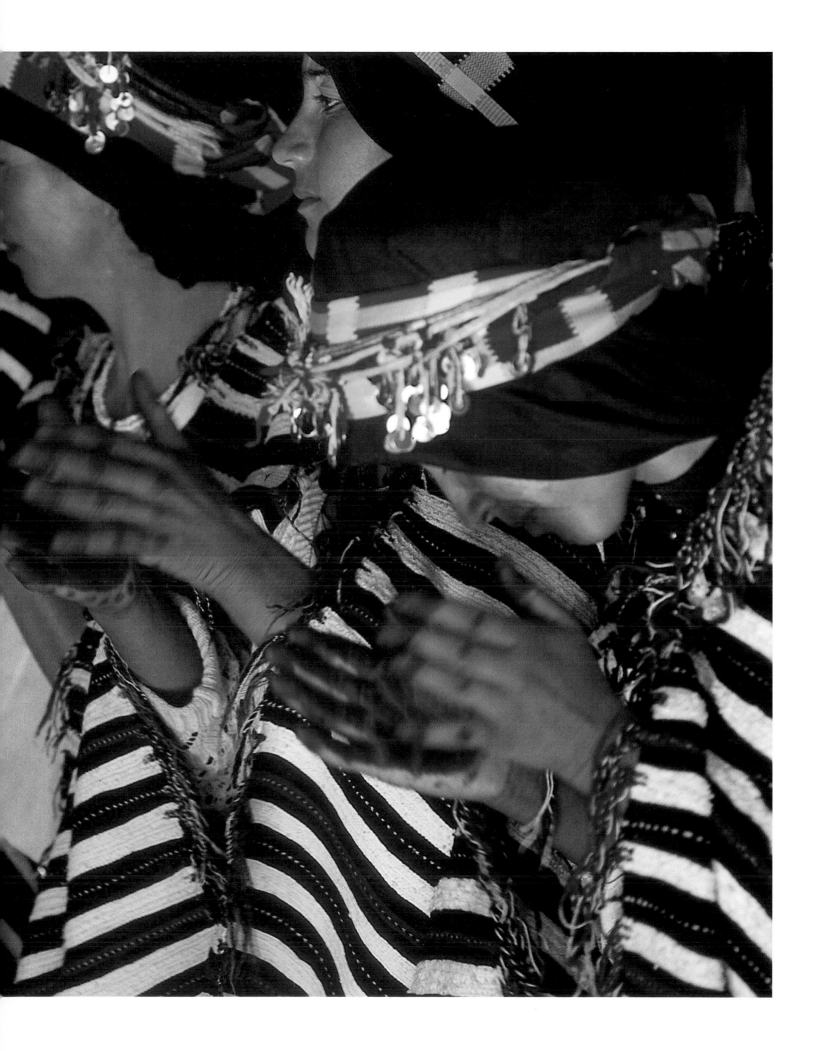

THE HIGH VALLEYS

To enter the high valleys of the Atlas Mountains you ascend steep passes on precipitous trails to an altitude of over 10,000 feet, arriving at last in the land of the Aït Bouguemez, the Aït Haddidou, or the Aït Atta. In Berber, the word "aït" means the people of a tribe or clan. A small detail of hair style, the colour of the earth, a pattern painted on a ceiling, or a nuance in pronunciation – any of these can distinguish the members of one clan from another. They all share a simple, profound faith in an Islam stripped down to its rudimentary spiritual principles. Life in the high valleys is organised according to the seasons, the agricultural cycles and religious festivals, the day of the weekly *souk*, and the hours of prayer, which themselves are determined according to the sun and the moon. Families live indoors during the long, snowy winter months. When the spring sun begins to melt the snows, the men build barriers with bundles of branches to check the flooding caused by the raging torrents rushing down the mountainside. An enormous effort is required, and it is because of their great hardiness combined with infinite patience in continually rebuilding these dams that the cultivations are preserved. The roads and trails having now become passable, travellers, nomads, and pedlars appear once again. Lorries bounce along the rocky tracks, taking men and women to begin tilling the arable areas of land for the next harvest.

By mule and on foot, long processions wend their way to the *souk*, often taking shortcuts across fields. In these barren regions, the market is a point of convergence toward which everyone seems headed. All can be bought or sold there, from a nail to a camel, from the indispensable to the superfluous. Each June, the market becomes a *moussem* in honor of Sidi Mohammed Laghad, combining a religious gathering with a commercial fair. The Muslim patron is commemorated and venerated in an atmosphere of popular joy, and his aid is solicited in prayers for nature to be lenient and for Allah to be merciful in the year to come.

An extremely pious people, the Berbers were converted to Islam in the 9th century. However, vestiges of pre-Islamic cults remain integrated into the Muslim religion as they practise it. They still worship the good and evil forces incarnate in nature. A rock, a tree, a spring or a cave are invested with magical powers of intercession in favour of a more harmonious life, based on the association between man, the heavens and the earth, the three of which, according to their belief, join together in a great dance of the universe, symbolised by the Berber dance, the *ahouach*. On their sacred threshing ground, the villagers form a circle and dance round and round, stepping in unison to the rhythm of the *bendirs* and the *zammer*, stretched goatskin tambourines, and a double flute, an ancestor of the flute of Pan, evoking in the minds of many visitors the spiritual celebrations of pre-Homeric Greece.

On the night of the summer solstice, far away from paved roads and modern comforts, the festival is celebrated throughout the valley. The music of the *ahouach* echoes across the wide plateaus. A huge bonfire concludes the night's festivities, dedicated

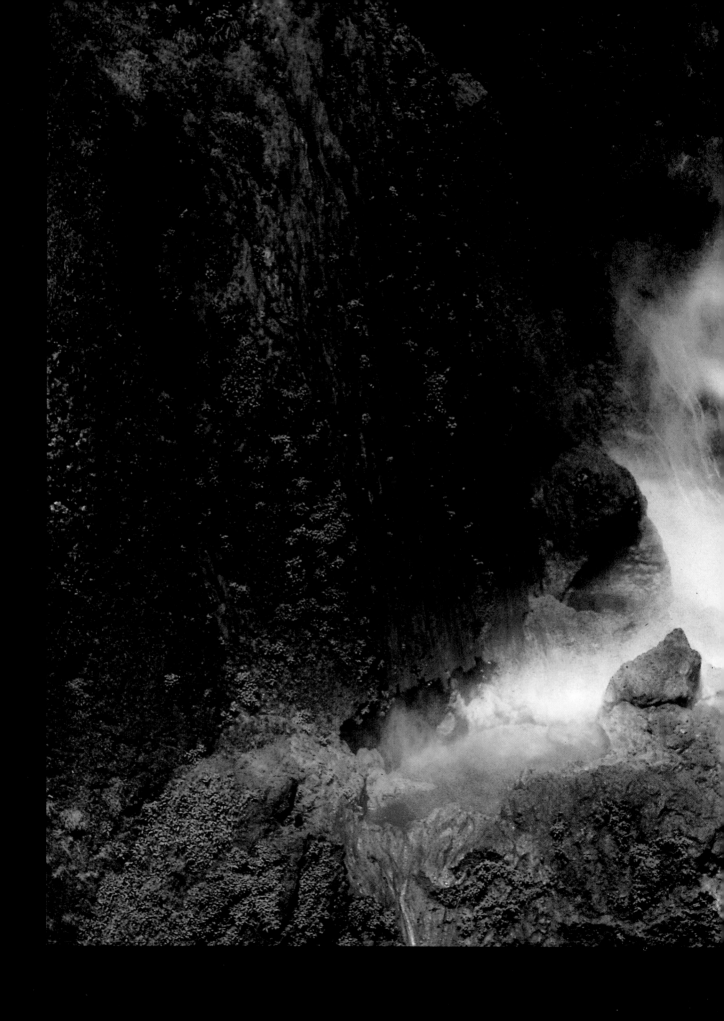

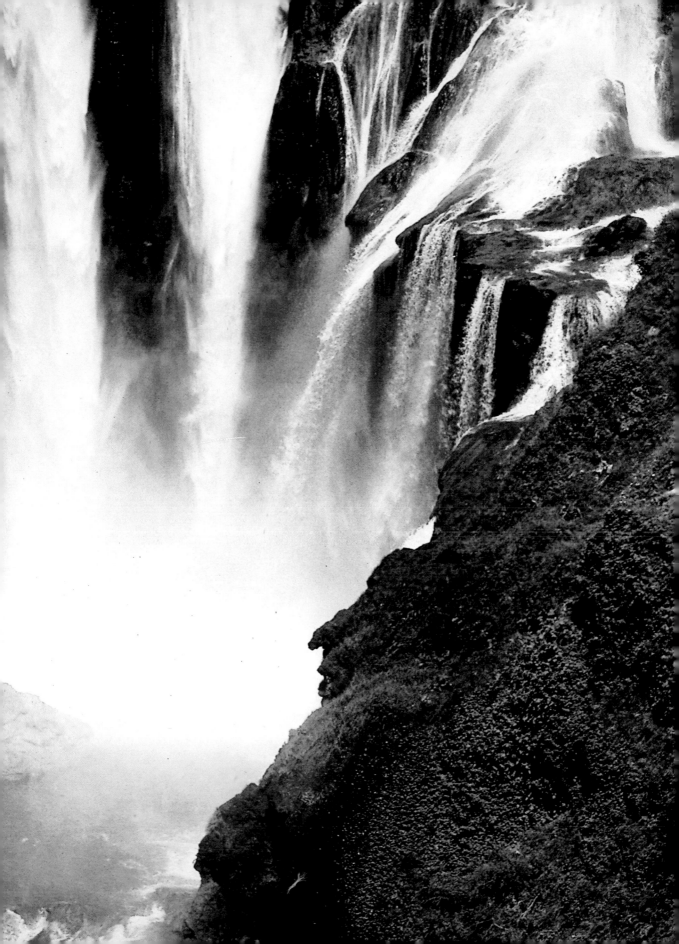

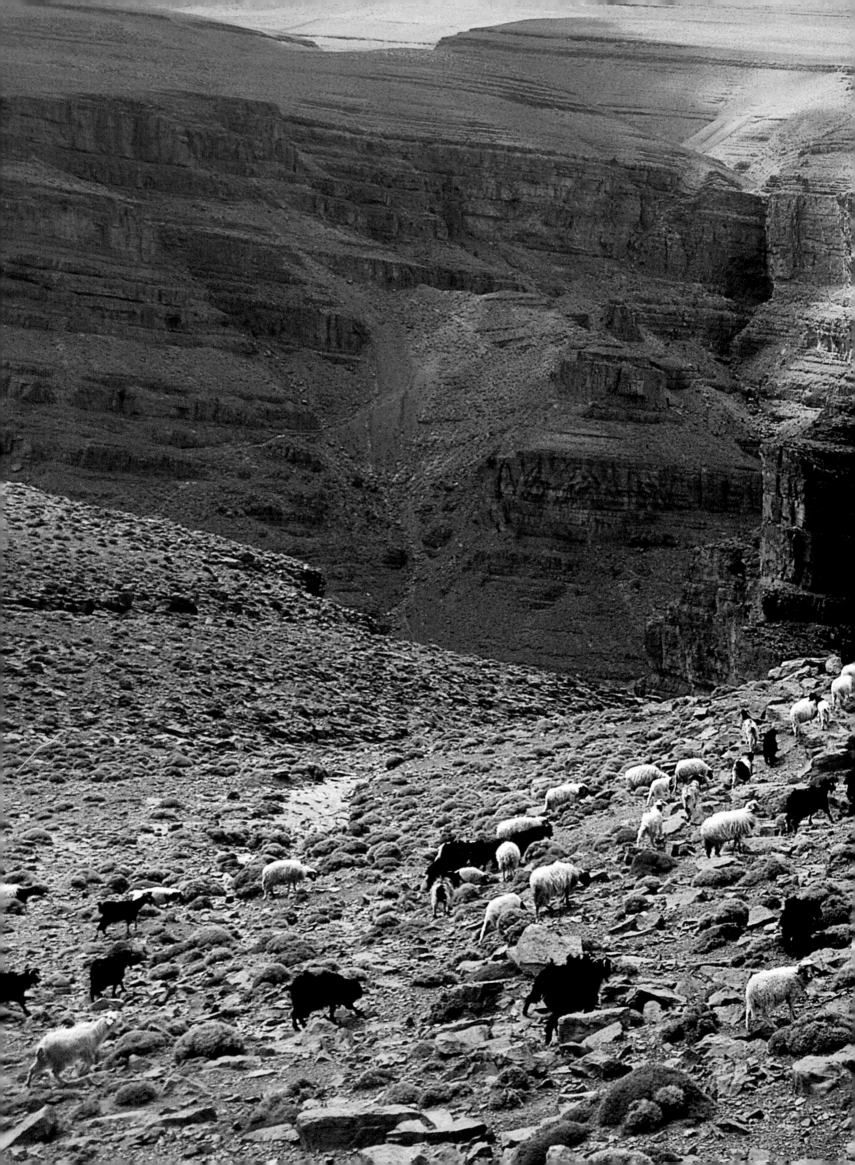

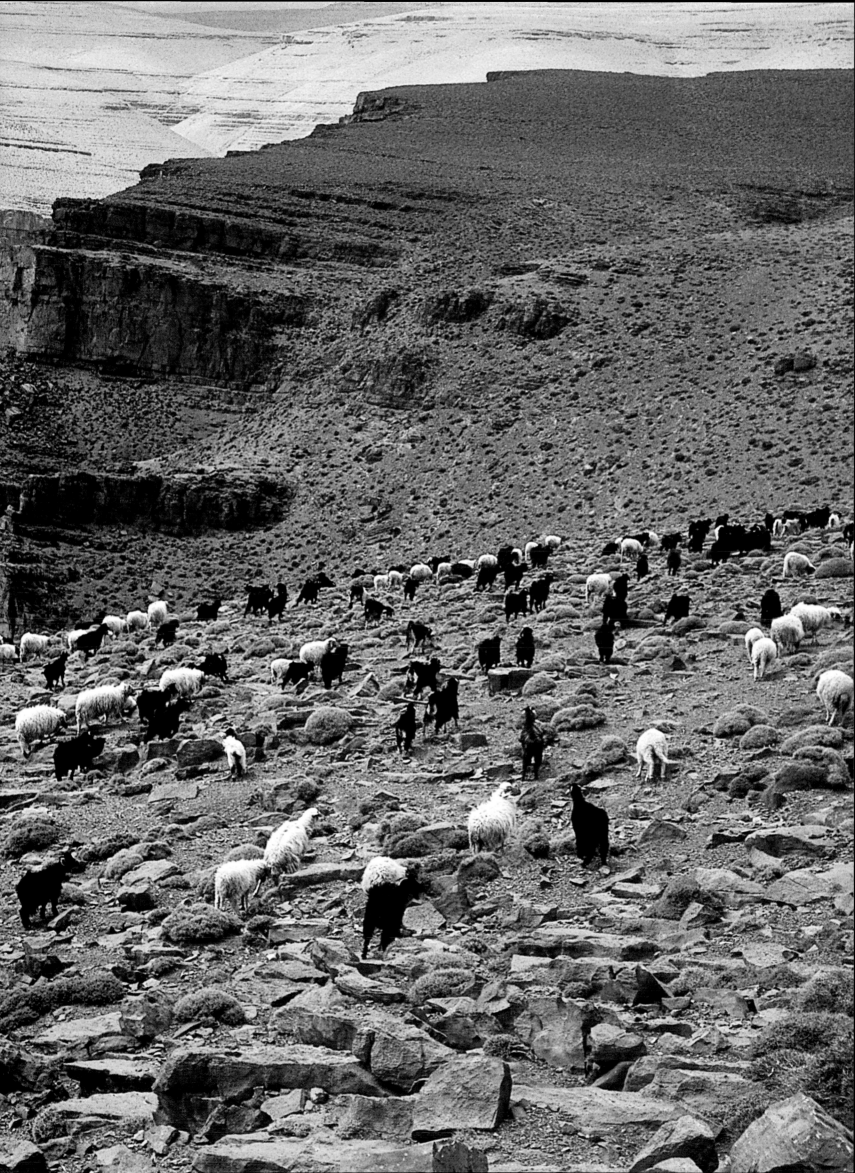

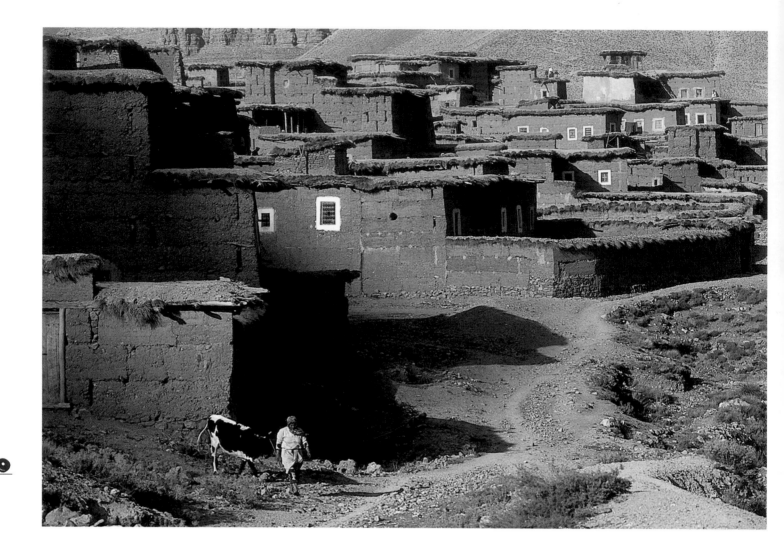

Pages 106-107

Near the Tighoughizin Pass. The arid perspectives of the high altitude open spaces, covered by herds of sheep and goats in the spring and summer, a series of precipices and flat lands which typify the Berbers' hard surroundings.

The members of the Aït Bouguemez clan, like other peasants of the high valleys, can tame the smallest irregular plot of land. A multitude of terraced surfaces growing barley, maize, beans, and potatoes, produce just enough for the needs of their families.

The *muezzin*'s voice echoes through the valley, calling the men to prayer. They arrive at the little mosque, its white minaret contrasting with the ochre houses built of earth, which blend into the countryside. Friday is a day of sharing and charity. Food and drink are offered to travellers, and money is given to beggars.

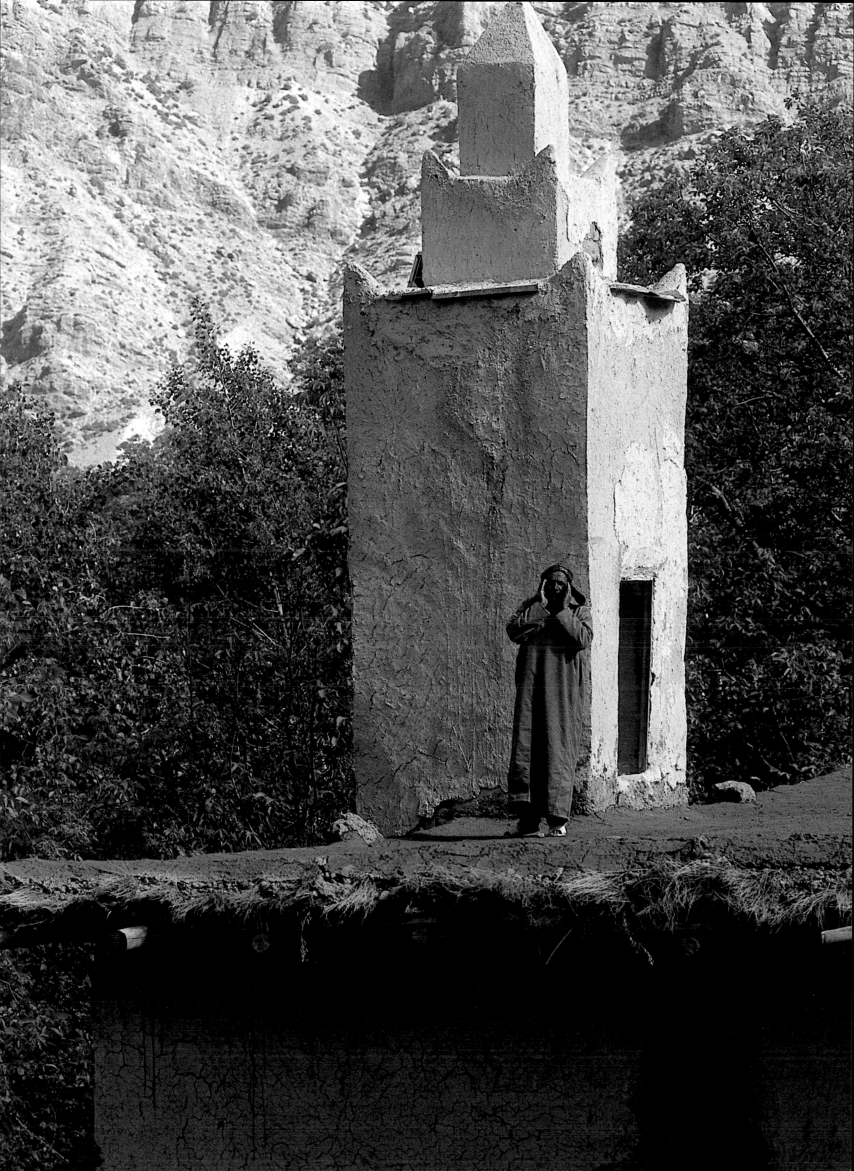

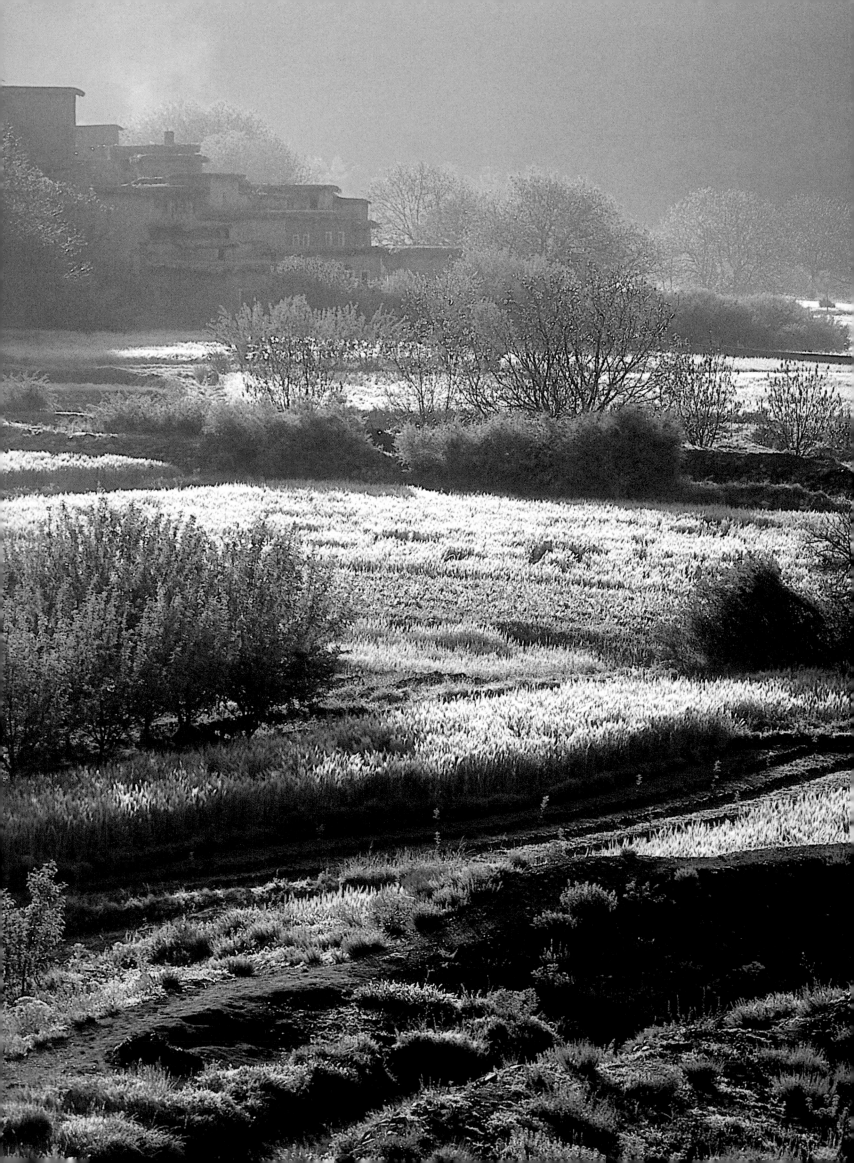

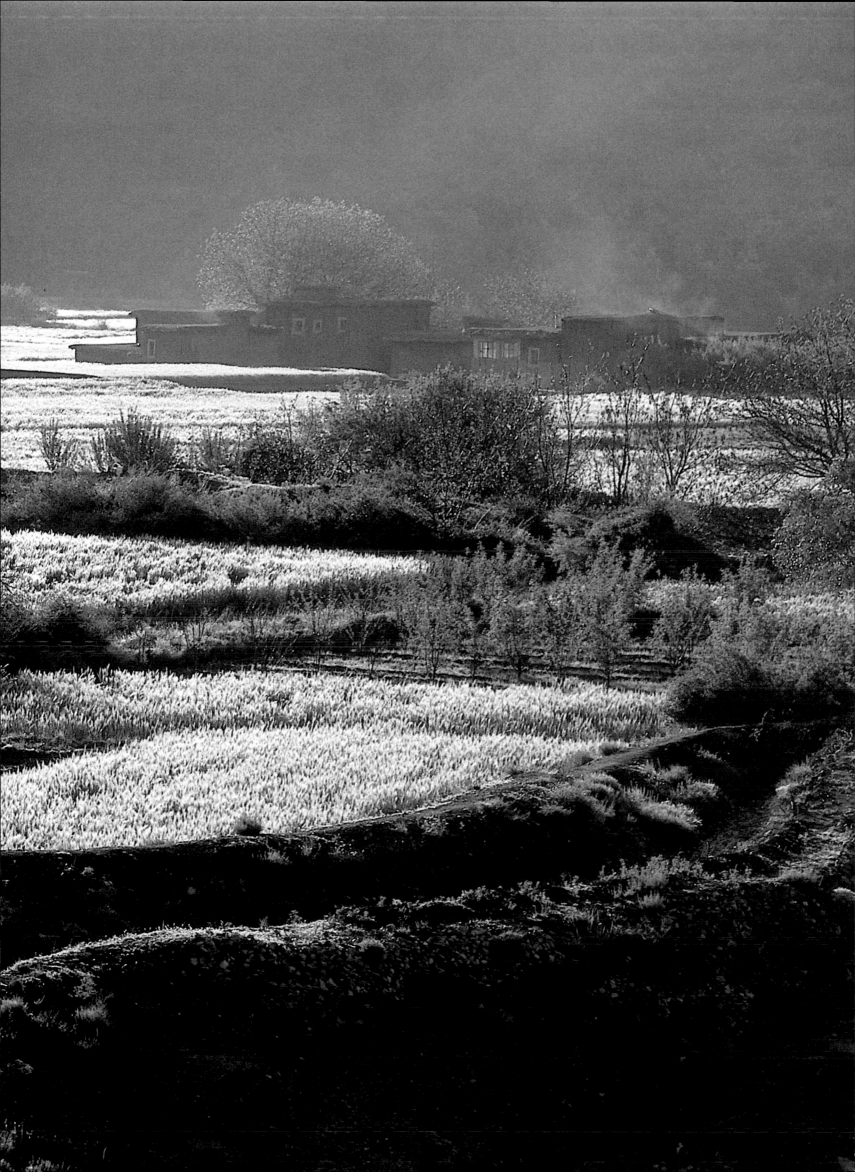

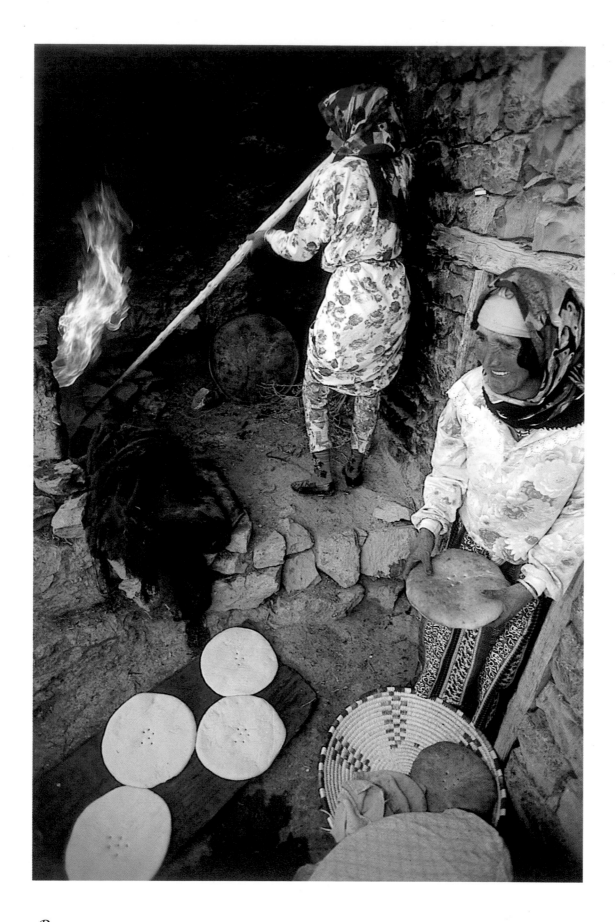

\mathcal{B}read *(aghroum)* is kneaded and baked several times a day. Made from barley or wheat, with its characteristic taste of cinders of the oven, it accompanies all courses of meals.

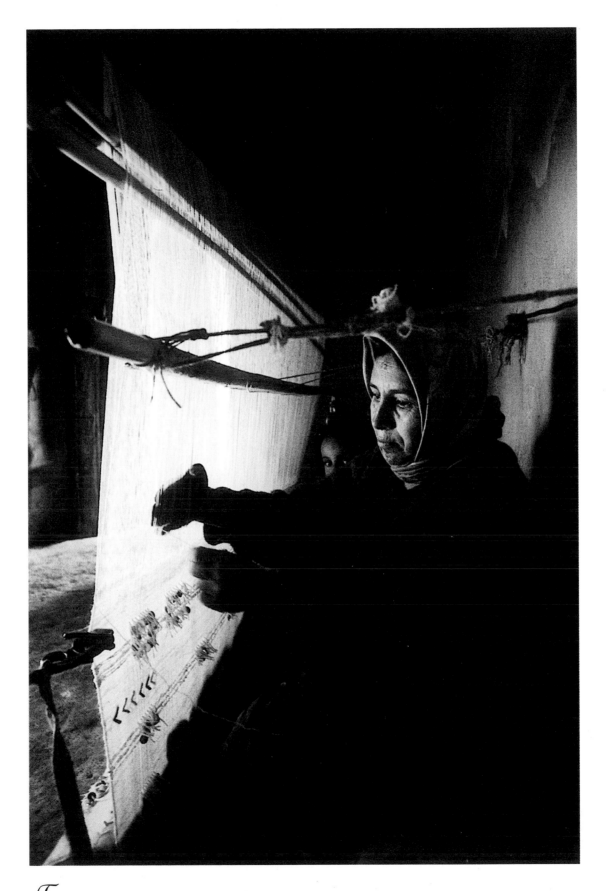

𝒯he wool of sheep is transformed by expert hands into carpets and blankets bearing the colours and signs of the clan, and embellished with spangles. Works of art, they are proudly exhibited as a sign of respect to guests, or to honour the heavens during the harvest festival. Three months of work are required to produce a blanket, six for a carpet.

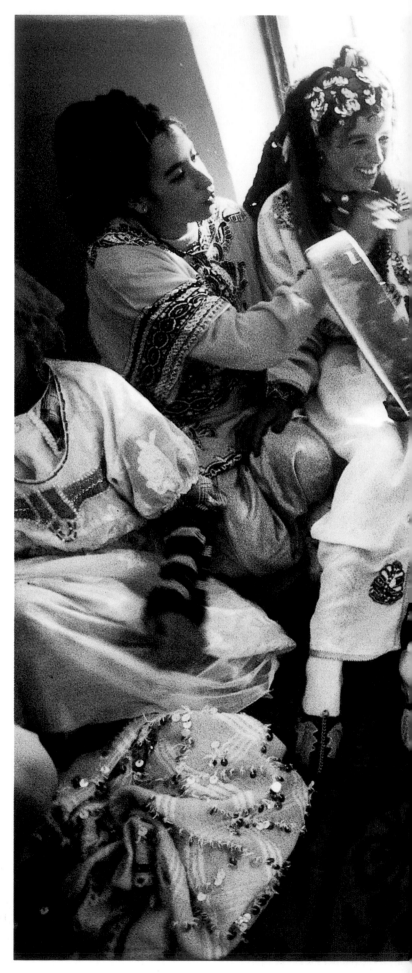

*W*hatever their age, all women of the clan play the *bendir*, the little round drum, and can raise their voices in the long, modulated 'youyou' cry of Berber women, or sing in crystal-clear harmony. The women of the Aït Bouguemez Valley seem to have an innate talent for celebrating festivals, the only interruptions in their lives of daily drudgery.

Pages 116

*T*he Todra Valley.

Pages 118-119

*T*he Dadès Valley in springtime.

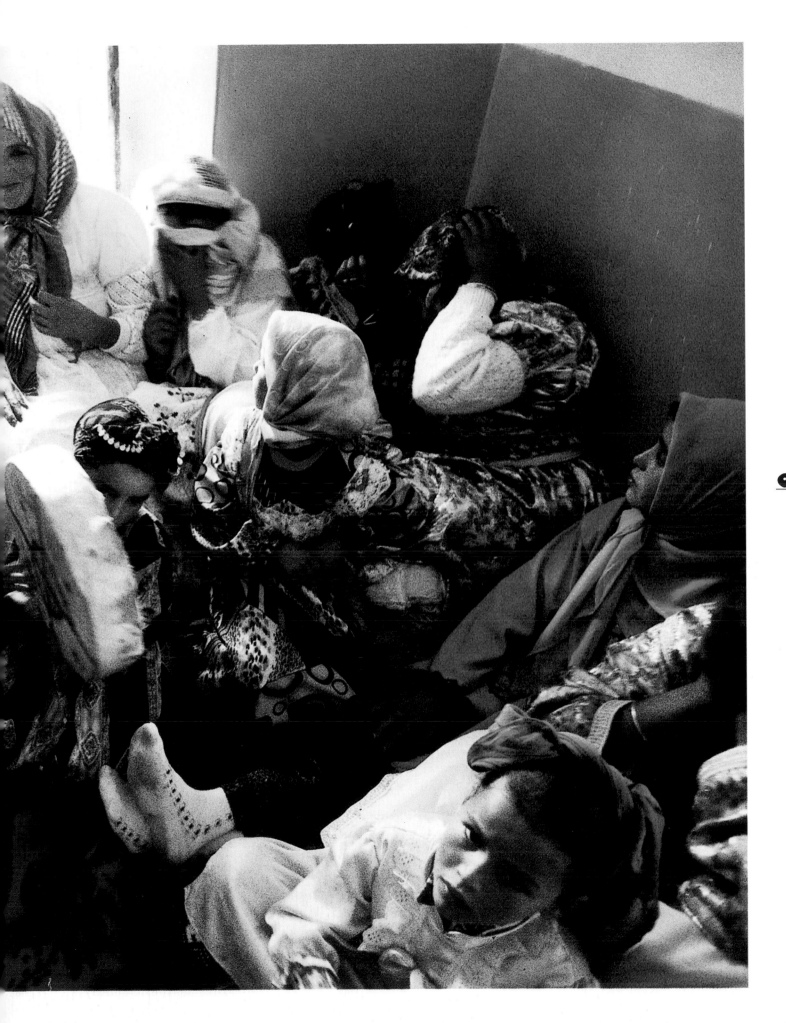

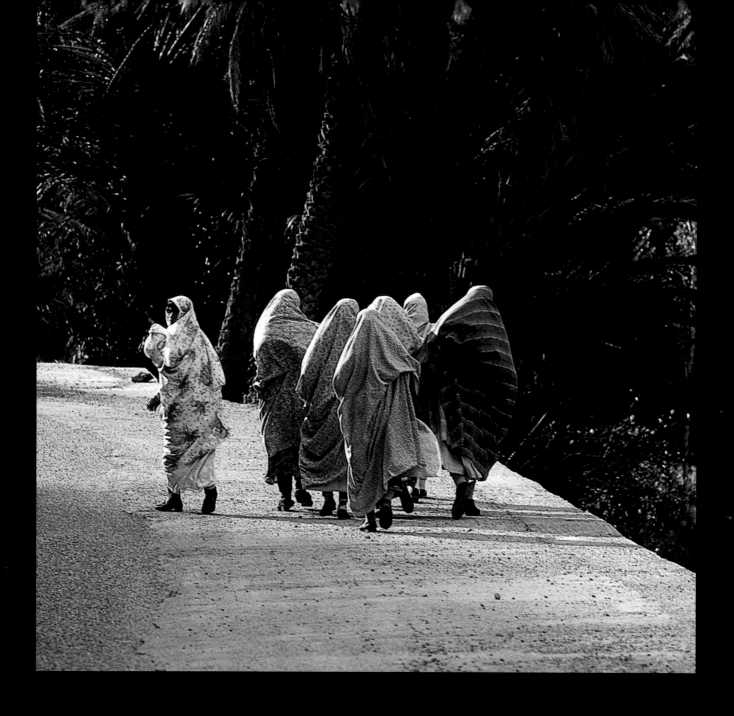

THE ROAD OF THE CASBAHS

In the Todra, Dadès and Drâa Valleys, at the base of the High Atlas, great strips of green mark the surface of the land like silent, immobile rivers. Under the palm trees the oasis seems suspended in another age, following a different rhythm of life. Hospitality, a virtue which seems to have originated in the desert, dominates the lives of the inhabitants of these valleys. Milk, dates and rose petals are offered to the visitor as a prelude to any encounter.

Caravans from the Orient and from Africa, bearing gold, salt, and slaves, once passed through these valleys, as well as princes, pilgrims and conquerors. Some decided to remain in this region of mild climate and rich agriculure. They built castles, massive but transitory structures built out of the clay of the river banks, situating them in the valleys or placing them imposingly atop hills. These dwellings are continually being rebuilt after regularly being devastated by time and the elements.

The population of the the *ksour* (*ksar*, in the singular), a palace or fortified village formed by a group of *casbahs*, or citadels built of earth, began leaving for the cities long ago, and today the exodus is nearly complete. Some people regret the departure. Certain of these palaces will perhaps be saved because of their cinematic fame, or by the alarmed conscience of institutions responsible for preserving the world's treasures. The *casbah* of Tiffoultoute, so impressive from afar, where the cast of *Lawrence of Arabia* once stayed while the film was being shot nearby, the *ksar* of Tamnougalt, and the *casbahs* of Aït Benhaddou and Skoura are such examples.

From Tinerhir, in the Tafilalet oasis at the foot of the Todra gorge, to Ouarzazate, passing through Boulemane in the Dadès Valley, the oases today are agglomerations which have succumbed to the perpetual flow of tourists, attracted by the grandeur of the decor and by the richness of the seasonal celebrations. Each year, roses, dates and henna provide reasons for popular rejoicing. At Boulmane, in May, tons of rose petals are scattered into the air, which is laden with intoxicating fragrances. There is no ceremony from which armfuls of the small, violet-coloured roses from the Dadès Valley are absent. And at the end of each meal, rose water is sprinkled on the hands of the guests

During the summer, a green tapestry of henna is spread out on the terraces of the houses of Tafilalet. There are different ways of appreciating henna: in great quantities of little white flowers, in perpetually green leaves, in a fine powder with its natural scent, and in a blackish paste at the bottom of a bowl. It can also be seen in reddish reflections when mixed into the hair and in the ephemeral tattoos on the hands of Berber women. Henna, a word meaning "divine grace", is believed to possess the secret of the mystery of seduction. Placed in the hollow of one's hand, on the forehead of a newborn baby, or on the lintel of a doorway, it is supposed to bring providential protection from the bad events in life. Henna is said to possess divine grace and the odour of godliness, and many people call it the plant of paradise.

In autumn, in the palm groves around Ouarzazate, and extending to the Tafilalet oasis, bunches of yellow dates complete their ripening in the sun. When the harvest is good, dozens of women in lively lace costumes, displaying their gold jewels, form the wavy circle of the *ahouach* around a fire, to the beat of a large drum. During the Date Festival, their songs rise into the night; the celebration continuing until the light of the dawn reveals the imposing natural beauty of the oasis and its setting: the vision of balanced harmony between man and the land. "In beauty," the Berbers say, "is the invisible hand of God".

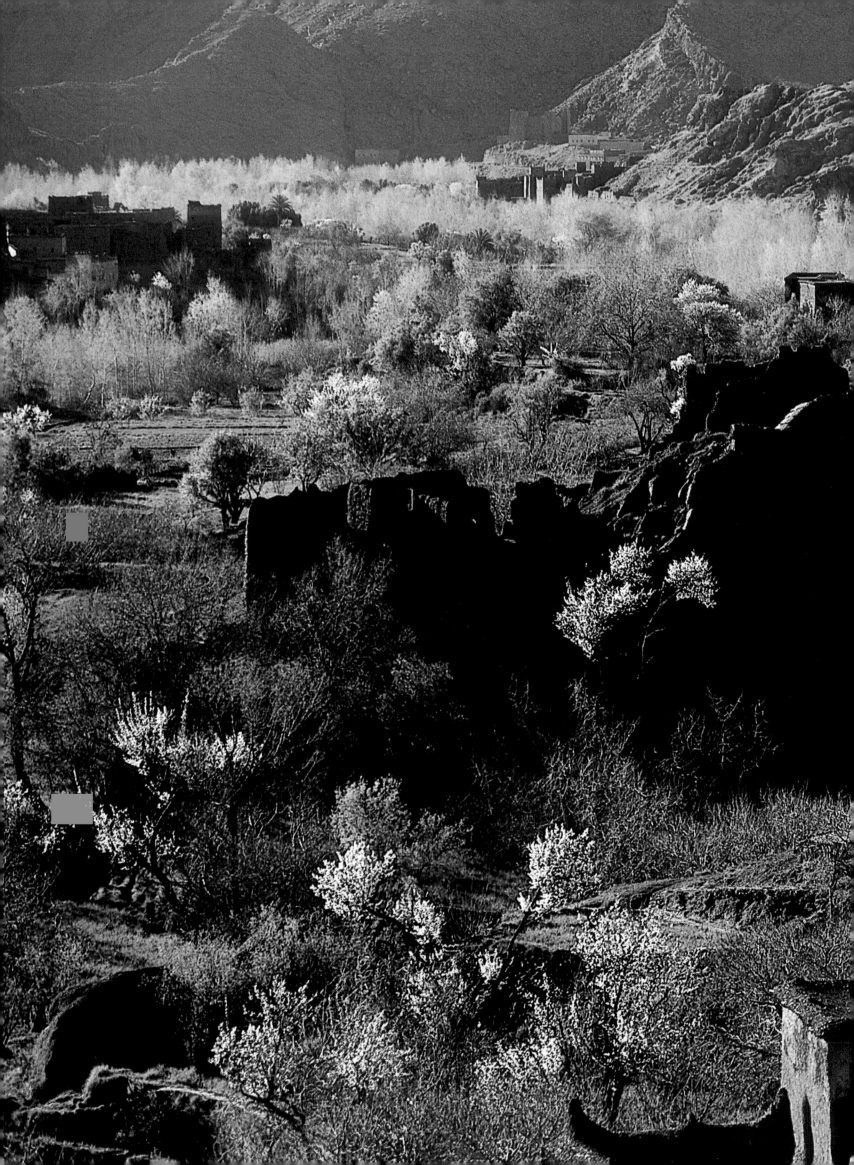

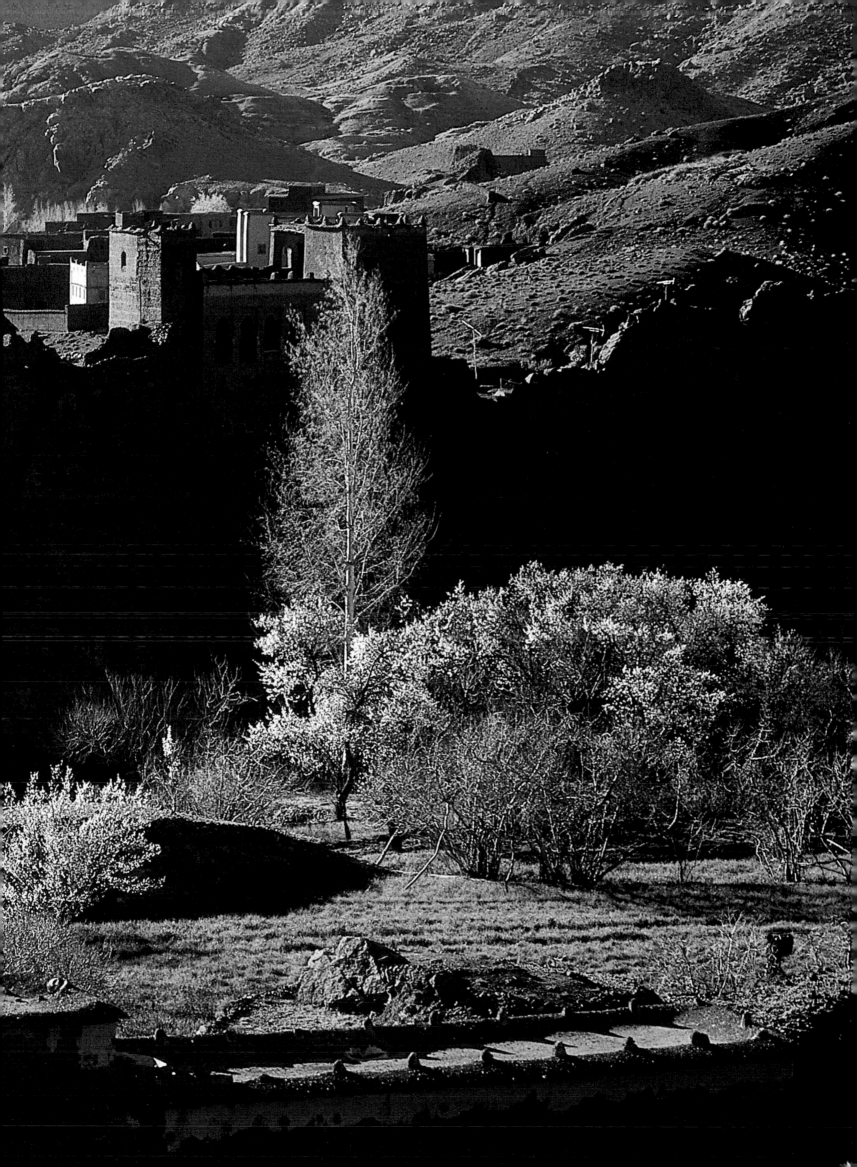

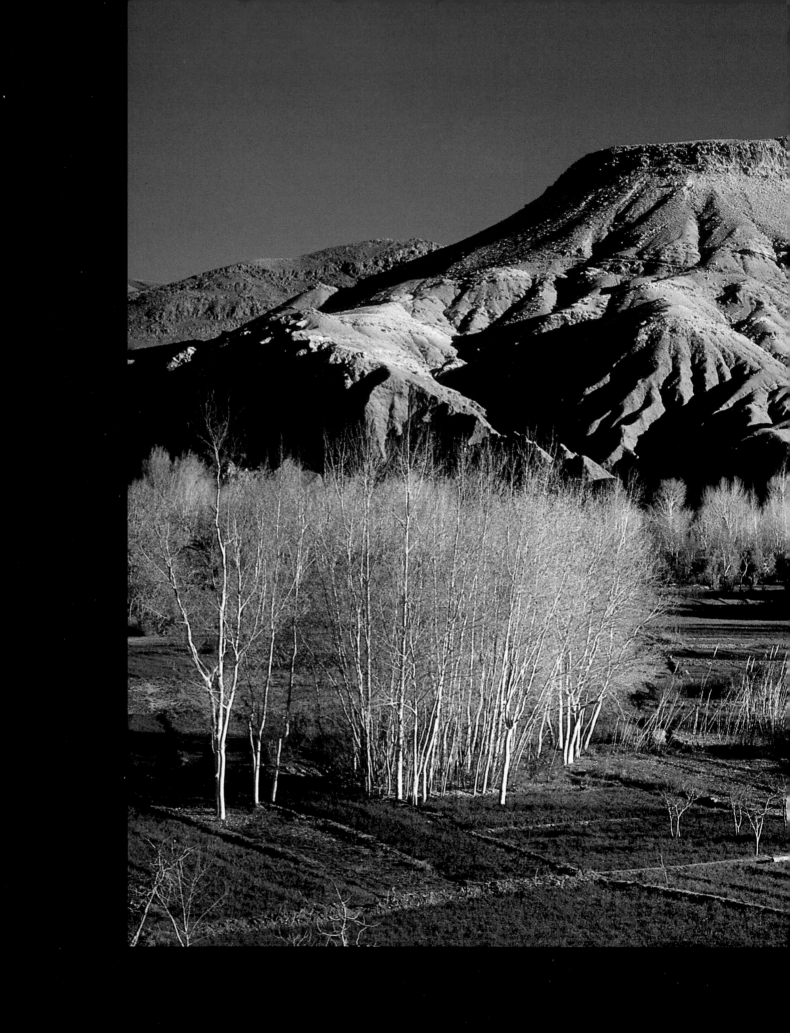

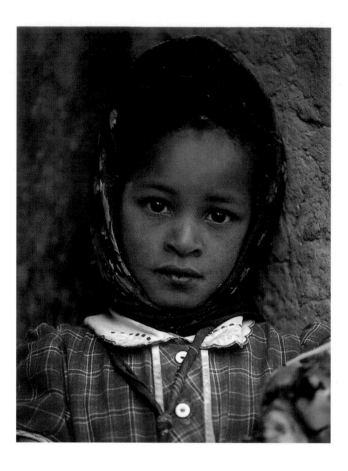

Pages 120-121

*A*long the road which goes through the gorge of the Dadès River are rocks of a varying range of red and purple colours. The arable land is cultivated down to its tiniest parcel, mountain gardens made up of different varieties of almond trees, olive trees, walnut trees, and poplars.

*T*his palm grove of the Dadès Valley contains many little gardens, which supply families with the vegetables they need. The earth houses, with their thick walls, signify the pre-Saharan region.

*A*t the foot of the steep Tudra Gorge, the town of Tineghir was once an important stopping place for caravans laden with spices and gold. It remains important today, filled with commercial travellers and tourists.

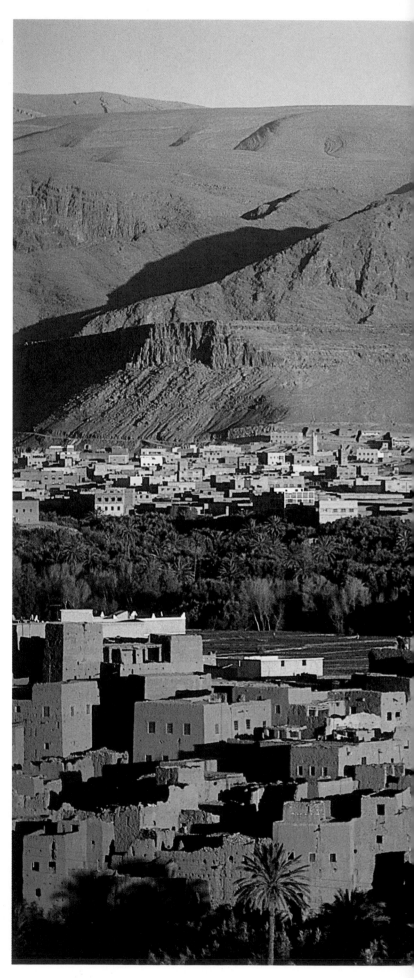

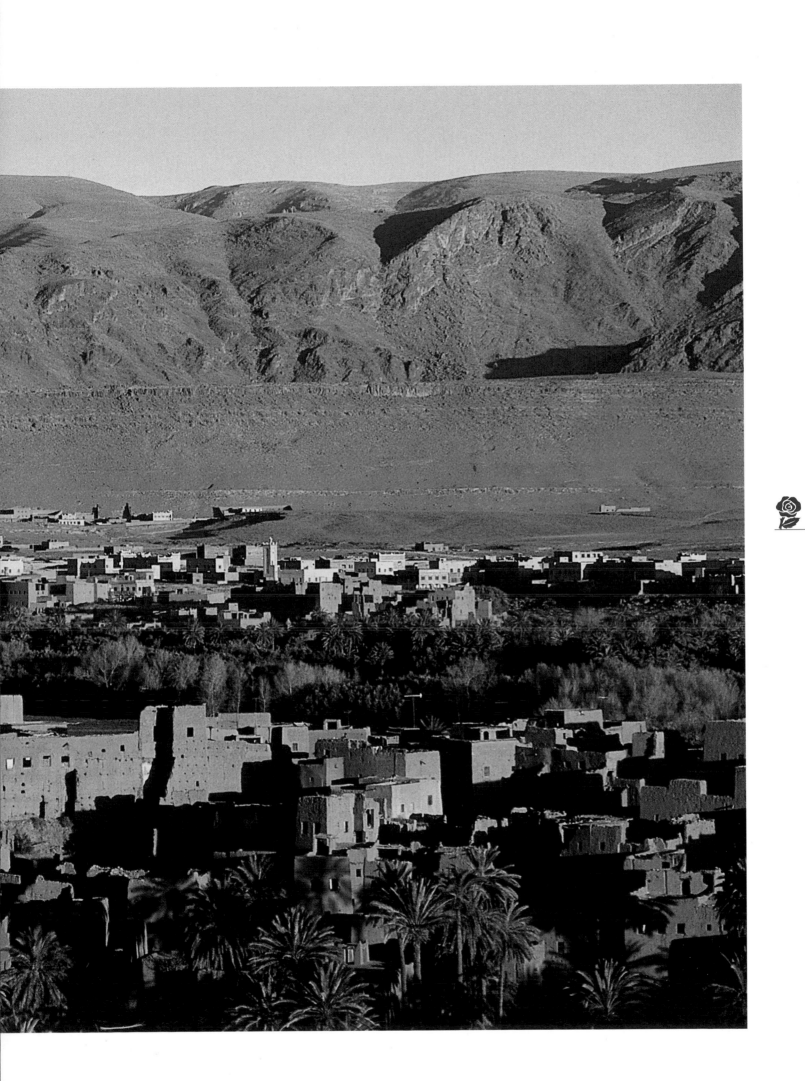

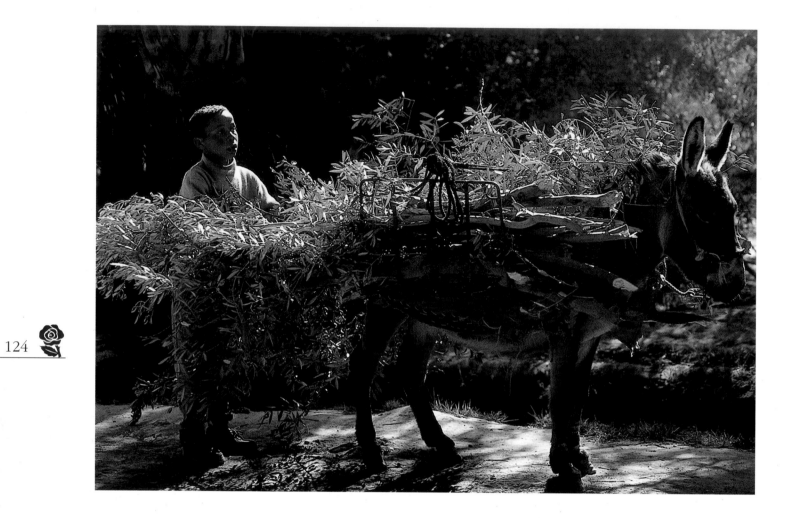

*B*efore the *makhzen*, the centralised power of the Moroccan state, came into being at the beginning of the 20th century, local tribes built fortified cities, castles built out of earth, of which the best preserved is the *casbah* of Tiffoultoute, near Ouarzazate, on the road to Zagora.

Pages 126-127

*T*he *casbah* of Aït Benhaddou near Ouarzazate.

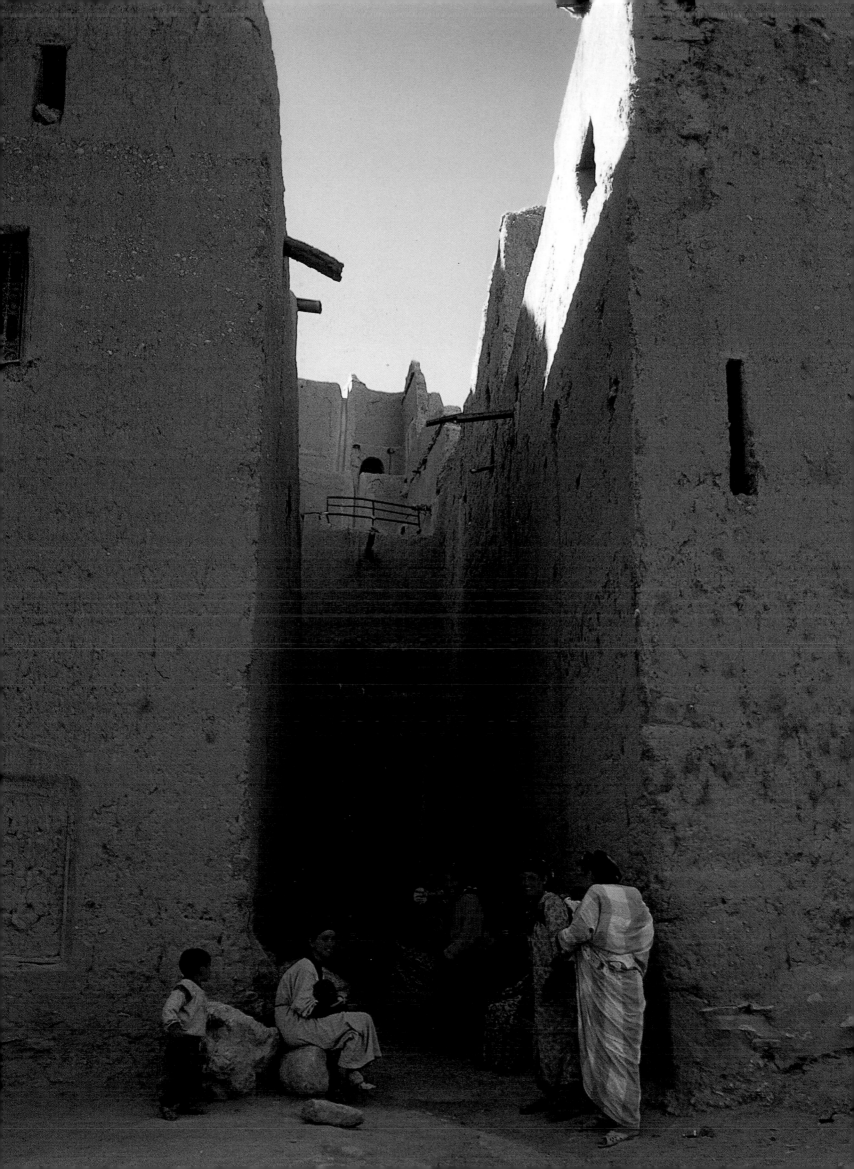

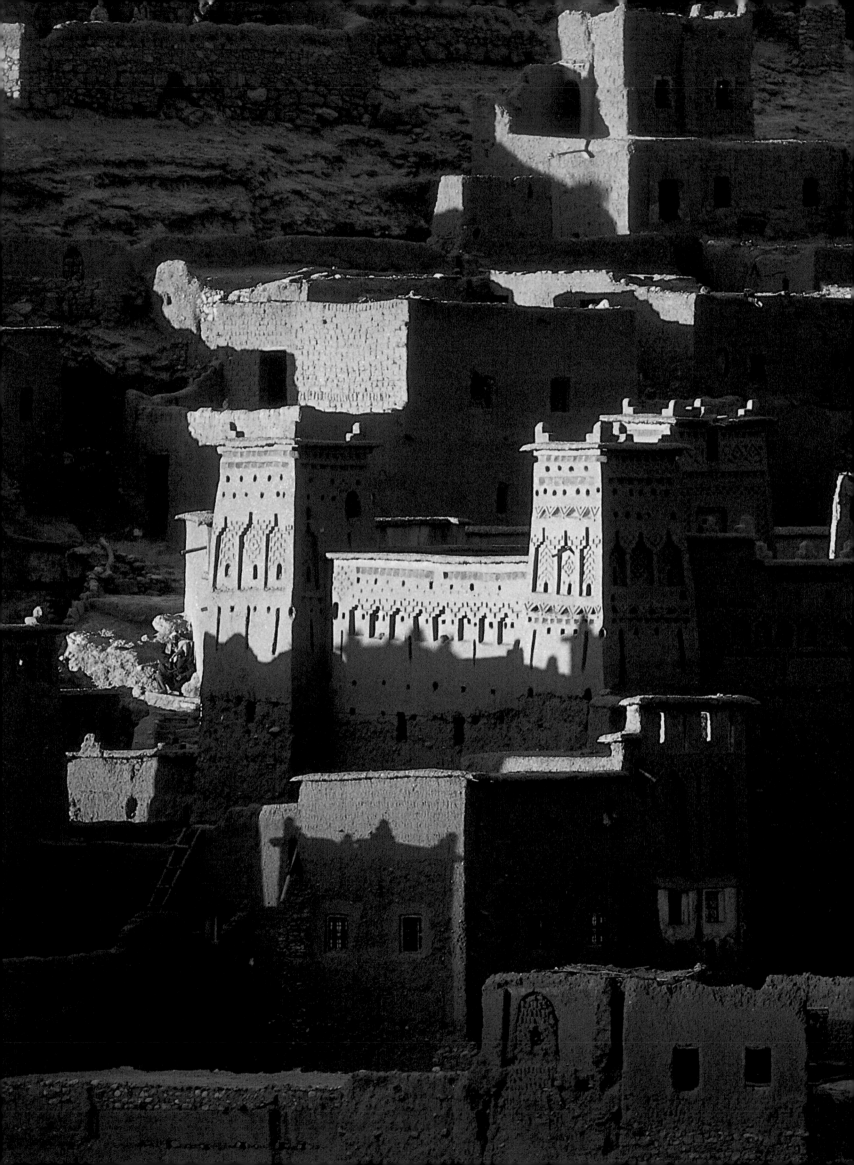

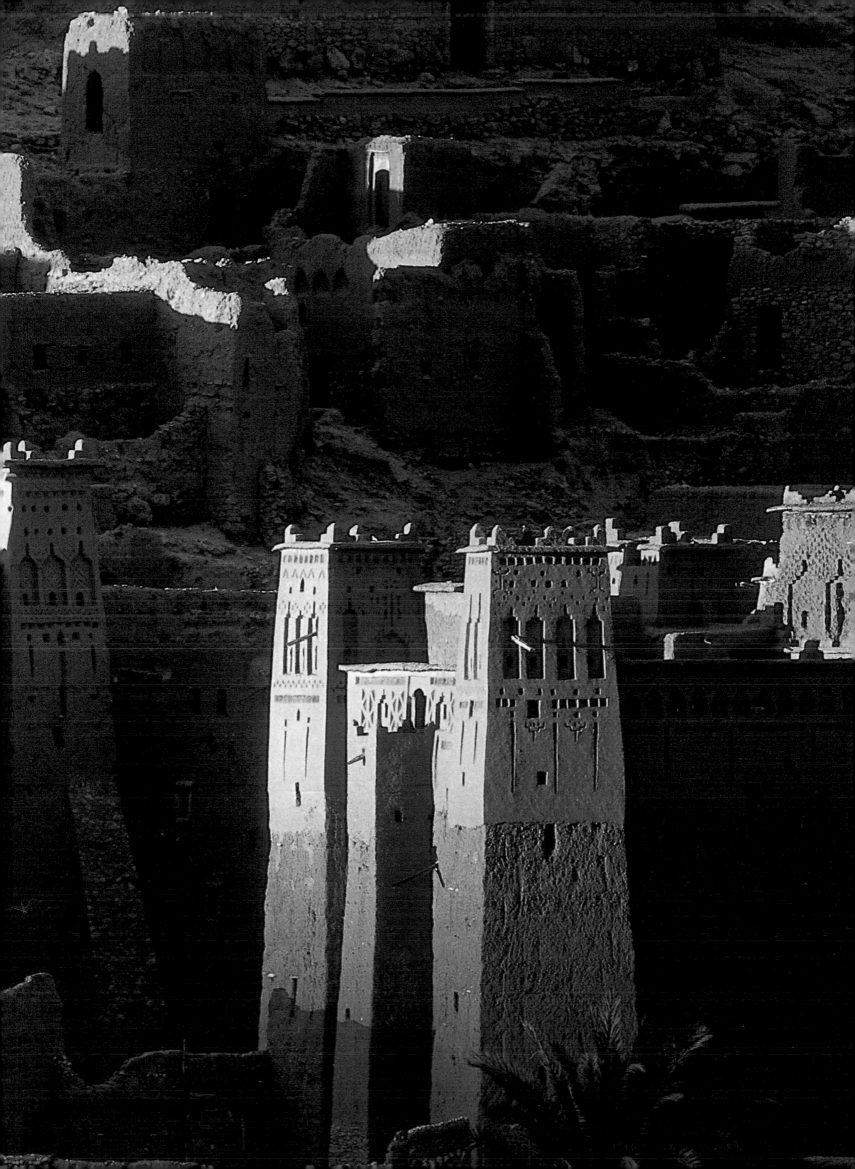

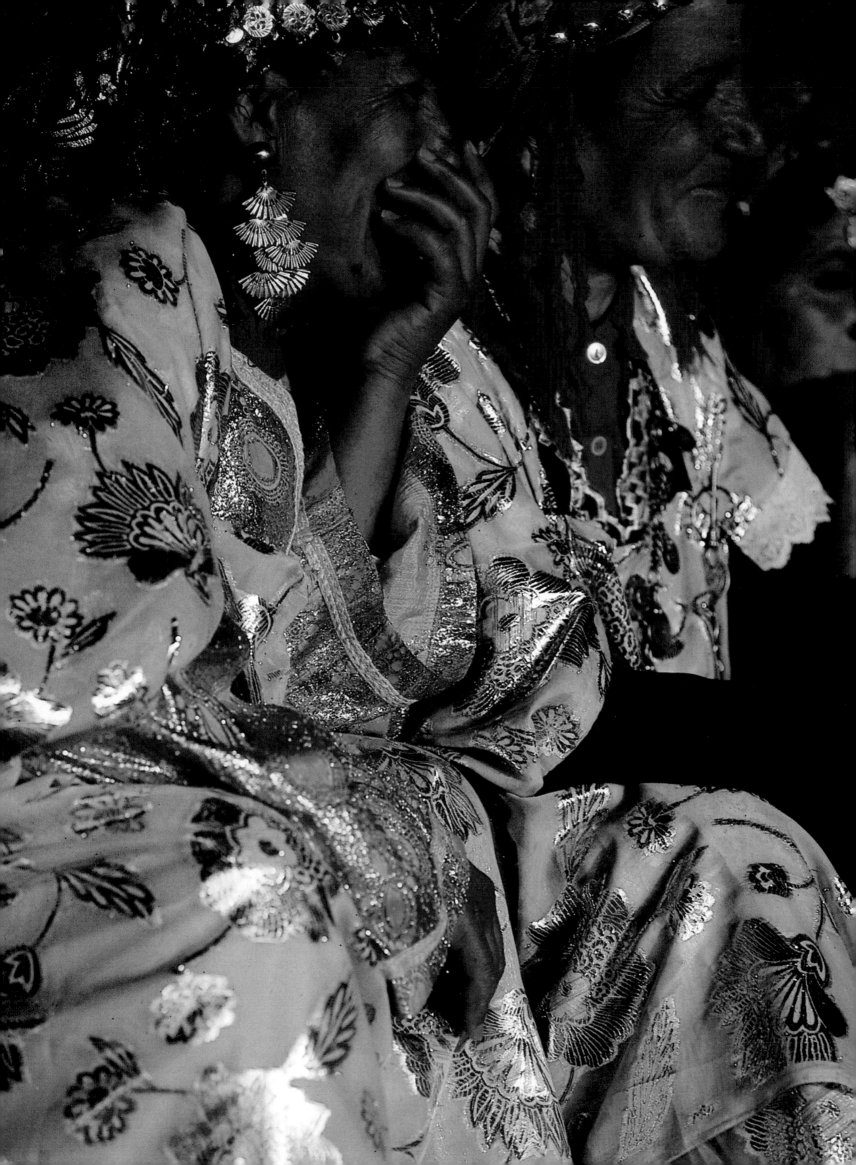

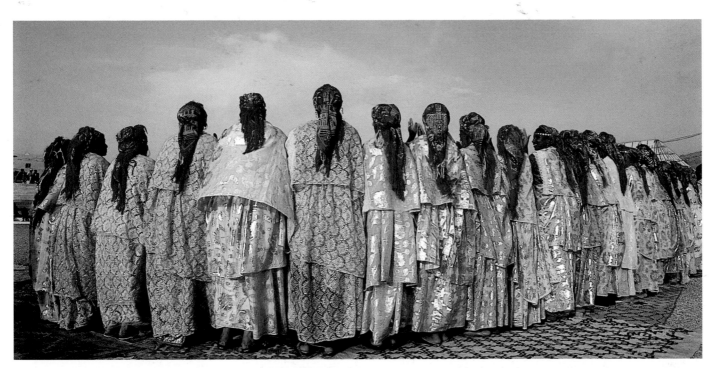

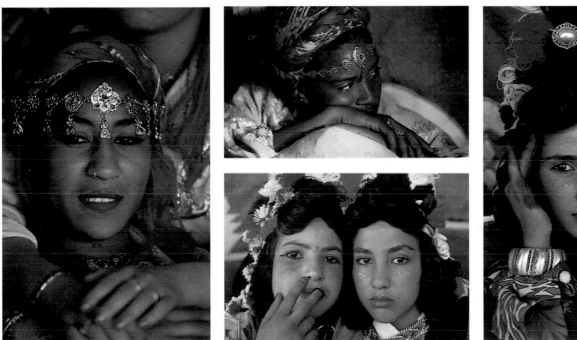

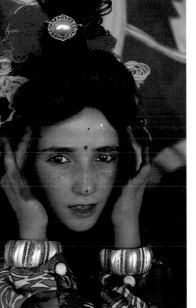

*T*he women of Ouarzazate and its surrounding oases, with their black African origins, have retained a taste for vibrant colours and percussive rhythms. In their bright costumes, in groups of over a hundred, they form the largest *ahouach* circle in Morocco. During the Rose Festival of Dadès, they join with the dancers of Boulmane and of Kelaa M'Gouna and the air vibrates with their singing as they express their shared joy.

Pages 130-131

*B*oulmane-du-Dadès. From the heights of the town, the view takes in the *ksour* and the *casbahs* scattered along the riverbanks. At the rear rises the snowy range of the High Atlas.

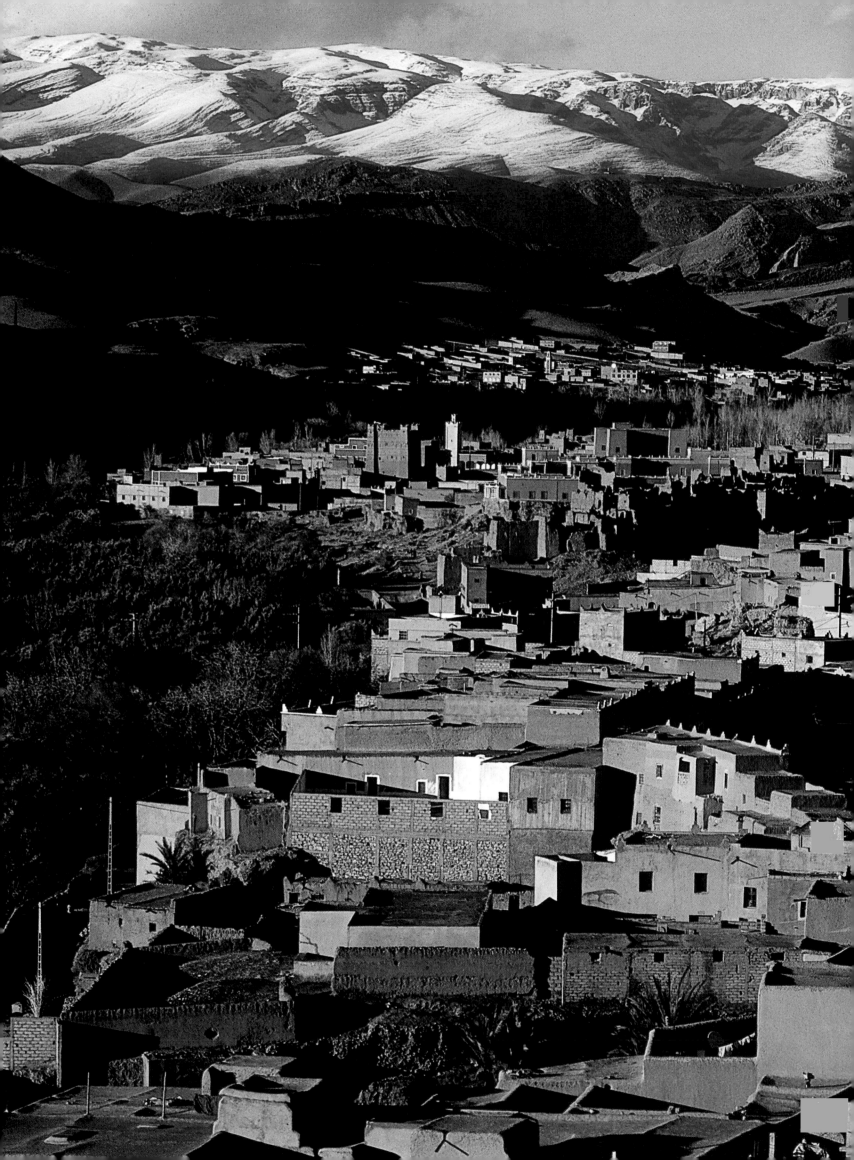

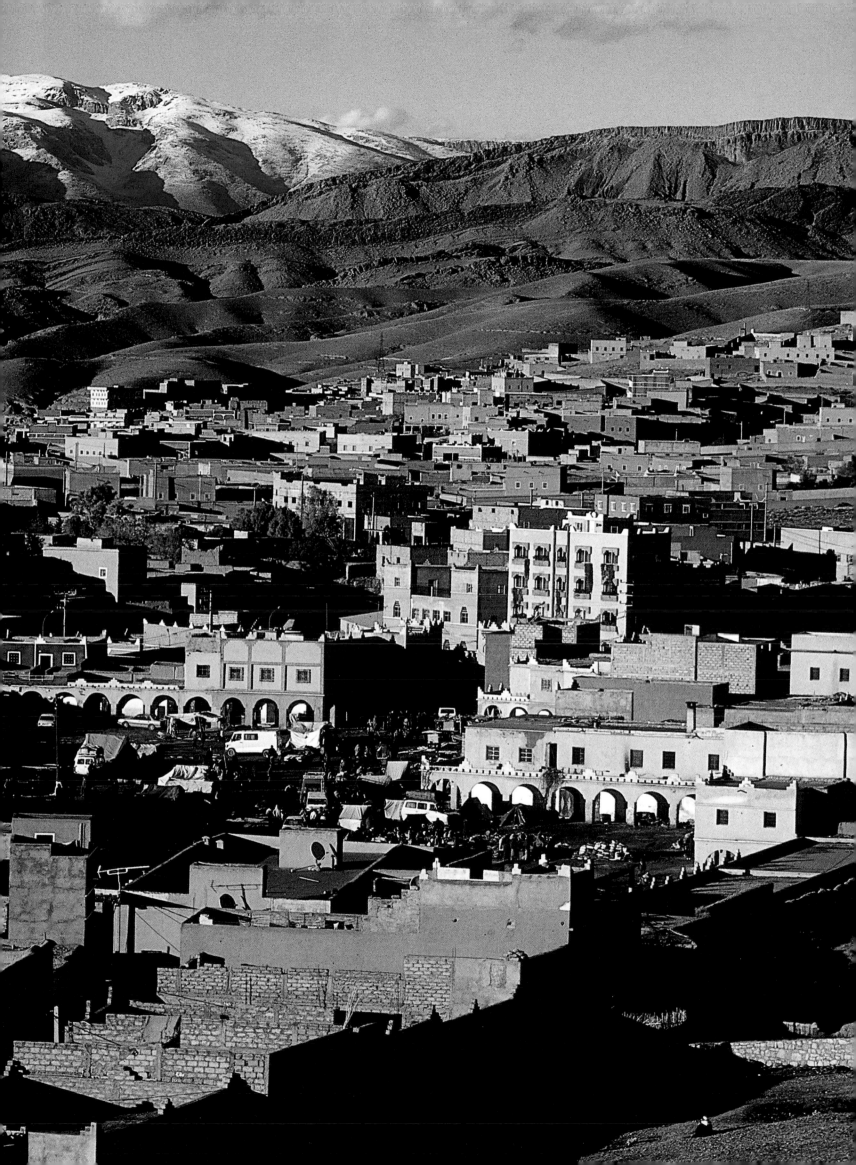

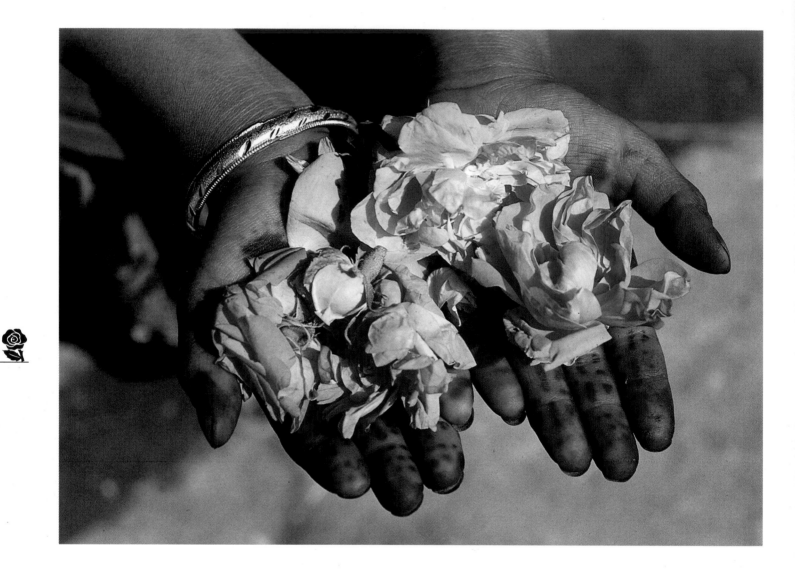

𝓡oses growing in the desert! In the Dadès Valley a small green paradise with rows of fragrant roses, the colour of lilacs, running through it. In the spring of each year, the whole region becomes animated. There is a feverish activity of picking, sorting, weighing and wrapping, and the festival involves the whole population. Harvested at daybreak, the Dadès rose is called the *Damascena*. It grows in wide, thick rows, demarcating the property of each owner.

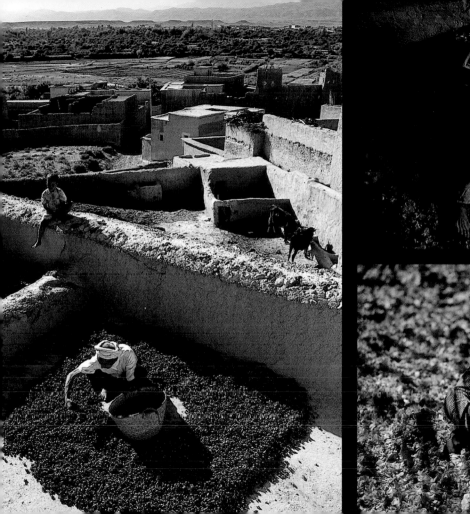
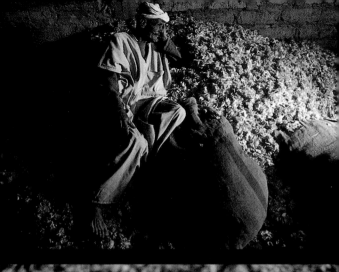
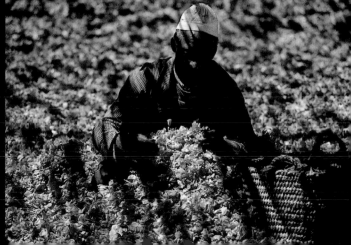

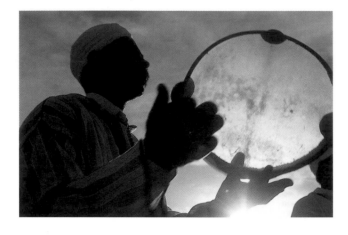

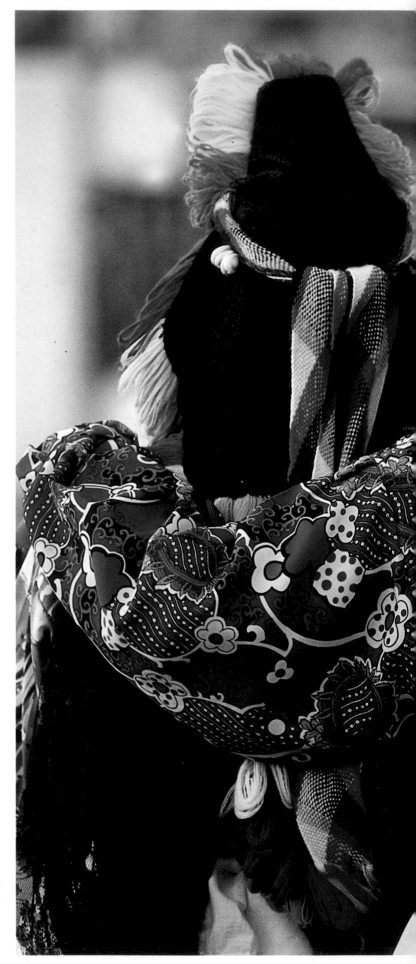

𝒯he traditional costume of Kelaa M'Gouna, near Ouarzazate, in the Dadès Valley. Femininity, beauty and seduction are the themes of the Rose Festival, which has evolved into a veritable carnival, with a procession of floats, the election of a Miss Roses, and some of the most remarkable choreographed tableaus in Morocco, like the "dance of the butterfly", which incorporate grace of movement and splendour of costume.

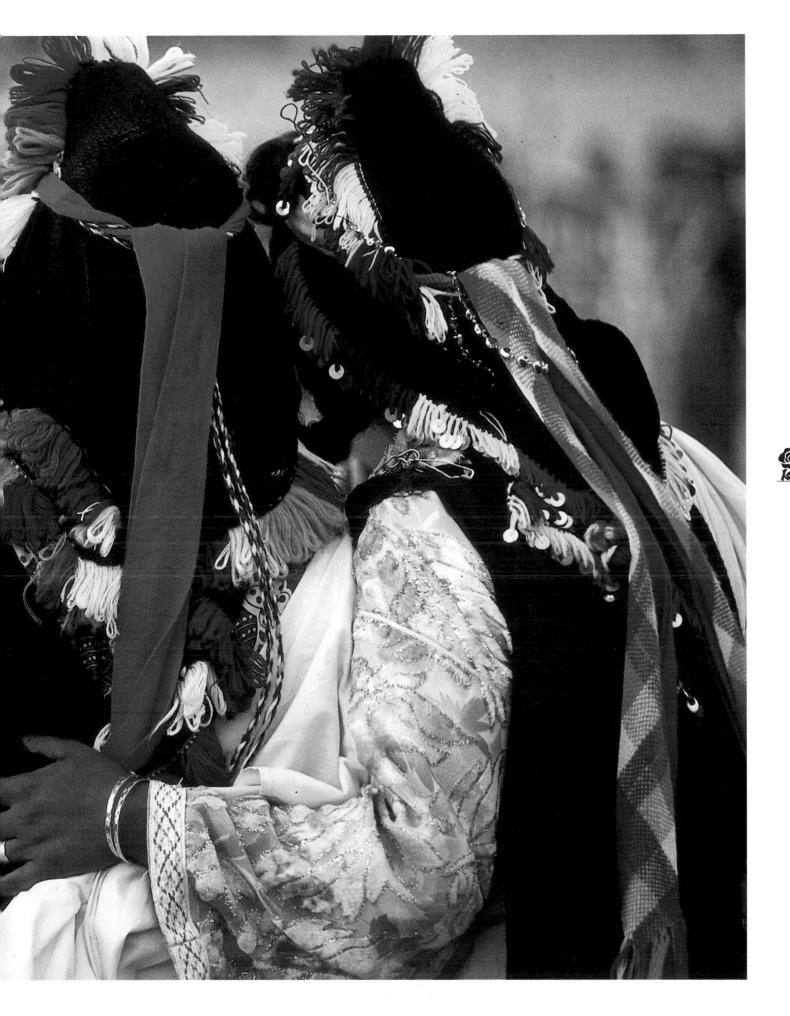

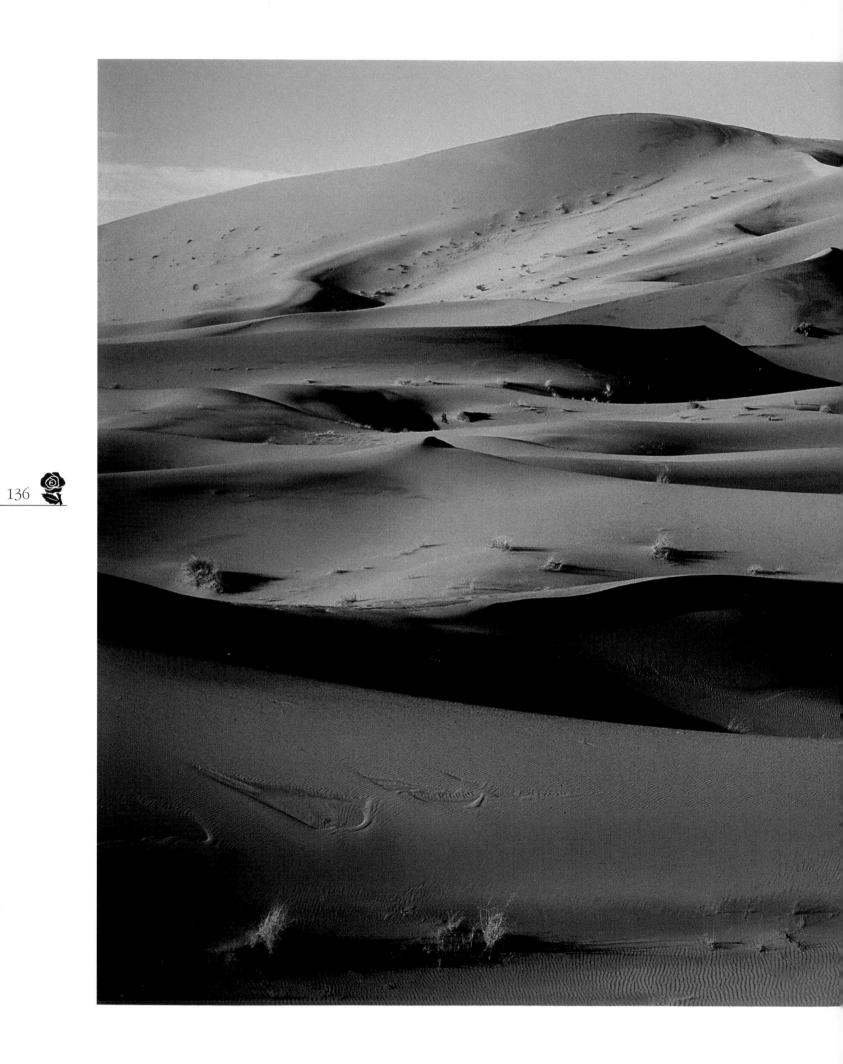

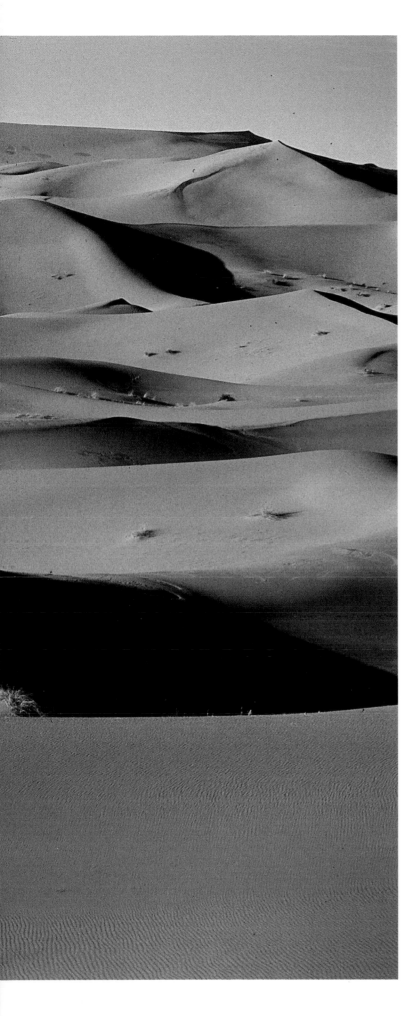

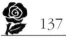

On the other side of the Drâa Valley, the last little islands of green disappear behind the dunes. It is here that the immensity of the Sahara Desert begins. Costumes inflated by the wind, moving as if in a dance, the graceful silhouettes of men and women of the desert emerge from a dune and then disappear. Always present to welcome the guest: the men of the desert, the messengers of hospitality.

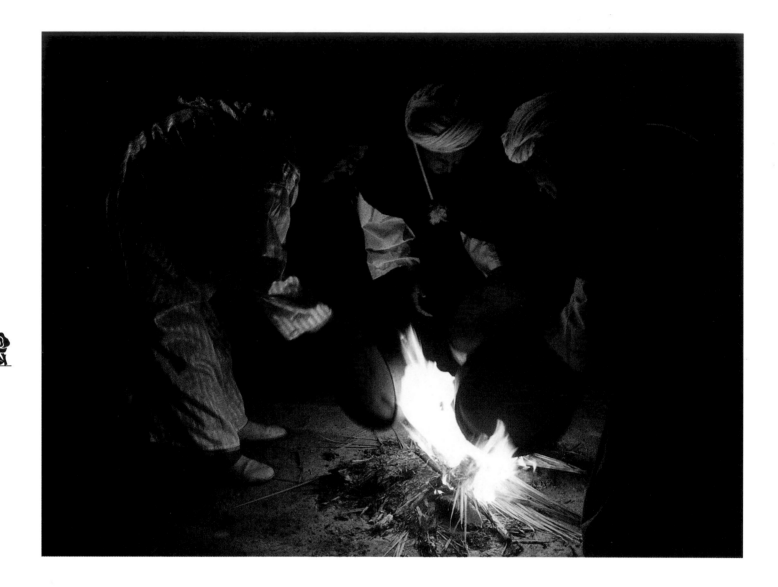

Before the celebration begins, the skin of the *bendirs* is heated over the flames.

At Tata, at the foot of the Anti-Atlas, and with the first dunes of the Sahara before them, the women play the *guerdra*, which is both the large, collectively-played drum standing on the floor, and a nomadic tribal dance. The poetry of the songs, the subtle movements of the hands, and the percussive rhythms of the *guerdra* in the night create an atmosphere of sensuality and sacred mystery.

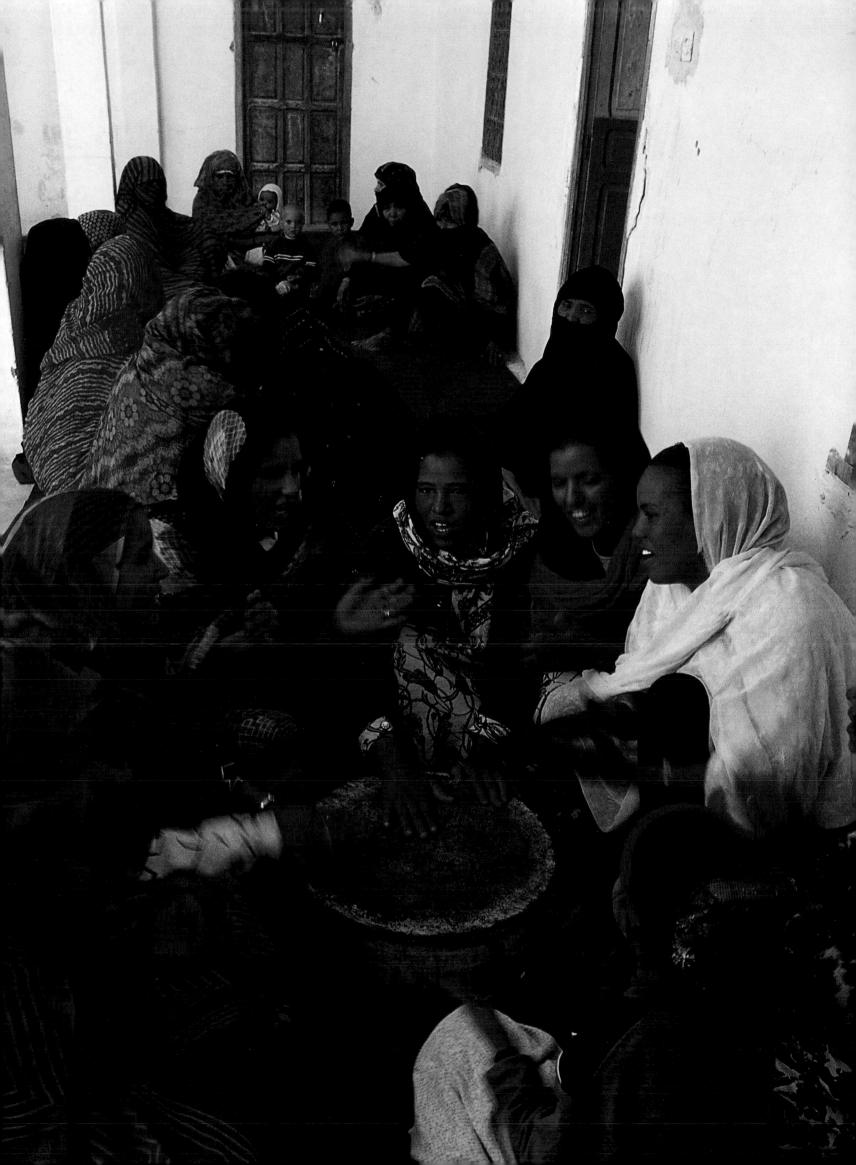

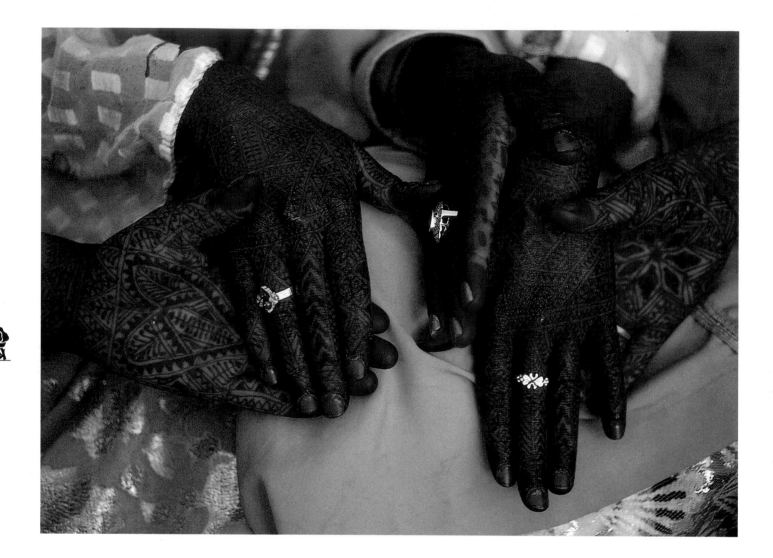

*H*ands displayed and ornamented with patterns made
from henna, adorned with jewels. Faces surmounted by
silver and coral crowns, accented by heavy collars made
from amber and decorative stones. Nothing is spared when
displaying the parts of a woman's body rarely offered to
the view of others.

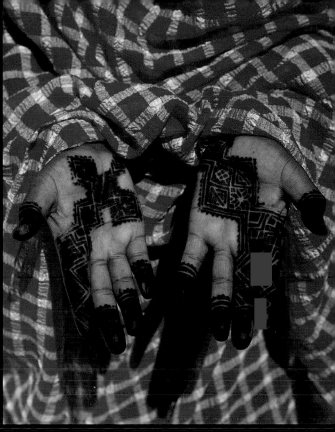
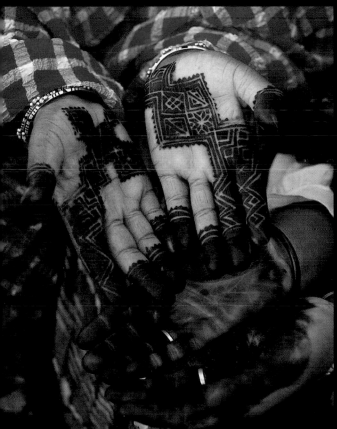
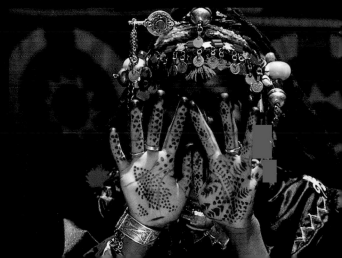

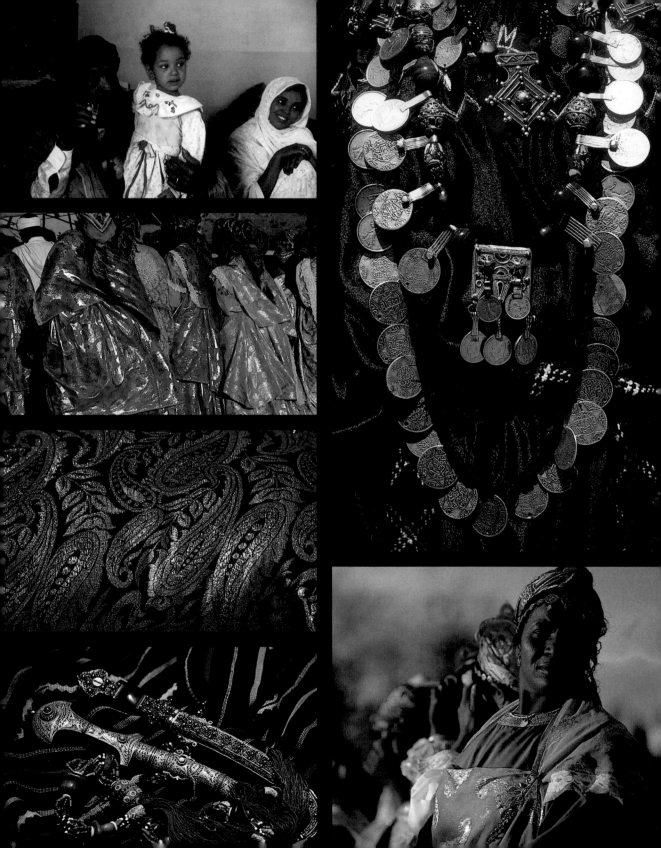

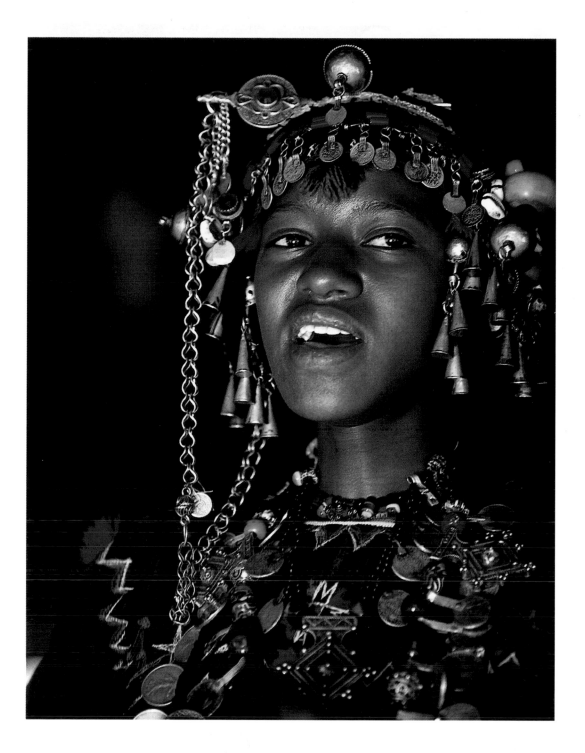

\mathcal{A}t Tissint, the women are beautiful. With their natural gift for displaying jewelry, the pounds of silver coins which hang from their necks affirm of the value of their treasures. The rare and aromatic plants which these desert regions supply in abundance complement their seductive appearance.

Page 144

\mathcal{T}he village of Adaï.

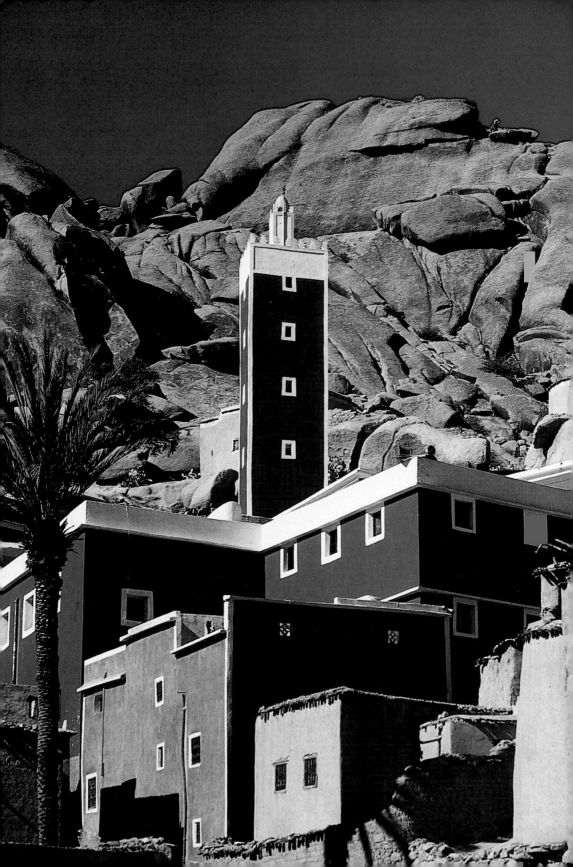

THE REGION OF TAFRAOUTE

The Anti-Atlas range is the barrier separating the desert expanses of the Sahara from the fertile plain of the Sous Valley and the gentle slopes of the Middle Atlas. Arriving by plane from the pre-Saharan African regions to the south, the panorama of Moroccan history is visible at a glance. One can almost hear the cries of camels, ridden by veiled desert warriors, sensing the presence of water when within view of the snowcapped peaks of the Atlas. In 1059, the Arab Emir Youssef ibn Tachfine, having converted the Sanhadja Berbers, who lived in what was then the kingdom of Ghana (today Mauritania), to a reformed interpretation of Islam, led an army across the desert and over the Atlas Mountains to propagate his stern vision of the Muslim faith. The group of tribes were called the Almoravids by the Spanish, from *al-murabitun*: men of the *ribat*, the fortress on the Atlantic coast where their spiritual movement had originated. Tachfine's *jihad* marked the start of the integration of Arab Saharan civilisation with Berber society. In the course of the following centuries, mixed tribes of Arabised Berbers spread their culture from the Tifilalet Oasis on the east to the Sous Plain on the west. In the process, the oases of the region were transformed into towns: Tata, Tiznit, Taroudannt, Tafraoute — the names of many of these oasis towns begin with the letter T, as does the local Berber language, Tachelhait.

For the Sanhadja tribe, and for the Lemtouna, blue robed mounted warriors who accompanied them across the desert, Taroudannt was an oasis stop along their conquest route. At the end of the 16th century, the town became the gilded capital of the Saadian dynasty, ruled by the Chérif Ahmed al-Mansour ed-Dahbi. His increasing wealth from the gold trade of the caravan routes, augmented by ransoms paid for captured Portuguese, led him to abandon Taroudannt after twenty years, to create an even more sumptuous capital in Marrakech, at the start of the 17th century. Taroudannt today is a stopping place on the Agadir to Marrakech highway. On the Place Assarag, buses and tour coaches are continually present, with passengers arriving and departing all day long.

Tafraoute, in the Ammeln valley, is located in the centre of a natural amphitheatre of rose-coloured granite. The angular houses, built on terraces, are brightly painted and trimmed with white, their assertive colours standing out against the background of rounded rocks. In February, the town is surrounded by a pink and white corona of almond trees in bloom. In the early morning, the air of Tafraoute is so soft and pure that it projects an iridescent reflection, like crystal droplets, on the wall of rocks surrounding the town.

Silhouettes of draped women stand out against Tiznit's red ochre walls. Under their caps, embroidered in solar colours, heavy jewels of hammered silver are suspended, set off with coral and enamel: a legacy from Jewish silversmiths whose arrival in the region dates from the Diaspora. Located at the entrance to the desert, with the romantic background of its palm trees, the walled town of Tiznit has a sense of elegant charm. Agadir, the biggest Berber city, was tragically destroyed in an earthquake in 1960. It seems still to be struck with amnesia. The centre of its life is the crowd of tourists on the white sandy beach, who have come in search of the sun. Many people from the surrounding countryside have migrated to Agadir who, like its merchants, arrive in the often illusory hope of a more modern life and the money they think it will bring. The Tafraoute region is famous above all for its performing artists: the green and red clad acrobats of the Brotherhood of Sidi Ahmad u-Musa, and its dancers with blue veils, whose movements progressively accelerate to the rhythm of the *guedra*.

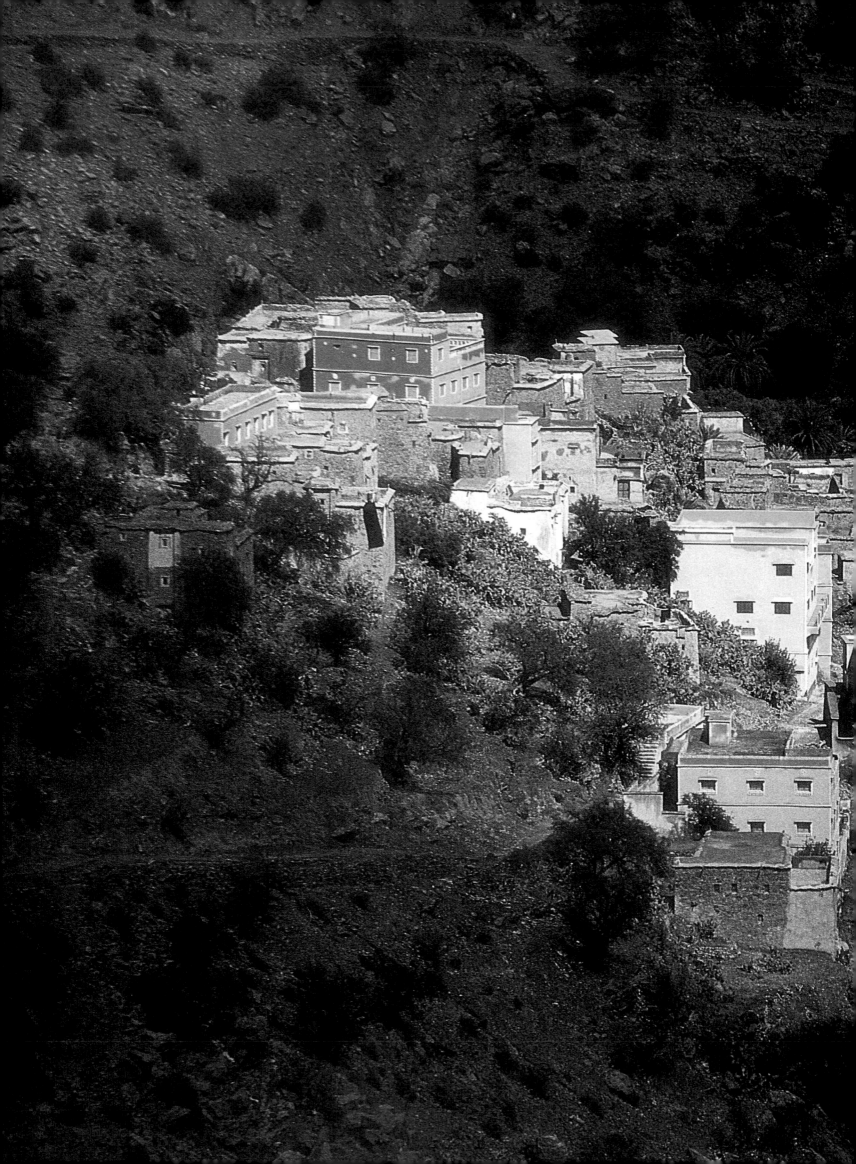

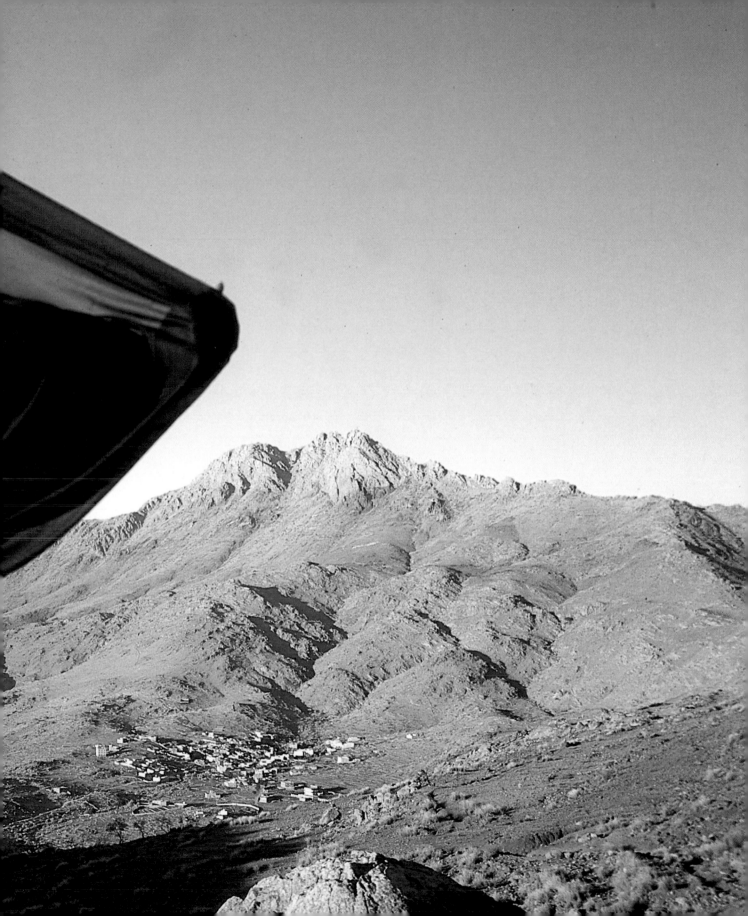

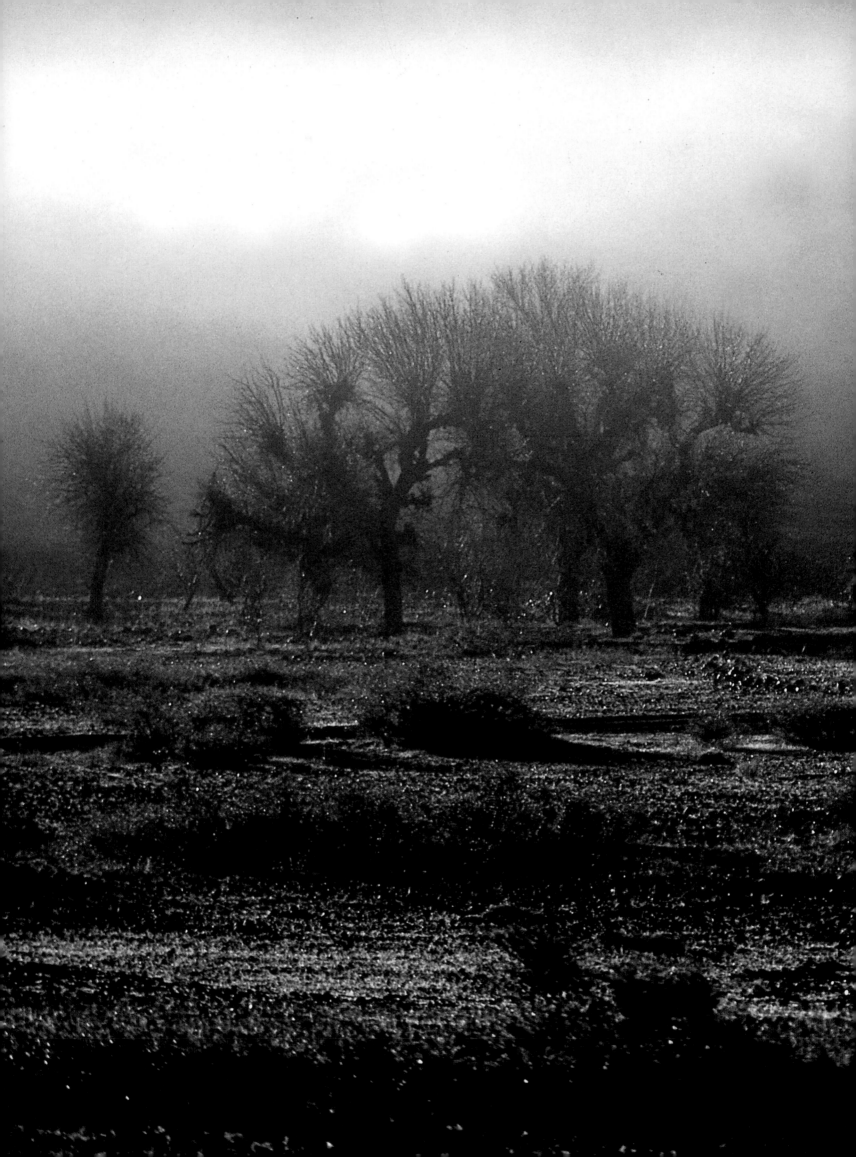

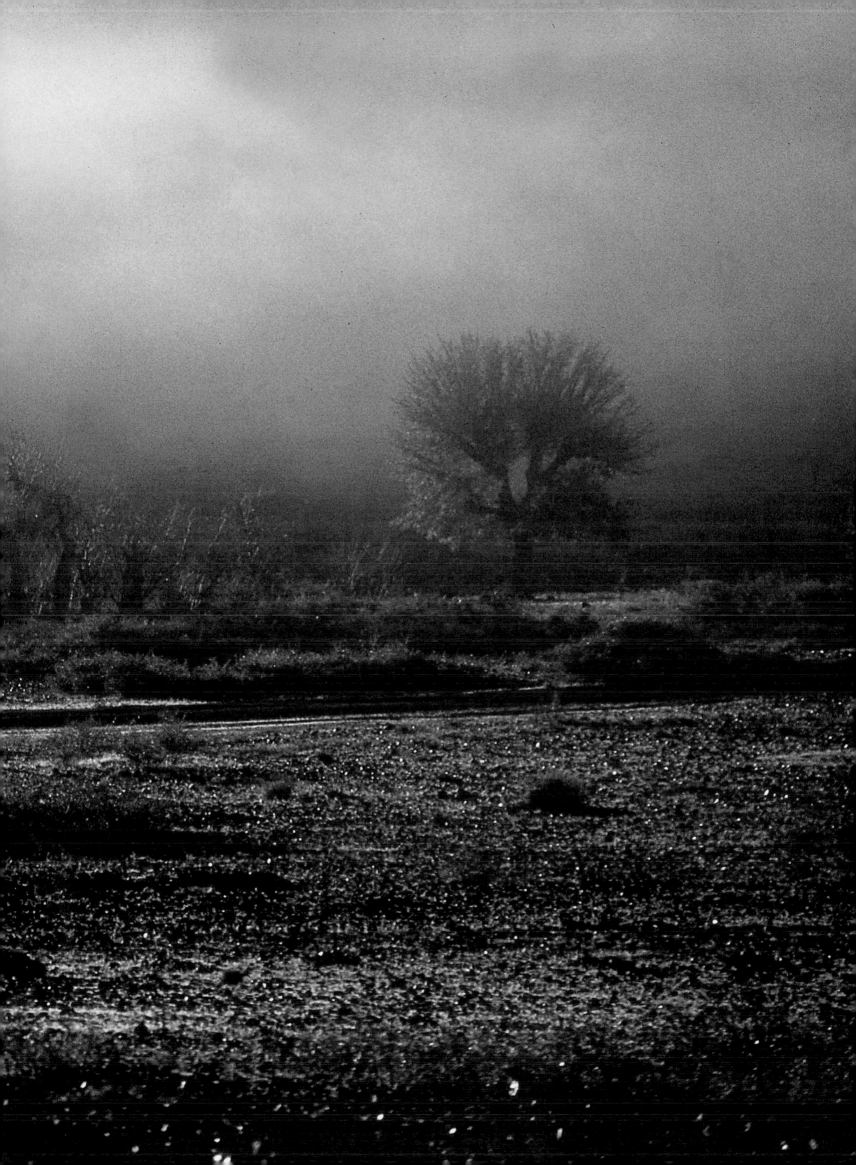

Pages 146-147

𝒯afraoute is a region of colourful villages, with architecture reminiscent of Yemen.

Pages 148-149

𝒜 woman of the village of Igherd cools off in the wind blowing across from Mount Adrar M'Quom.

On the right :

𝒯he boys of the Anti-Atlas and of the Sous plains, with their *djellabas* and white caps, are easily recognisable. Their education is based on discipline and moral principles. Their integration into the male community is through the circumcision rite of *thara*, a word also meaning purification. After the ceremony, amid great pomp, they enter the village on horseback, escorted by a procession of musicians.

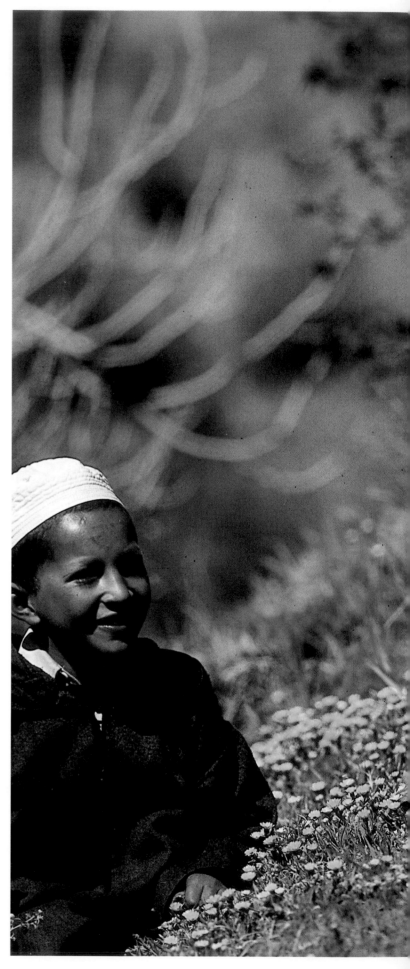

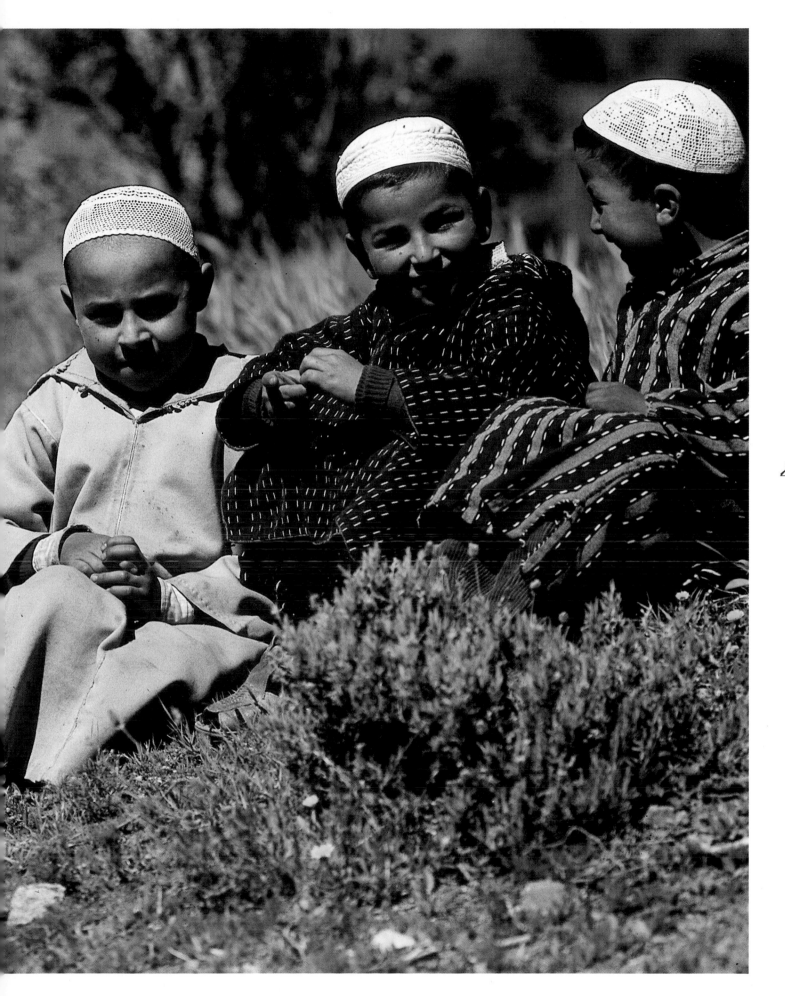

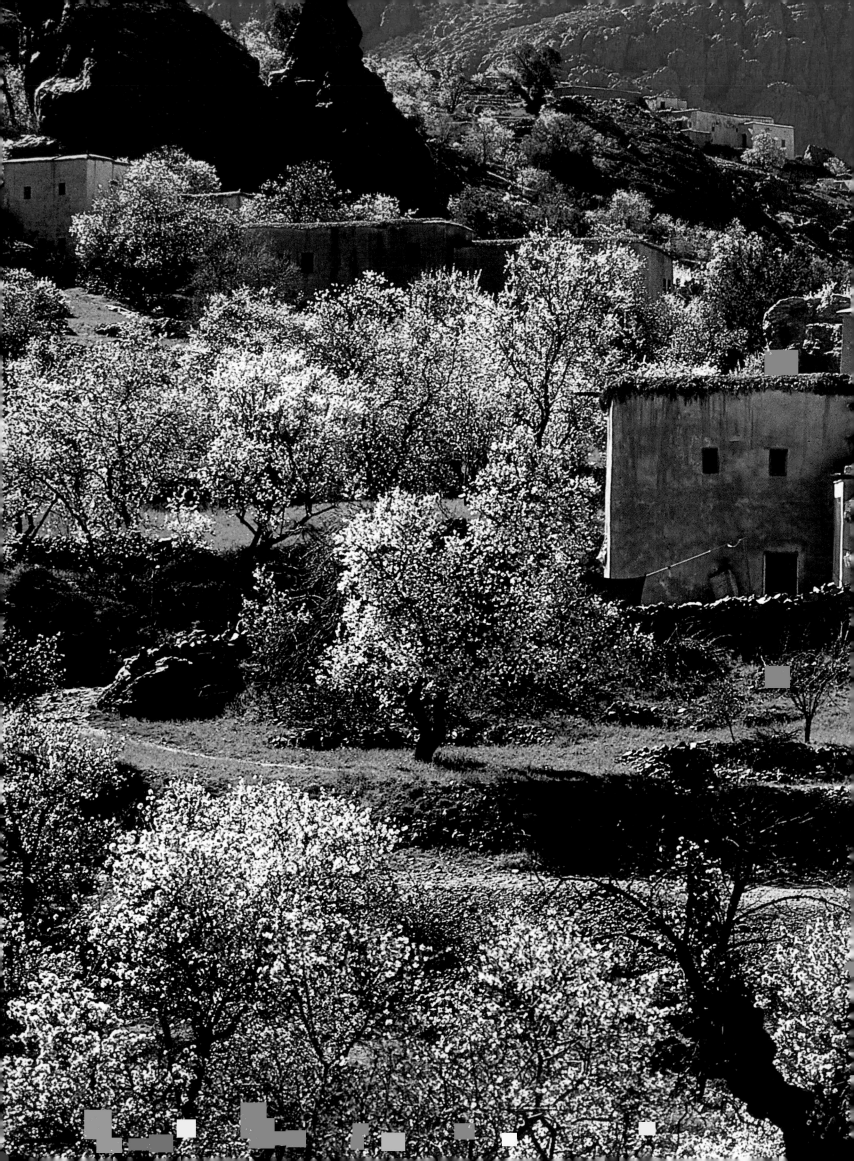

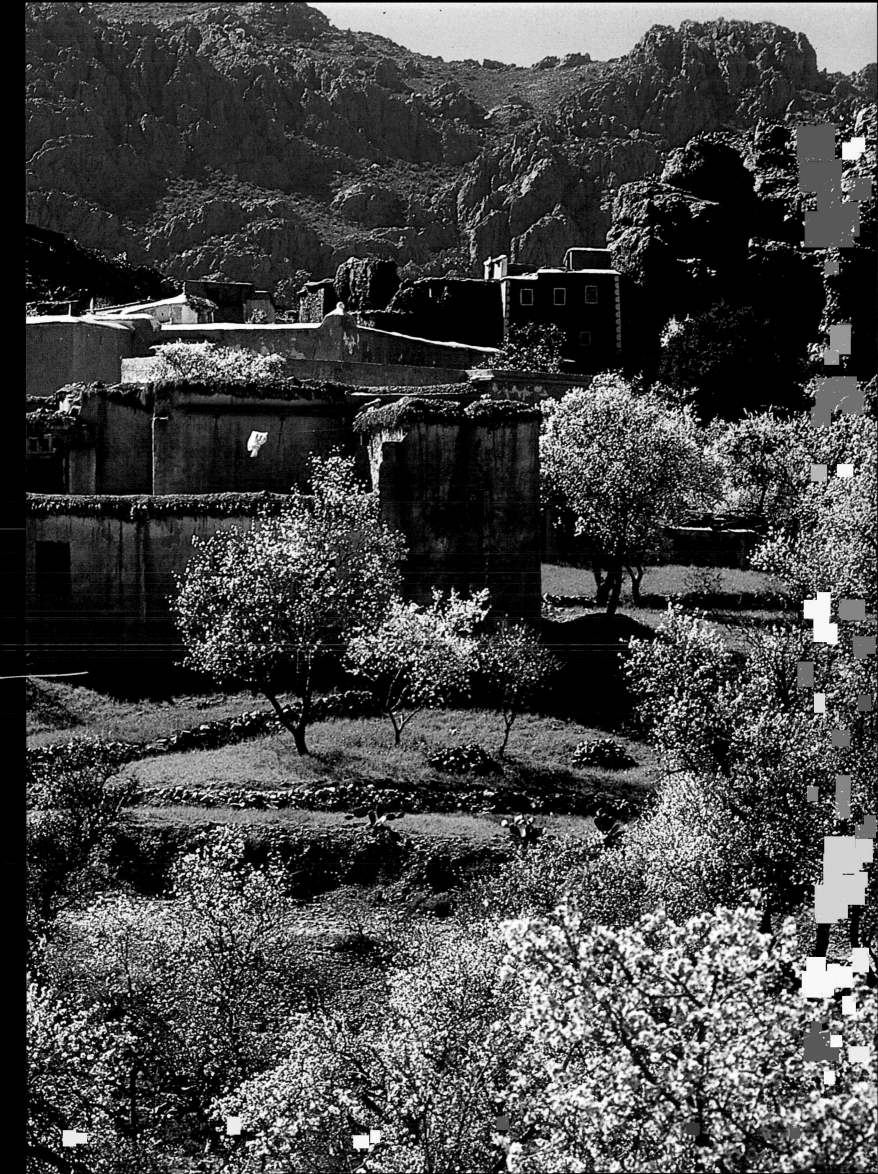

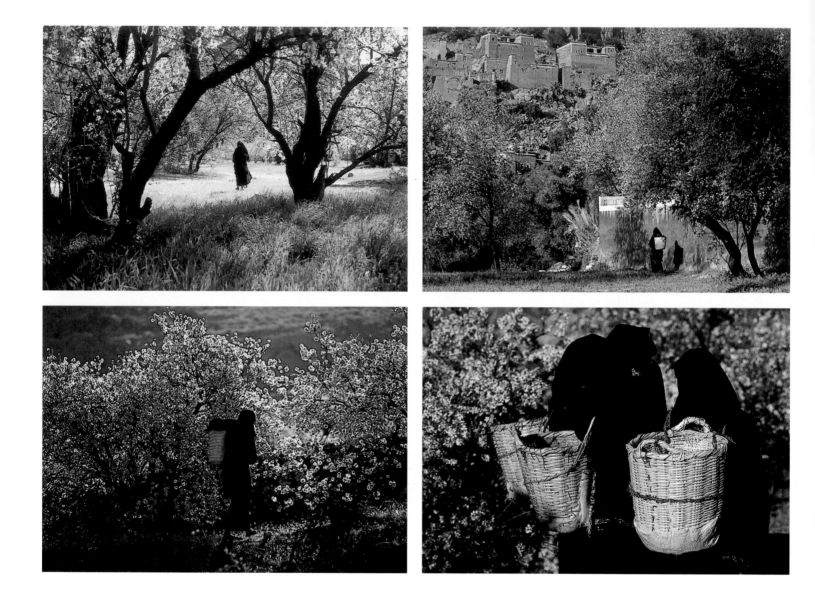

*I*n favourable years, from February to March, the
Ammeln Valley around Tafroute radiates with thousands
of almond trees in bloom. The moussem, or Festival of the
Almond Trees is celebrated in February by a grateful
population, which joins in the folkloric festivities, original
and rich in emotion.

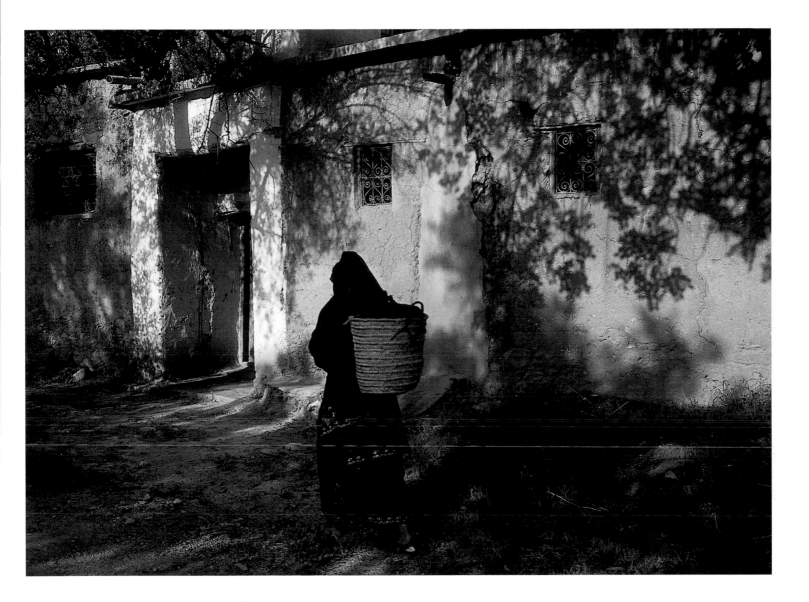

The shy women of Tafraoute seem to hide behind their black garments of wool cloth, bordered with lively colours. They only reveal one eye, underlined with khôl, furtively re-hidden as soon as it meets the eye of a man. Could the costumes of these women, observed against the predominant pink and white of the walls of the houses, have inspired the artistic sensitivities of the masons who created these villages?

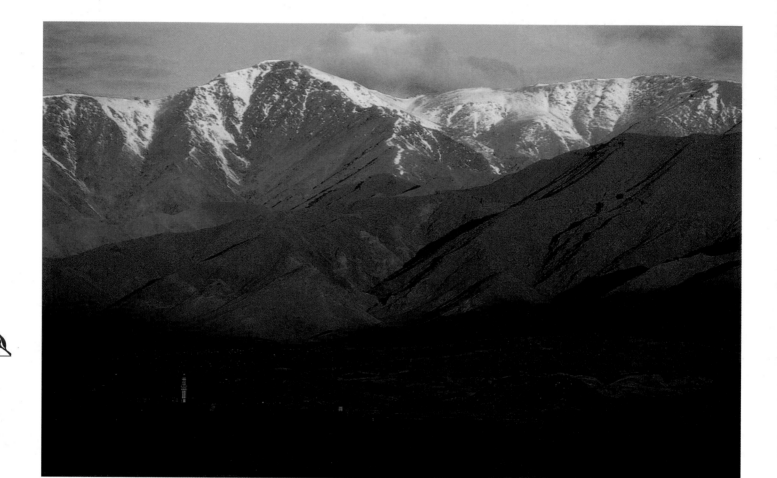

𝒯he fiery colours of evening arrive late on the white
summits of the Atlas, setting aglow the last moments of
daylight. They penetrate the smallest cracks of the
rampart walls, and cling to the draped costumes of the
women of Taroudant or Tiznit.

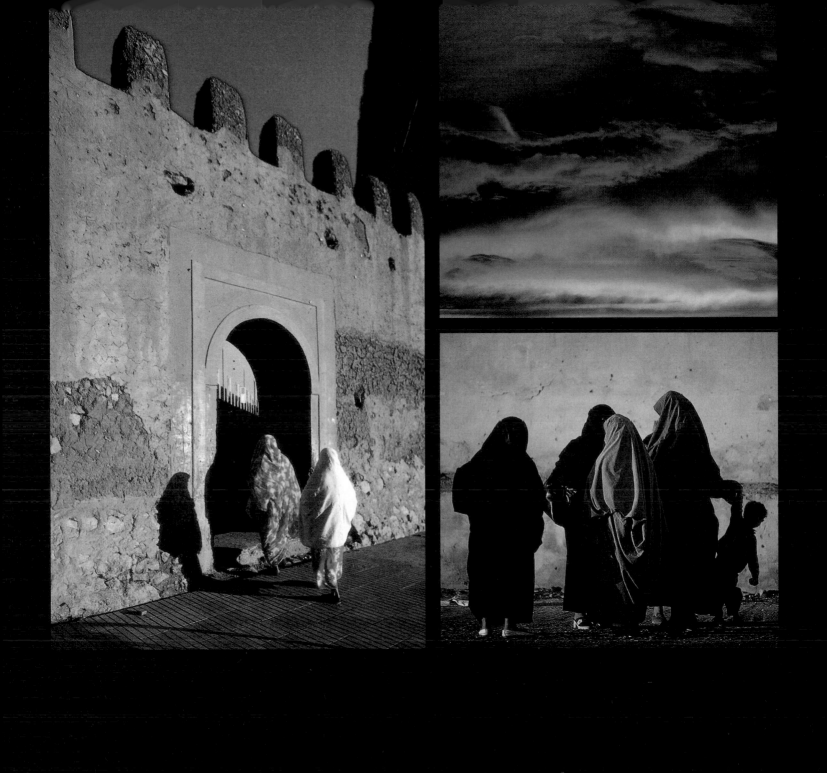

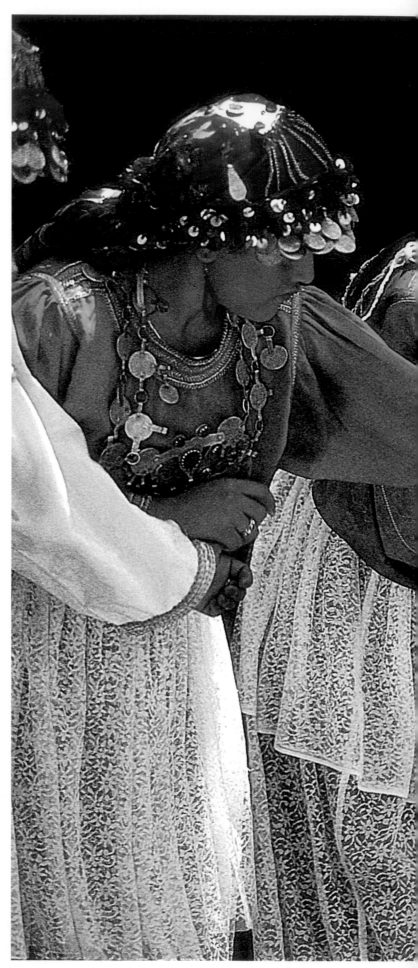

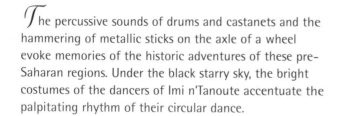

The percussive sounds of drums and castanets and the hammering of metallic sticks on the axle of a wheel evoke memories of the historic adventures of these pre-Saharan regions. Under the black starry sky, the bright costumes of the dancers of Imi n'Tanoute accentuate the palpitating rhythm of their circular dance.

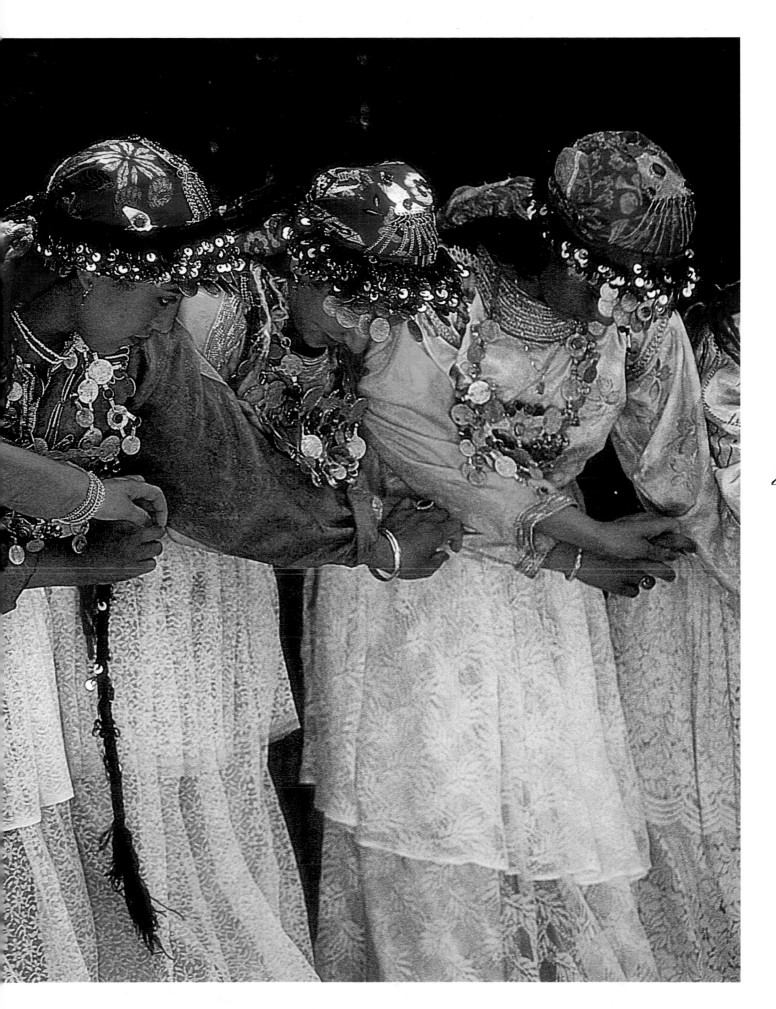

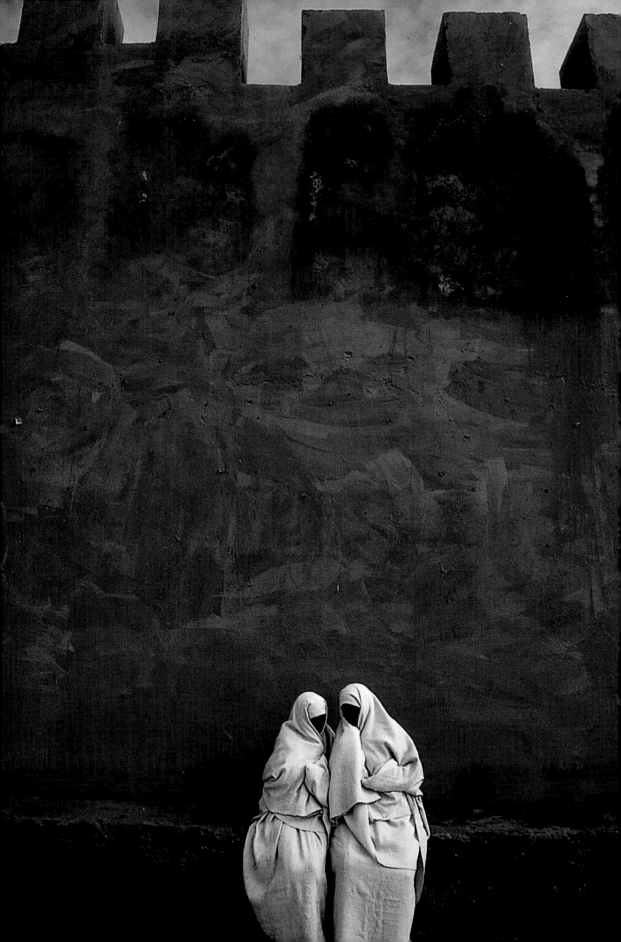

ESSAOUIRA

The word "Essaouira" means "image". Taken from any perspective, Essaouira is a perfect photograph. Behind its purple ramparts, inside the white *medina* with its blue doors, brown-skinned silhouettes draped in white linen huddle against a biting wind. Such images, and other scenes of Essaouira, are reminiscent of compositions by a naive painter.

Various civilisations and cultures have influenced Essaouira over its history: Carthaginian, Berber, Portuguese, English, Hebrew or Bambara, some of them are still present. Here in the region of the Haha Berbers, some past traces survive, in stone graffiti on the ramparts of the Sqala fortress, on the front walls of houses, and in the spoken dialect, dominated by the accent of the Jews, who once formed the majority of the population, and in the primitive, trance-inducing rhythms of the Gnaoua.

In the second century AD, Juba II, a Romanised Berber king, built a dye works to make the dye used by the Romans for their imperial purple cloth, extracted from the Purpurair Islands, in the centre of the bay. In the 16th century, to protect the main commercial road from the fury of the ocean, the Portuguese built fortifications. After their departure in 1760, the Sultan Sidi Mohammed ibn Abdallah had the words *"Barakat Mohammed"* engraved: "guarantor of the Moslem faith". Essaouira was then known as Mogador to European traders, and the Sultan commissioned a French architect to redesign it in a rectangular grid, in what was then considered the most modern European style. In the 17th and 18th centuries the slave trade provided an important part of Essaouira's wealth. But it was the activity of Jewish merchants which transformed Essaouira into what became Morocco's most prosperous city and a hub for their diplomatic and commercial missions in Europe. Strategically located on the itineraries of caravans converging from the south and east, Essaouira was known as the "port" of Timbuktu. After Casablanca took over the commercial leadership of Morocco in 1912, Essaouira sank into decline. It became a centre for American hippies in the 1970s.

Spirits and genies have guarded over Essaouira ever since the black Brotherhood of Gnaoua began living here. Their ancestors, African slaves brought across the Sahara by Arab traders, built the town where their descendants remain to this day, holding ceremonies to placate the spirits which inhabit a person or a place. Often called on to play a medical role in the treatment of mental disturbances, they are musicians, seers of the invisible, and healers of wounded memories and souls in exile. The night—*lila*—signifies both the hour and the name of their ritual, which is conducted by the *maalem* (master), inside the *zaouïa* (sanctuary). After the sacrificial phase of the ceremony, and evocations of the past to the sound of the *guenga*, a large drum, and the *garagab*, metallic castanets, the time for convening the protective genies arrives. To the call of the *guembri*, a three-stringed bass guitar, accompanied by incense vapours, and in the presence of colours attributed to each genie, the patient, in a complete state of trance, is able to restore the lost unity of his being.

The fishing port and the fishermen of Essaouira are active night and day. Tourists and residents come to dine on delicious fresh fish and shellfish served at outdoor grills, set alongside the port. From the nearby *medina* can be heard the lively activity of the merchants' shops installed in small alcoves in the little right angled streets, selling grain, olives and poultry.

The creative nature of Essaouira is best revealed in the *ateliers* of its artisans, situated in niches under the Sqala fortress. This setting seems to transform the city's craftsmen into artists, its street orators into poets, and its musicians into soul healers.

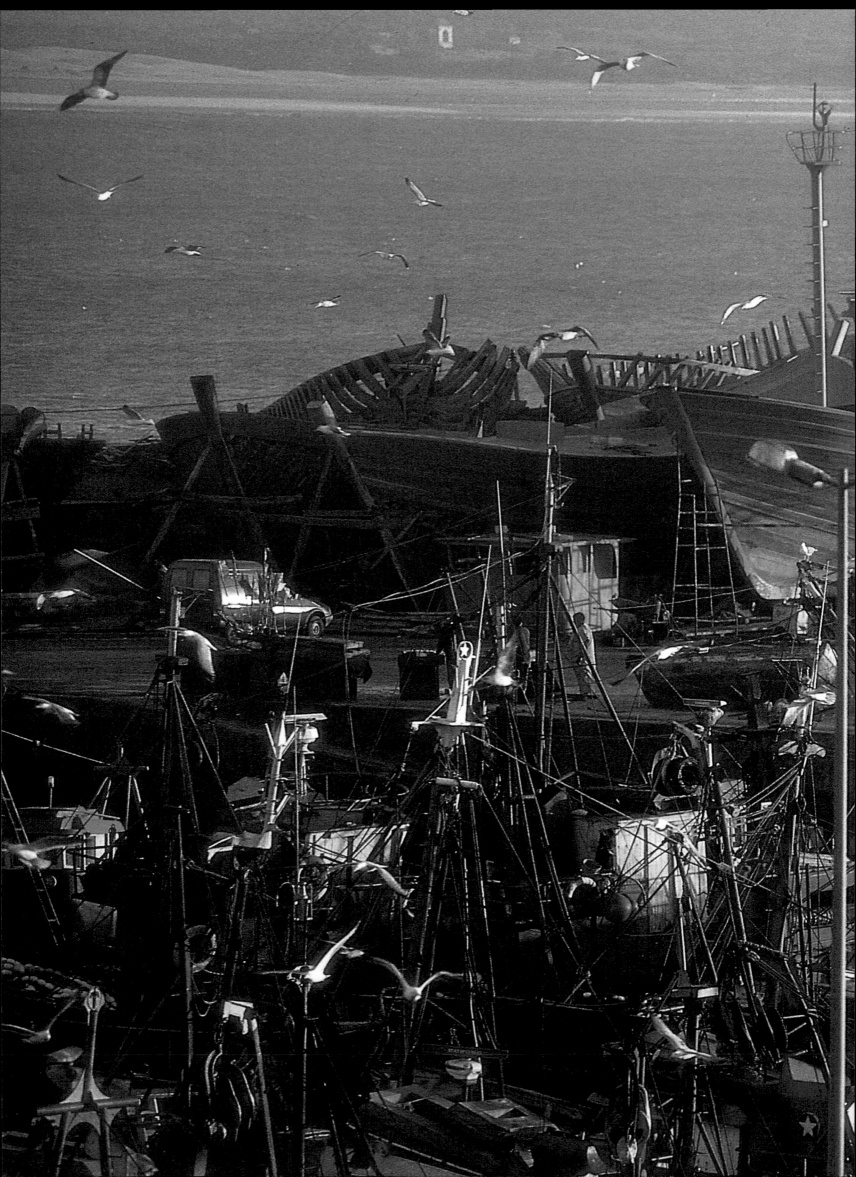

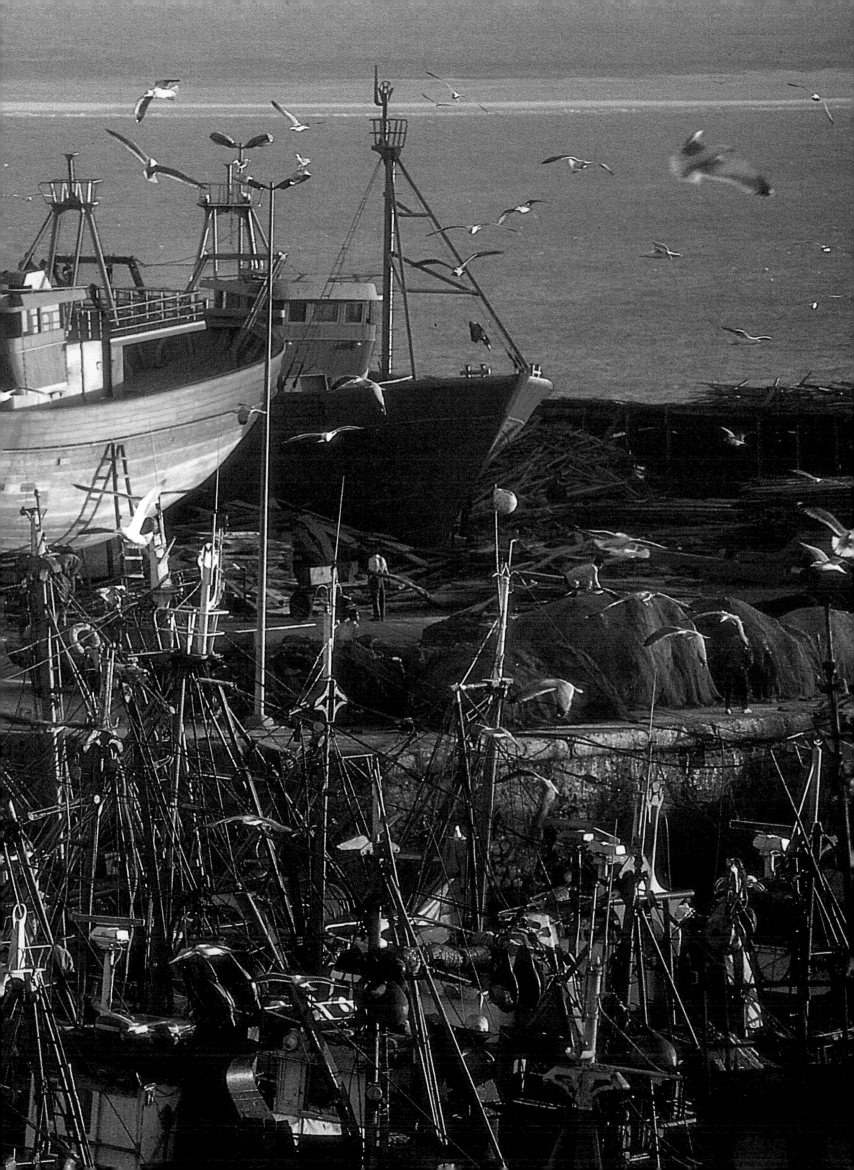

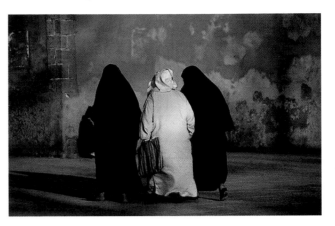

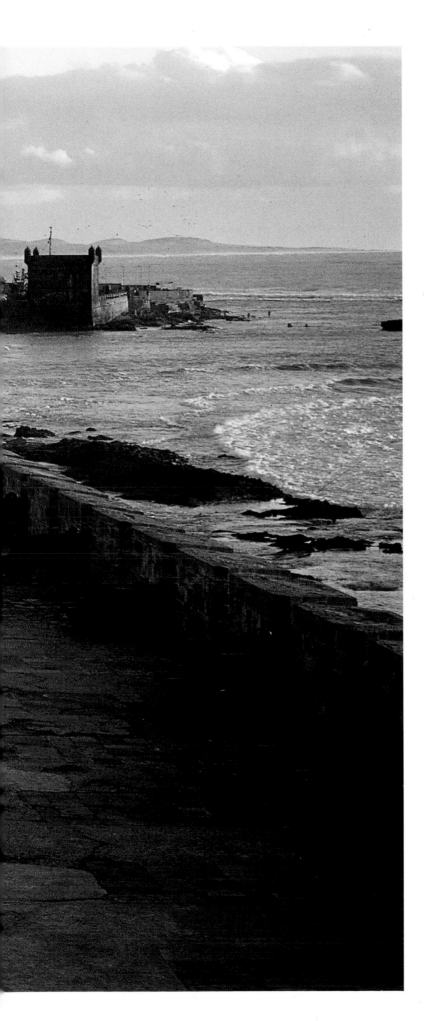

Pages 164-165

*T*he fishing port of Essaouira.

*T*he ramparts of Essaouira, which is known as "the well-built city". The Sqala is an old fort, a raised platform over 200 yards long, protected by a chiselled wall defying the ocean. Bronze cannons, cast in Spain at the time of Philip II (1595), Philip III (1614), and in the eighteenth century, seem to be on the lookout for an approaching enemy. It was here that Orson Welles filmed *Othello* in 1951. In the distance, in the part of the Sqala near the fishing port, in blockhouses below the ramparts, craftsmen, among the most renowned of Essaouira, create marquetry and sculpted wood from roots and trunks of the mahogany-like *thuya* tree.

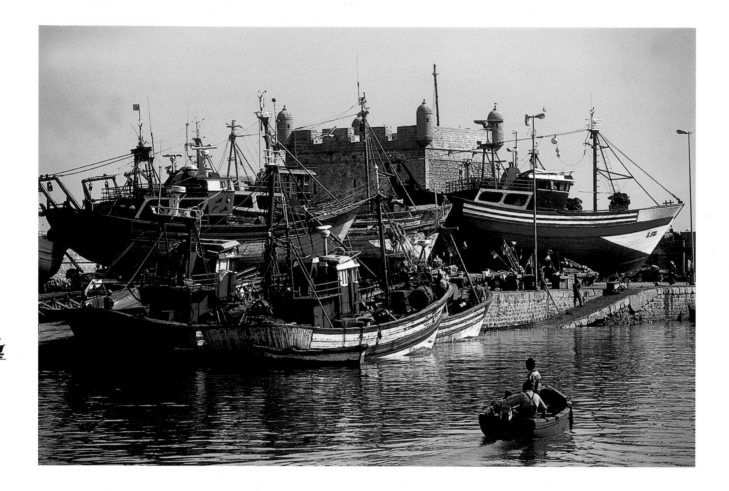

*E*ssaouira is a well-known shipyard, where the hulls of trawlers from Agadir are repaired. From the height of the Sqala is a view of the ocean and the ramparts of the white *medina* with its blue doors.

*T*here are still women in Essaouira who take the time to wrap themselves in linen or wool *haïks*, a traditional practice which ended long ago for most Moroccan women with the introduction of the one-piece *djellaba*, with its sewn-in head cover.

Pages 170-171

*T*he falconers of El-Jadida travel all over Morocco, associated with all festivals.

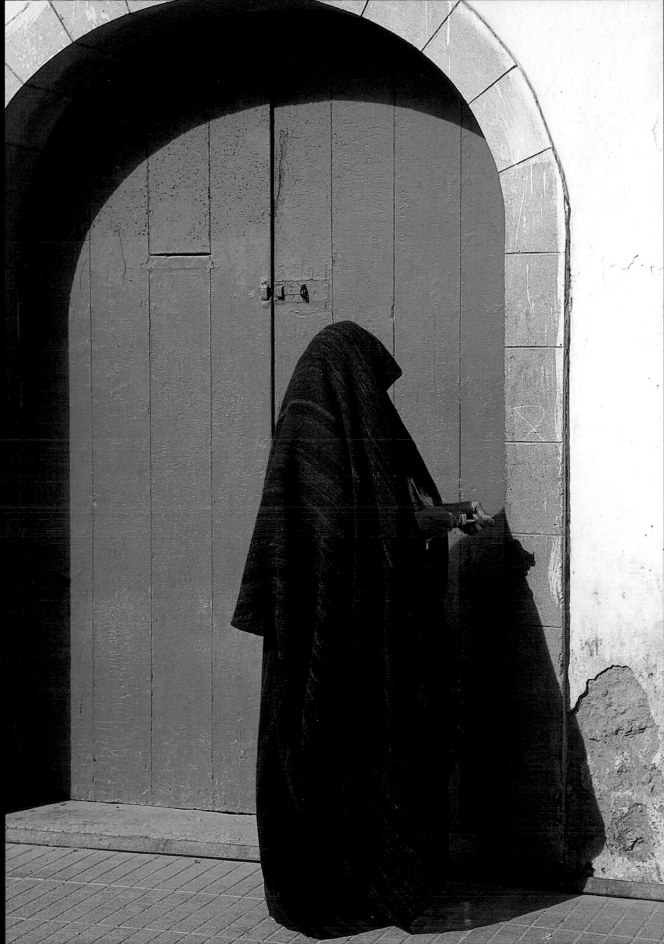

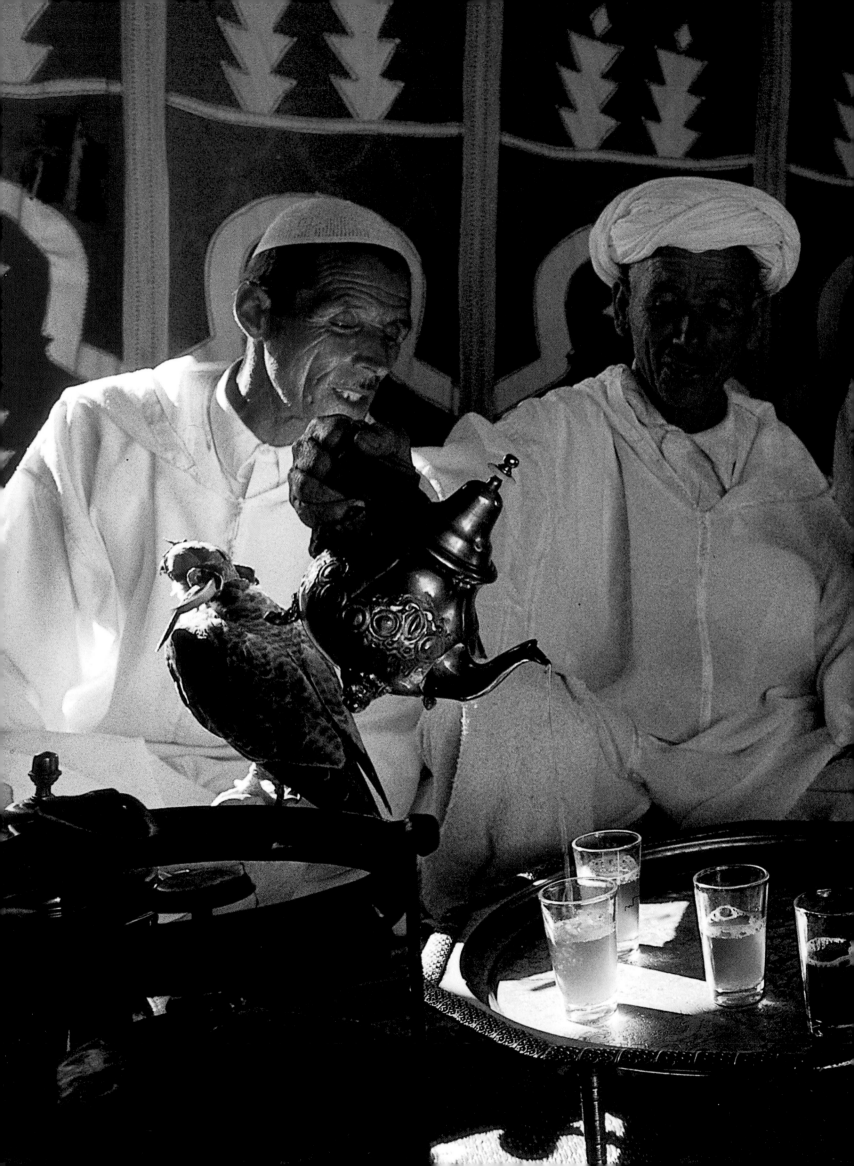

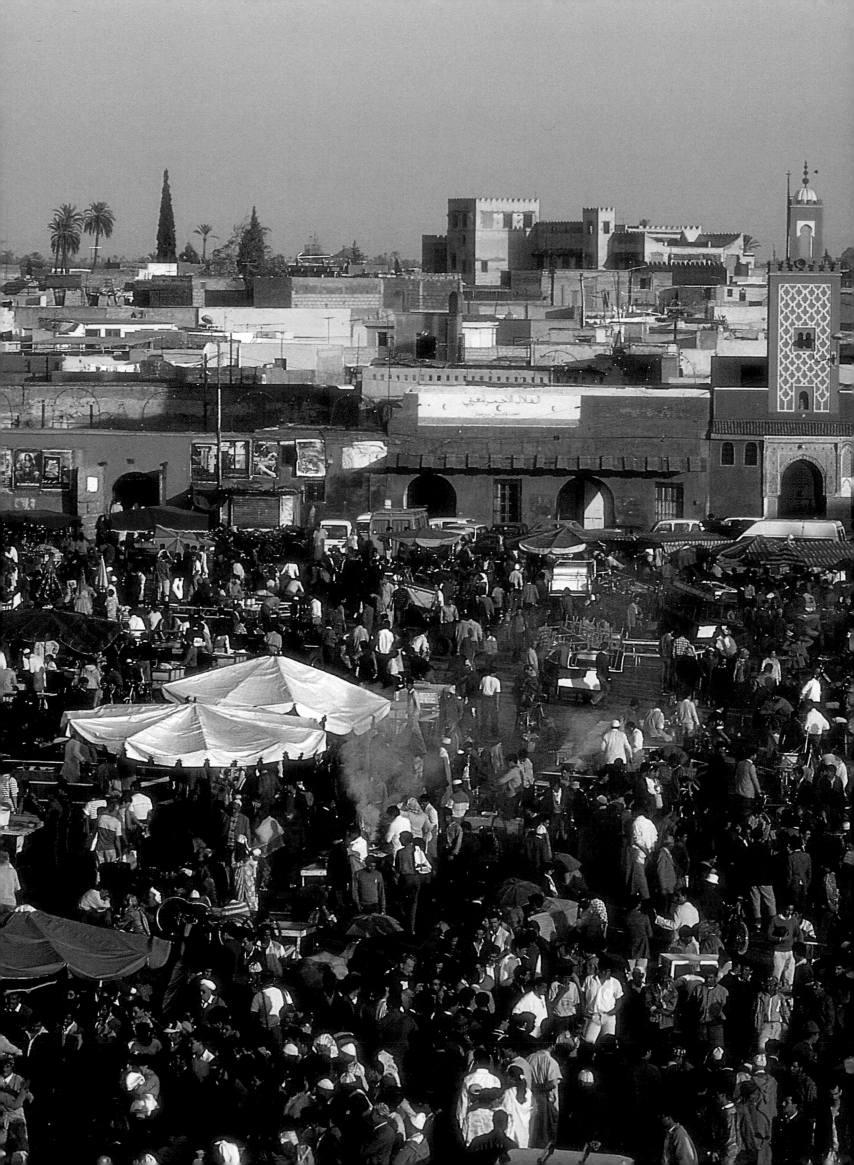

MARRAKECH

You do not talk about Marrakech. You live it. From the very first moment you see the immense oasis of palm trees, crowned by the grandiose wall of the Atlas mountains in the background, your passions are roused by Marrakech, the red city, its profile indented against the pure blue of the sky. The arriving traveller is assailed by hordes of would-be guides. You just need to choose one to open the gates to a city whose fascination is endless. Marrakech, whose very name is at the root of the word 'Morocco', originated when desert nomads, thirsting for green oases, were attracted by the chilliness of the nearby snowcapped Atlas. The first stone was laid in 1067. "Marrakech is a rose," says an old adage. If it were a flower, Marrakech would be purple, with an intoxicating perfume, and would draw its strength from the *khetteras*, subterranean veins of rock where an irrigation network invented by Arab-Andalusian engineers over a thousand years ago still functions. In the central market place of the *Guélz*, the new city, merchants try to sell you bundles of roses, whose colours are seen in the streets of the city.

Black Africa is nearby, and so is Haouz, the region of the Atlas to which Arabs from the Orient travelled long ago, which also was settled by Islamic and Jewish Berbers. Andalusian Spain is not far away. People of all these ethnic influences can be seen in the streets of Marrakech, who, alongside many Europeans and Americans, make up a population united by love for this captivating city. Winston Churchill leads the list of illustrious people who have frequented the legendary Hotel Mamounia. The magnificent residences of the *Medina*, built in the Andalusian style, the palaces of the palm grove, and the houses built of earth, with their terraced roofs open to the sky: creative buildings revealing their owners' and architects' profound attachment to Marrakech. Less fortunate people show their love simply by the way

their faces light up whenever the name of the city is mentioned. Once you pass through the rampart gates between the modern city and the *medina*, from the world of today to that of yesterday, Marrakech stays with you for life.

The dominating Koutoubia mosque and its minaret also marks a frontier between the old and the new Marrakech. Far from ignoring each other, they are complementary universes, and communicate in an atmosphere of celebration when, in winter, the orange trees of the Avenue Mohammed-V are full with fruit. At mealtimes, Marrakech is bustling from one end to the other. Bicycles, motorcycles, carriages and ordinary pedestrians invade the streets and sidewalks on their way back to the shuttered coolness of their homes. A tasty *touijen* - [diminutive of *tajine: please see the following recipes section*] - simmering with vegetables in season and spices, exhales its perfumed aroma. After an indispensable glass of mint tea has concluded the meal, a siesta on a sofa or in the shade of an orange tree is required, because of the overwhelming heat, whitening everything outside. At night, another life begins for Marrakech. People out for the evening meet up at outdoor cafés to take in the cool breeze. Acrobats, musicians and dancers perform by the light of fires, and moonlight reveals the silhouettes of lovers. Under the starry sky of Marrakech, transient travellers waiting for their coach at dawn are among the attentive spectators of these artists of the night. The Marrakechis, who adore music and poetry, take great pleasure in watching the performers combine their talents with the accompanying music.

When spring arrives, the heart of Marrakech palpitates with celebrations, the most important of which is the National Festival of Popular Arts. The streets of the city and the imposing ruins of the el-Badi Palace welcome artists and performers from all over the

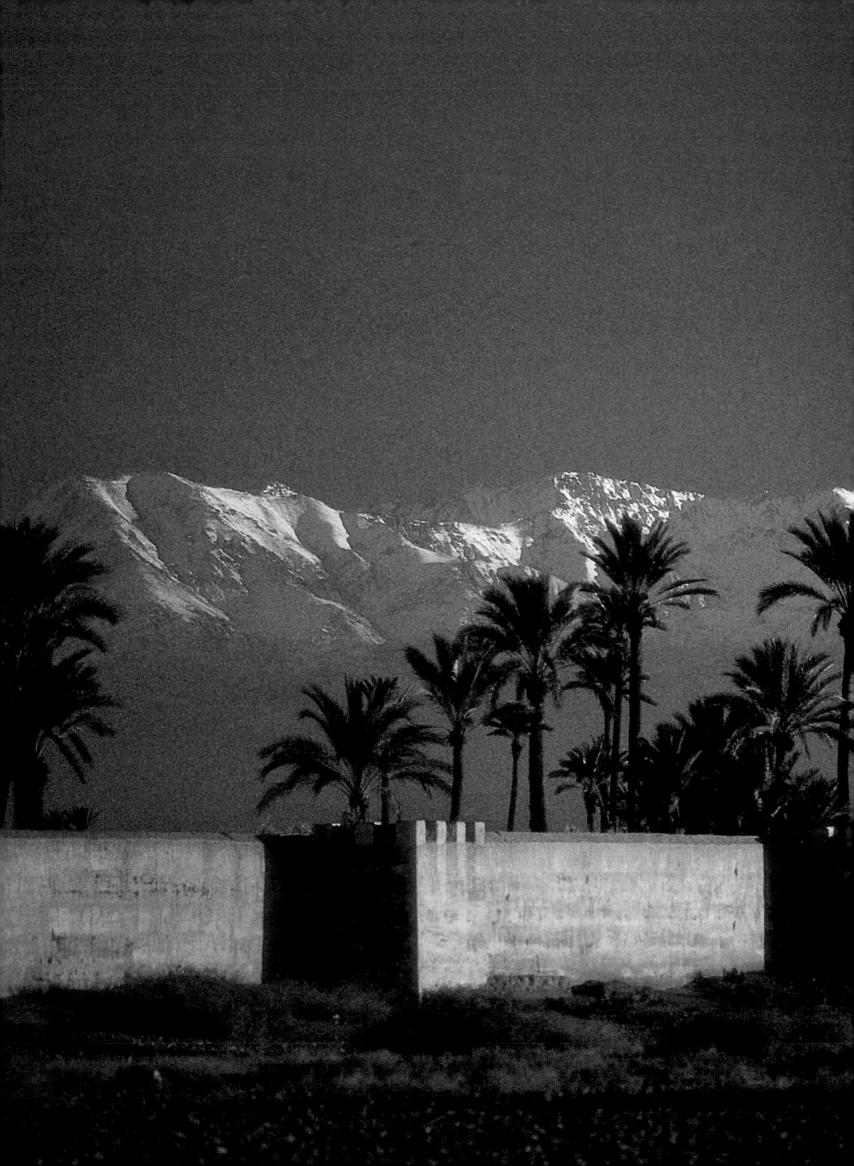

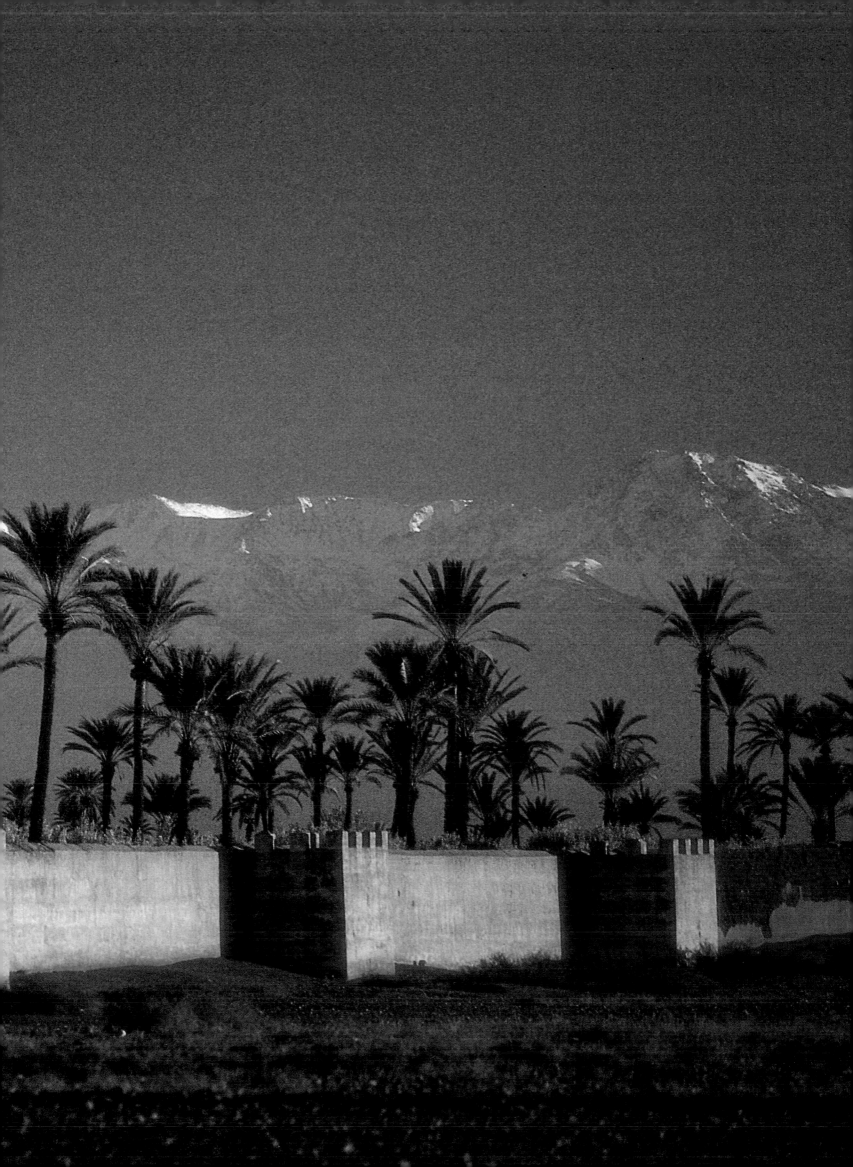

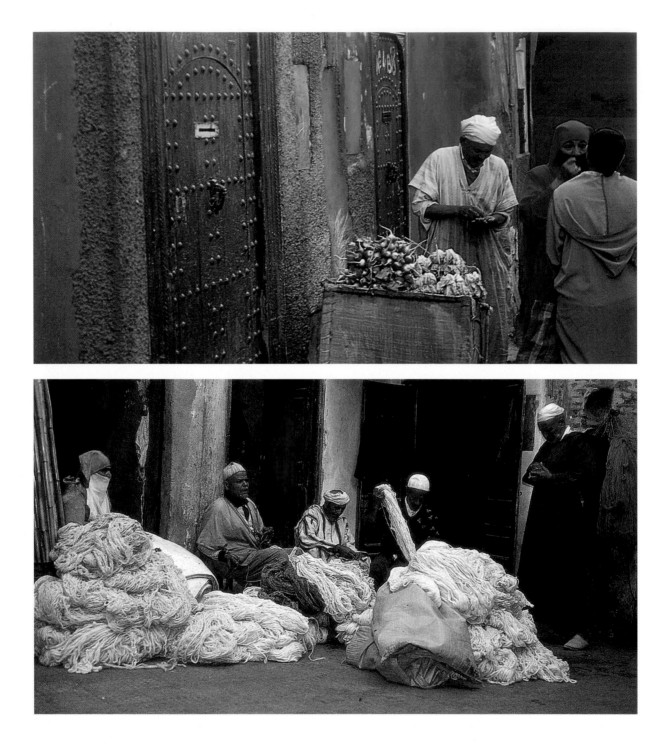

Pages 172 and 174-175

\mathcal{T}he Place Jemaa el-Fna

\mathcal{T}he ramparts of Marrakech (about 6 miles in length) against the background of the snowcapped Atlas Mountains.

\mathcal{W}hat a *souk*! What a bazaar! These exclamations, which, for better or worse have made their way into many of the world's languages, often give an impression of Marrakech which does not correspond to the extremely neat reality of its bazaars: the babouches, belts, wool, leather, fabrics and caftans are arranged so meticulously that you would hesitate to upset such a display!

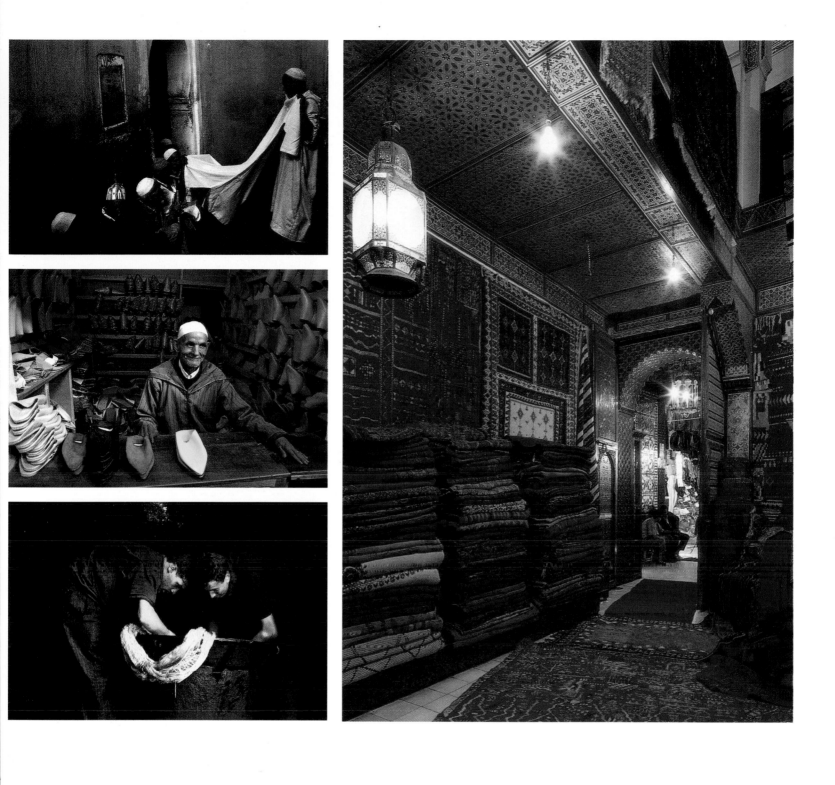

*I*n the Attarine Souk of Marrakech one can touch the velvety surface of a leather slipper, feel the delicacy of a fabric, smell the tart odour of dyed wool, or take part in a carpet auction.

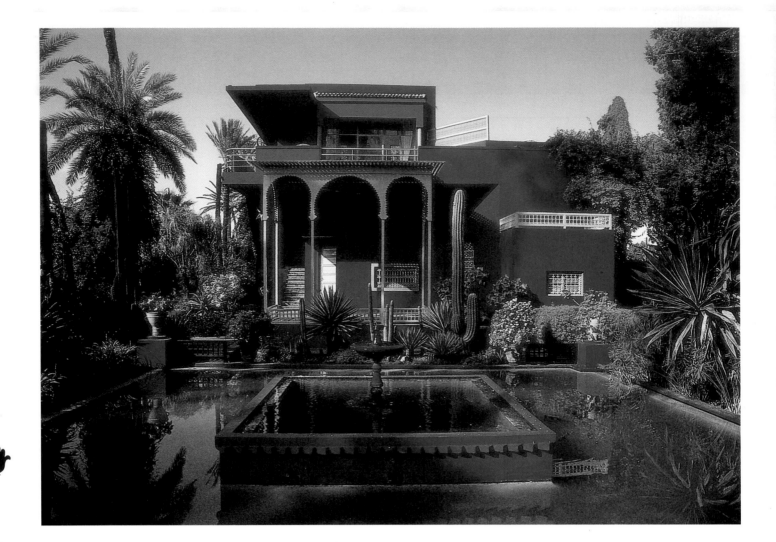

178

The painter Jacques Majorelle loved Morocco and Marrakech so much that he lived here up until his death in 1952. He composed his house as if it were a painting, transfigured by his genius for colour. Another person who fell in love with Marrakech, Yves Saint-Laurent, will open up Majorelle's garden to the occasional visitor.

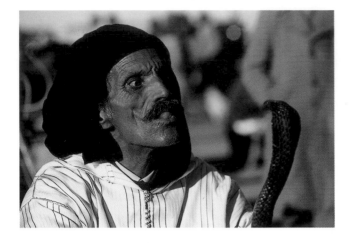

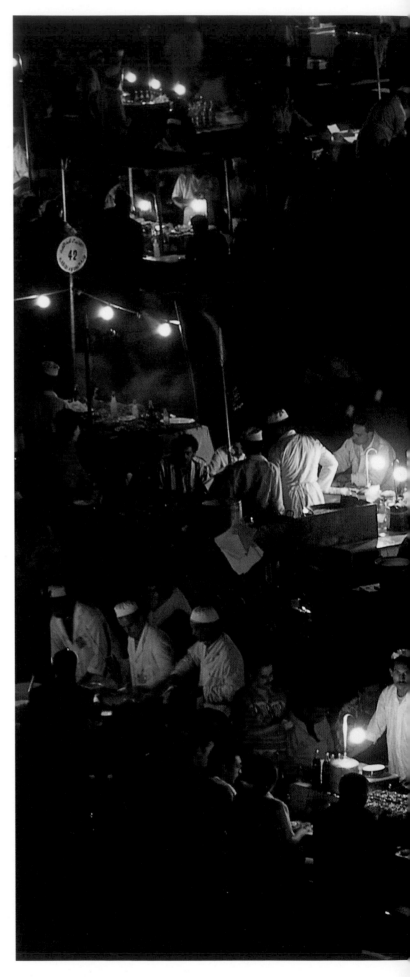

*S*ouini, the famous snake charmer, with one of his cobras.

*M*iraculous Marrakech, city of seven religious patrons, which knows how to join the day to the night, the desert to the mountain and the sand to the snow. The outdoor restaurant stands of the Place Jemaa el-Fna are set up around 5pm. People who stay out at night, indefatigable street performers and transient travellers will stay awake here until dawn.

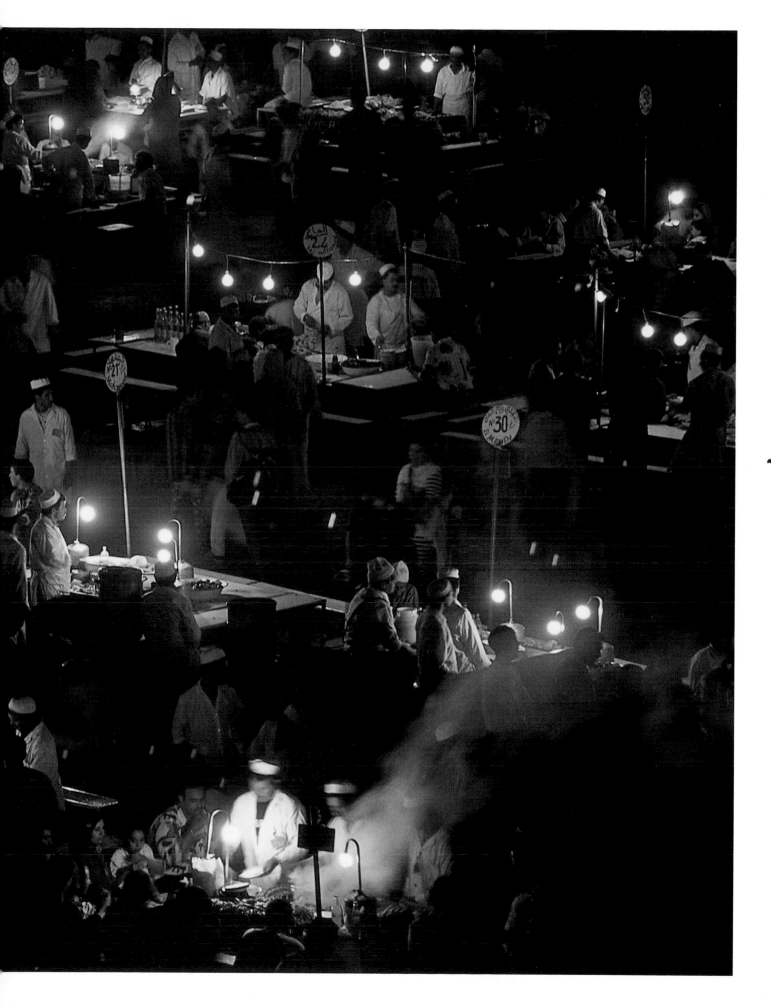

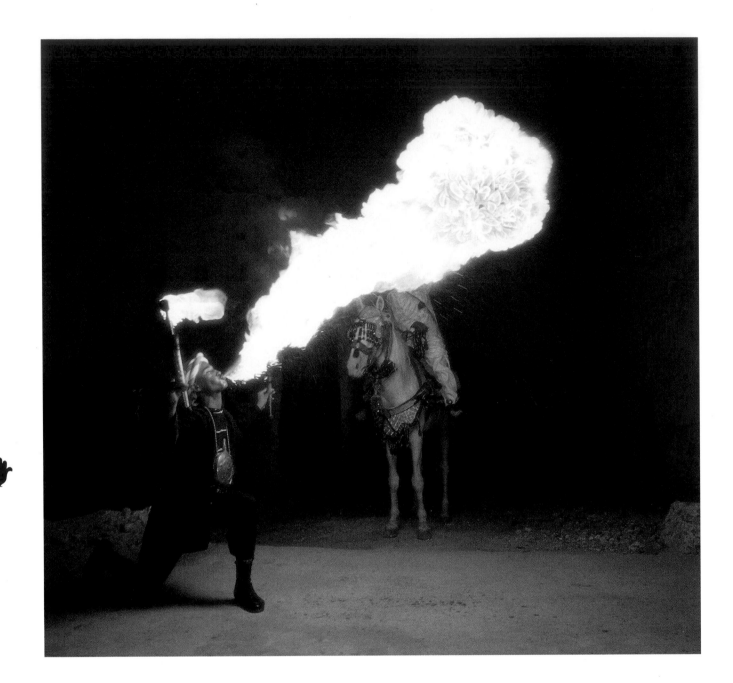

*F*ire eaters, troubadours, and *cheikhates*, women who have mastered the art of singing and dancing, form part of the spectacle in the ruins of the el-Badi Palace in Marrakech.

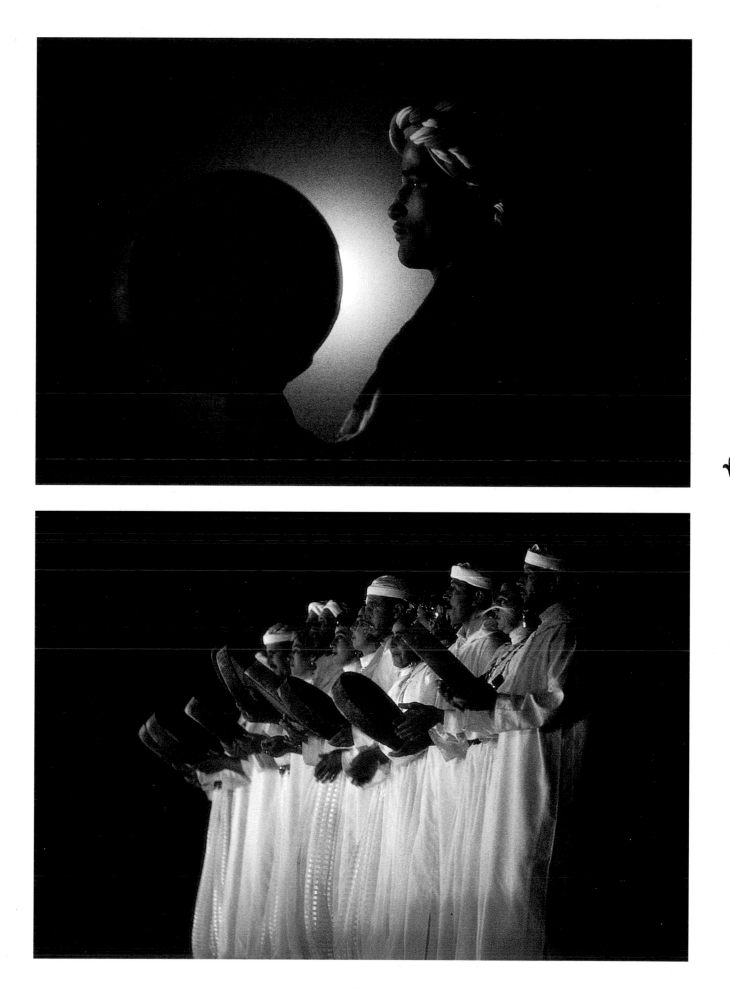

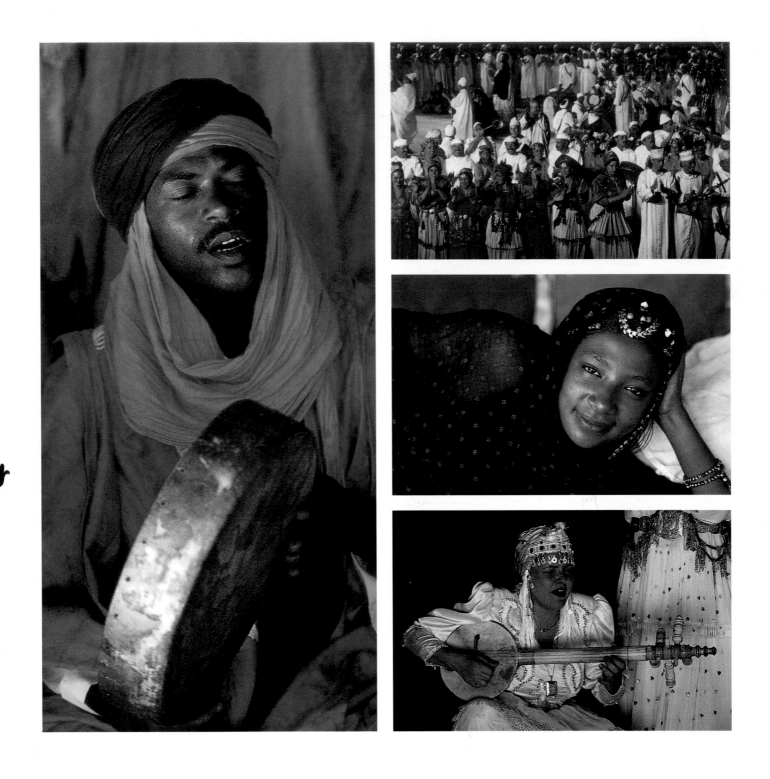

They have come to the el-Badi Palace for the Popular Arts Festival: players of the *bendir*, and the *guembri soussi*, a small, three-stringed mandolin. Some are from Khenifra and Agadir, others from Tissint and Taza, Imi n'Tanoute and Goulimine. When the lights of the el-Badi Palace are extinguished after the show, their own private celebration, in which they perform for each other, will begin.

Pages 186-187

Between shows, the girls of the Ourzazate dance company relax in the *caïdal* tent.

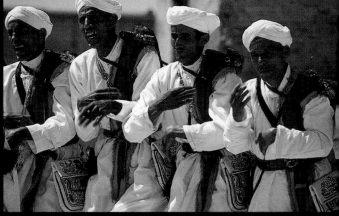
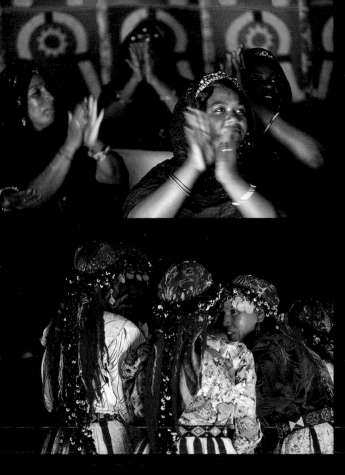
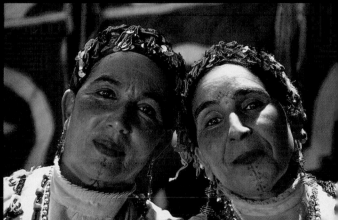
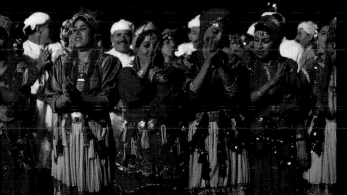
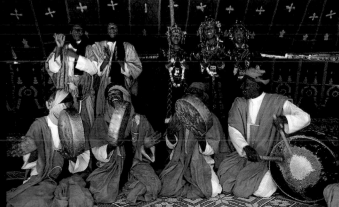

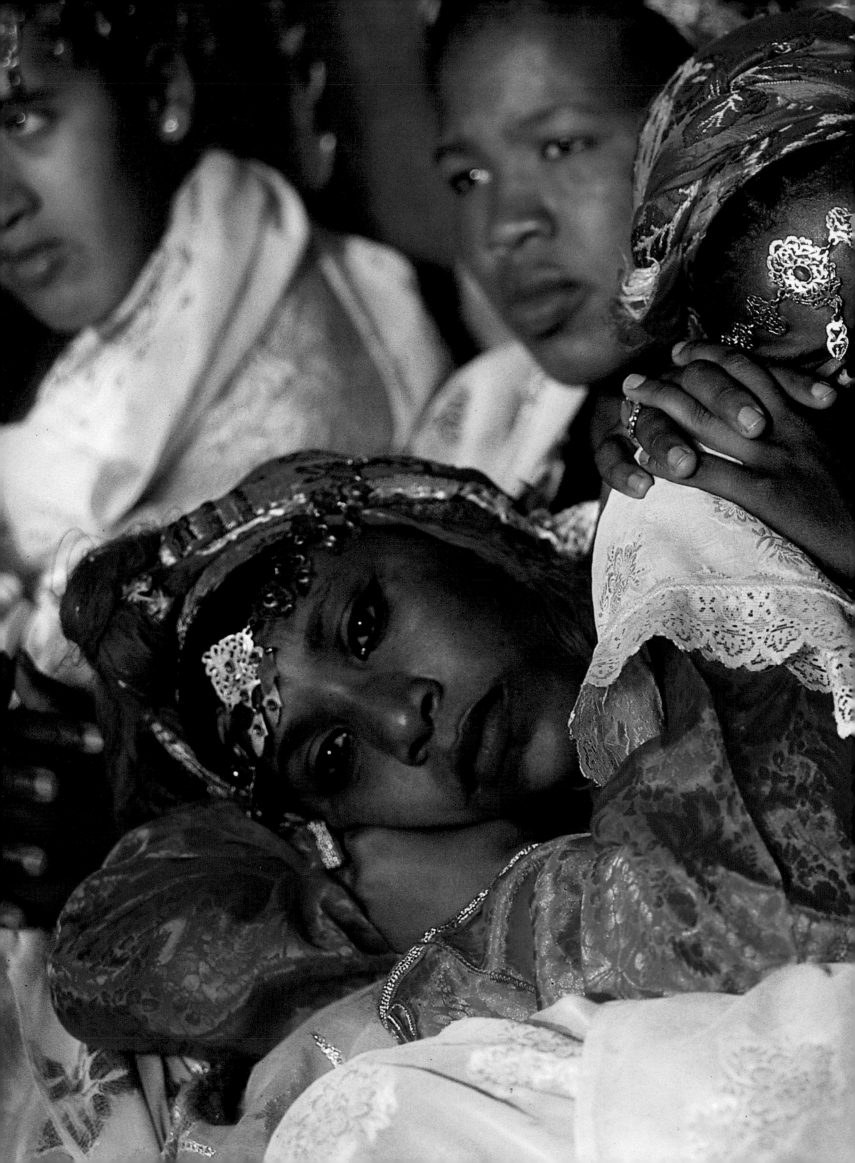

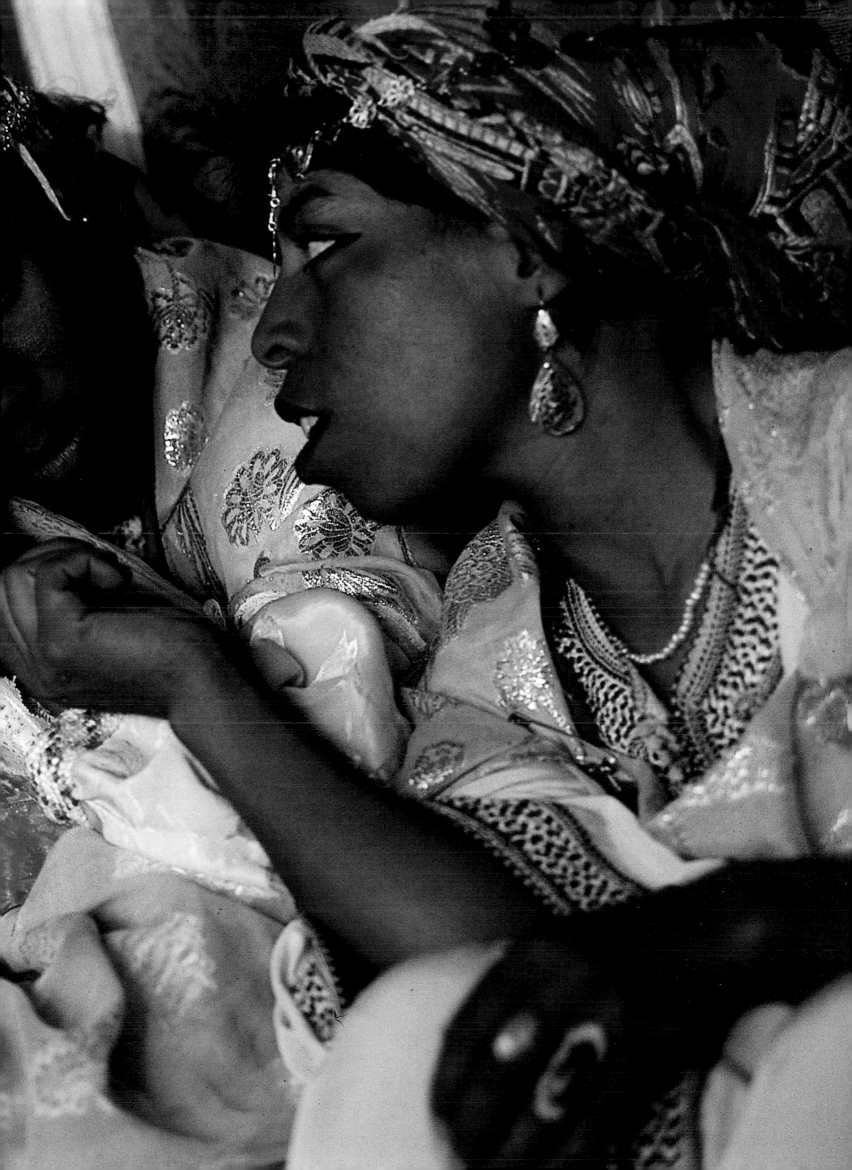

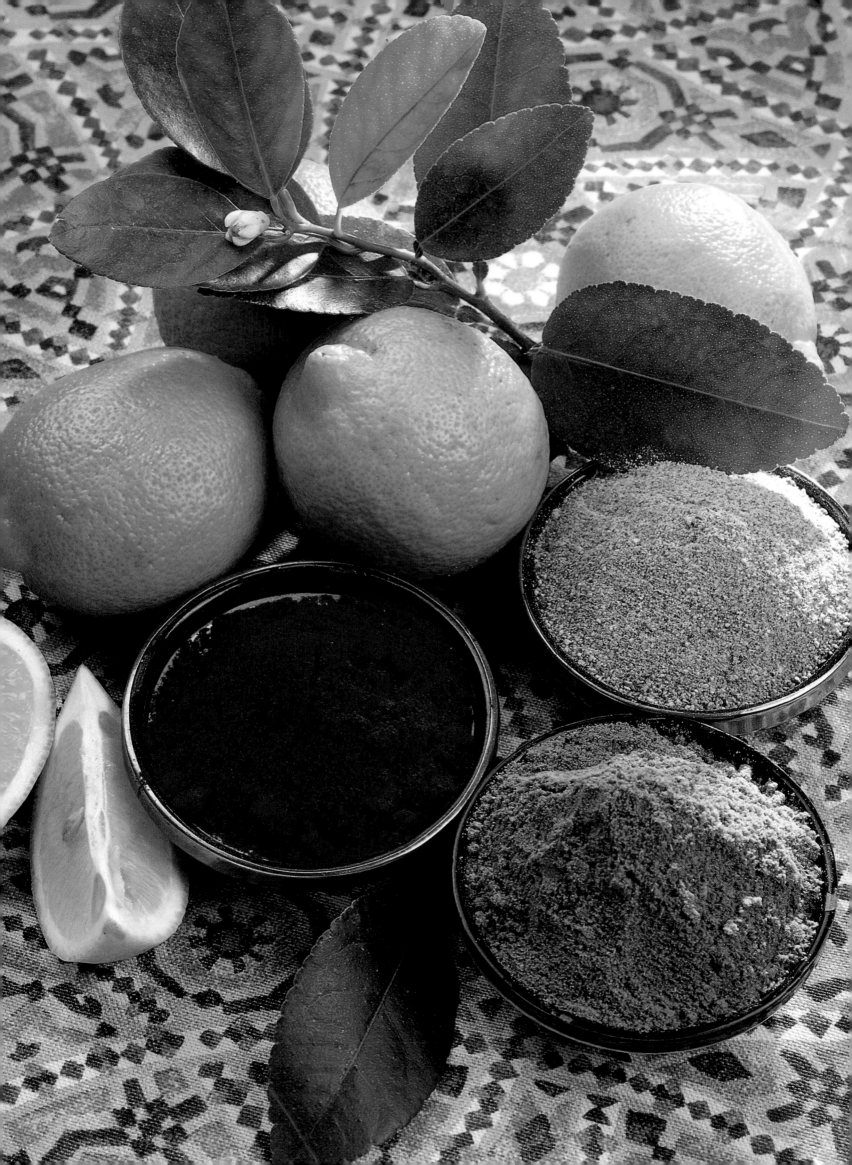

A Thousand and one Flavours

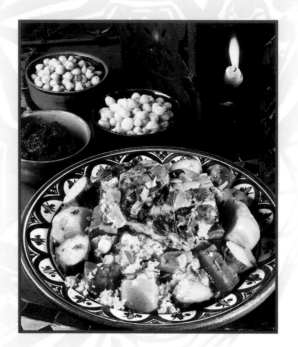

Couscous with Lamb

For 8 to 10 Guests

1 Shoulder of Lamb with fat removed, cut into quarters. • 14 oz. fine Semolina • 3 Carrots • 2 Zucchini • 2 Turnips • ¹/₄ Whole Green Cabbage • 2 Celery Stalks • 1 Green Pepper • 1 Bunch of Coriander, chopped • 1 Onion • 1 Tin Peeled Tomatoes • 2³/₄ oz. Butter • 1 Slice of Pumpkin • 3¹/₂ fl. oz. Cooking Oil • 1 Tablespoon of each of the following : Salt, Pepper, Mild Chili, Ginger, and Ras al-Hanout (mixture of 27 spices) • A Couscoussier (or a pot with a steamer).

Braise the 4 pieces of lamb in oil on all sides for 10 minutes in the bottom part of the couscoussier, then add the salt, pepper, spices, the chopped coriander, then the mashed tinned tomatoes, and cover with water.

Place the semolina on a flat dish, salt and moisten it. Then put the semolina in the upper portion of the couscoussier, cook for 15 minutes, then remove it back to the dish and let it cool completely. Then mix in the softened butter.

In the liquid with the meat, add the sliced carrots. Coòk for 10 minutes, then mix in the turnips, cook for another 10 minutes, then add the cabbage and cook for another 10 minutes. Finally, add the sliced zucchini and the whole green pepper and continue cooking for 10 more minutes.

Cut the pumpkin into cubes and cook separately in some bouillon.

10 minutes before serving, put the semolina back into the upper portion of the couscoussier, cover, and re-heat.

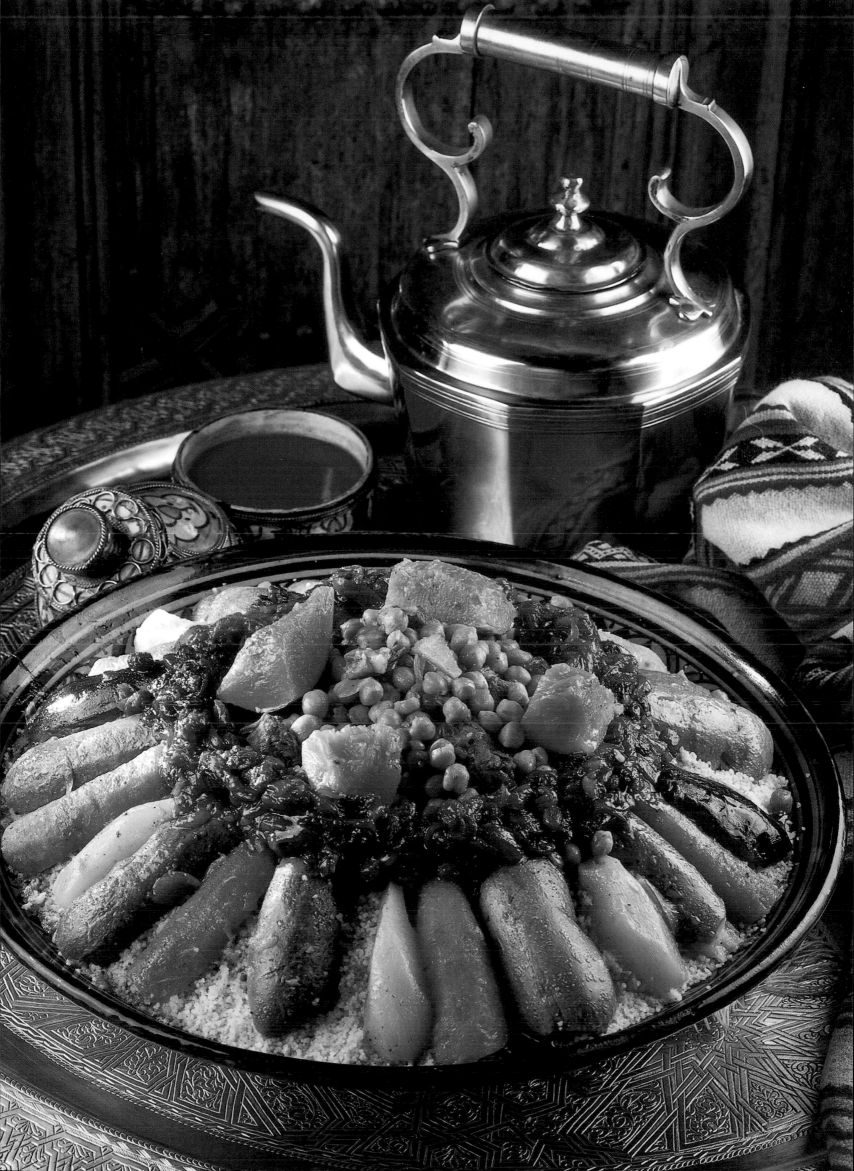

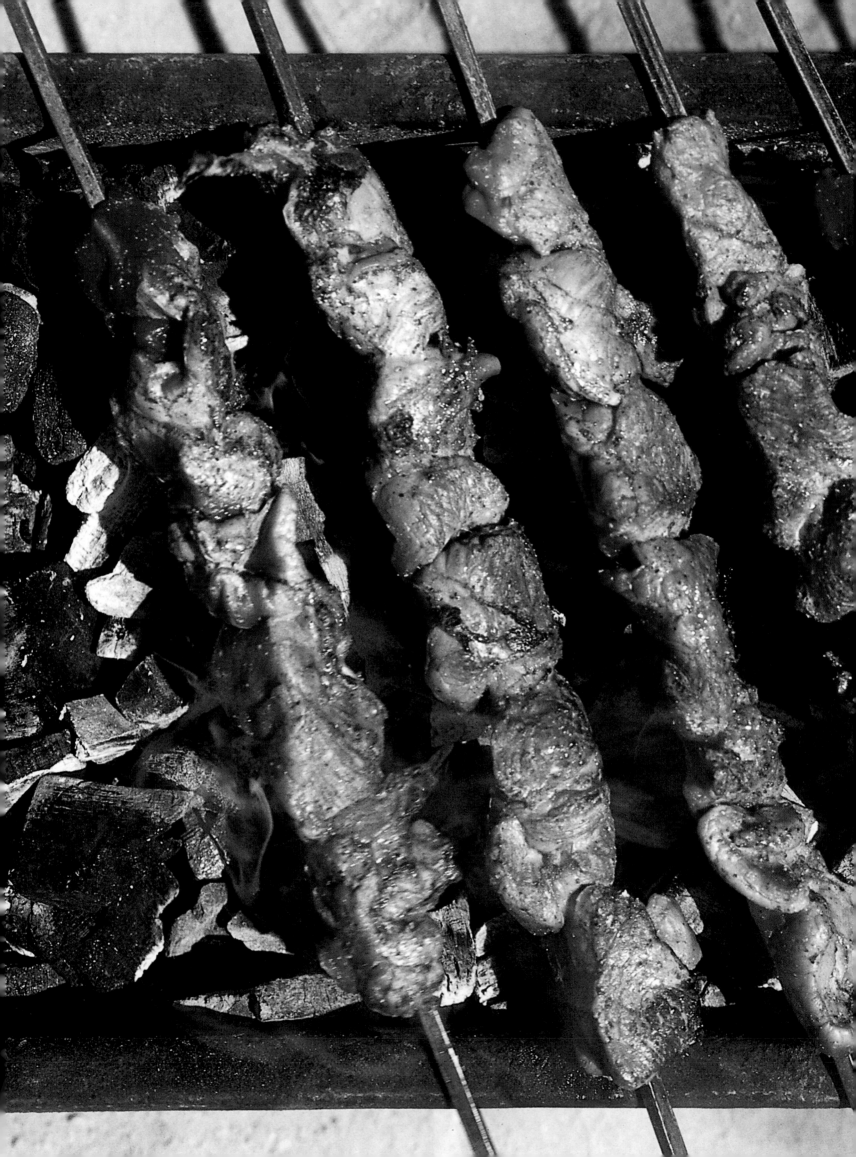

Brochettes

For 8 to 10 Guests

• 14 oz. of Lamb or Beef (preferably fillet) • 9 oz. of Mutton or Beef fat • 14 oz. Onions • Salt and Pepper • Powdered Saffron (1 pinch) • Skewers • This recipe is intended for either an outdoor charcoal barbecue or an oven

Cut the meat and the fat into pieces, peel the onions, and place everything on a dish together. Powder with saffron. Mix everything well to let the spice penetrate the meat. Leave for 1 hour. Then, prepare the skewers, alternating the pieces of meat, fat, and onions. Grill for 30 minutes, turning constantly. After removing the meat and vegetables from the skewers, serve sandwich style, between two pieces of flat Moroccan bread.

Green or red peppers or chilies may also be included on the skewers.

Couscous t'faya with Onions and Raisins

For 8 to 10 Guests

• 3 lb. 6 oz. Lamb, cut into pieces • 2 lb. 10 oz. Couscous (fine semolina) • 2 lb. 7 oz. Onions • 11 oz. Raisins soaked beforehand in water • 3½ oz. Butter • 4 tablespoons Cooking Oil • 7 tablespoons Sugar • 3 teaspoons ground Cinnamon • ½ teaspoon Turmeric • ½ teaspoon Ginger • 8 stems Coriander • ½ teaspoon Saffron • 1 teaspoon Pepper • Salt • A Couscoussier is recommended for the preparation of this dish.

Place the meat in the bottom of the couscoussier with a finely chopped onion, the coriander, the saffron, the ginger, and the turmeric. Add salt and pepper and cover with water. Place the steamer of the couscoussier over the lower section and seal the two together with a strip of cotton material which has been soaked in a mixture of flour and water, and cover. This is in order to prevent steam escaping from the sides. The meat should now cook for 1 hour.

Then, place the cooking liquid in a bowl, to be served hot when the couscous is served.

Mix the couscous with the cooking oil and two glasses of salted water, working the mixture well, to make sure the couscous is impregnated and begins to become tender. Place the couscous in the open steamer part of the couscoussier, uncovered, and cook for 20 minutes or so, until the steam rises freely through the couscous. Then place the couscous in a big dish, and cool it down with half a glass of cold water, smoothing out any lumps. Wash and oil the steamer and once again place the couscous in it. Continue cooking for 30 to 40 more minutes. Take the couscous out of the steamer and, away from the heat, work in the butter and salt to taste. Re-heat in the couscoussier before serving.

Preparation of the *t'faya*: finely chop the onions and cook them with a glass of water for 30 minutes. Just before the end of this time, add the raisins which have been soaked beforehand, the cinnamon, the saffron, the sugar, salt and pepper. Cook slowly until nicely caramelised. Place the couscous in a serving dish, with the meat on top, and cover with the *t'faya*. Serve with the hot cooking liquid alongside.

Moroccan Taboulé (Semolina Salad)

For 8 to 10 Guests

1 lb. 5 oz. medium Semolina • 2 stems Coriander • 10 stems fresh Mint • 2 Tomatoes • 2 Sweet Red Peppers • Salt and Pepper • 4 tablespoons Olive Oil • 4 tablespoons Safflower Oil

Place the semolina in a bowl, salt it, and mix well with the safflower oil and 10 fl. oz. of water. Steam the semolina for 15 minutes, then mix again, add a little more water, and let it cool. Cut the sweet peppers and the tomatoes into small dice. Chop the coriander and the mint. Mix them all into the semolina. Salt and pepper to taste, add the lemon juice and olive oil.

Mix again and place in the refrigerator.

Chicken m'qualli with Lemon

For 8 to 10 Guests

• 3 Chickens, cut into pieces • 3 stewed Lemon Rinds • 2 sliced Onions • 1 cup Cooking Oil • 3¹/₂ oz. Butter • 1 pinch of Saffron Filaments • 3 tablespoons Saffron • 2 tablespoons Cumin • 2 tablespoons Ginger • 2 sprigs Flat-Leafed Parsley (chopped) • Salt, Pepper, Marinated Green Olives.

Melt the butter with the oil in a large frying pan. Fry the pieces of chicken, along with the sliced onions. Mix in the saffron, the cumin and the ginger. Add salt and pepper. Add the chopped parsley and the stewed lemon rinds.

Cover with water and cook for 1¹/₂ hours. Then remove the chicken and reduce the sauce over a high heat for several minutes. Serve the chicken with the sauce and the green marinated olives.

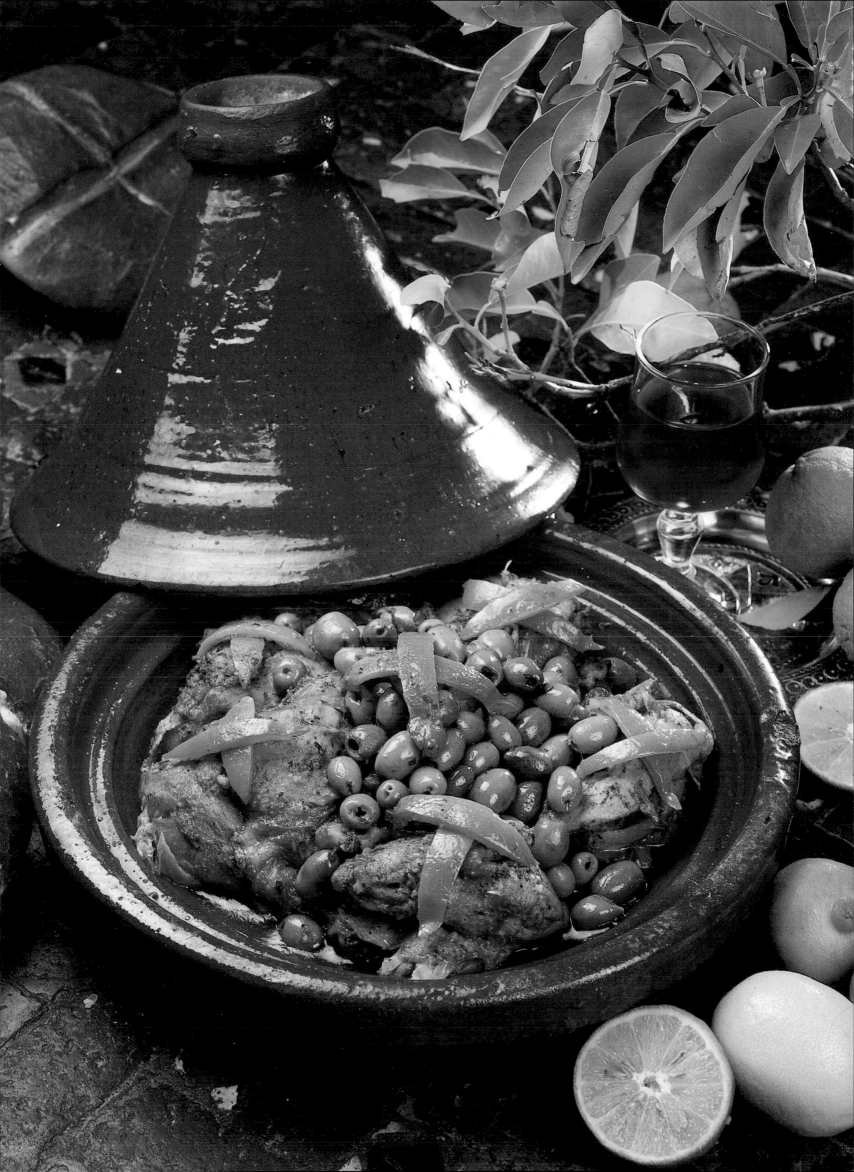

198

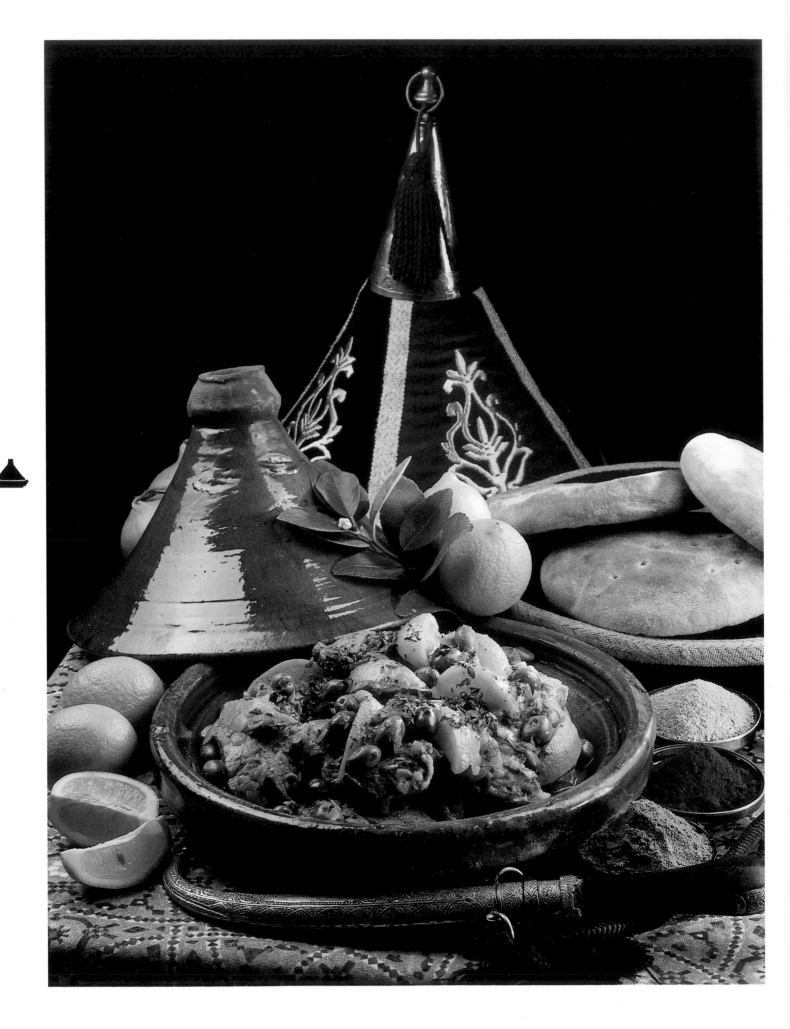

Deep Fried Rice Briouats (Triangles)

For 8 Guests

• *8 squares of puff pastry* • *3¹/₂ oz. cooked drained Rice* • *2 tablespoons Orange Blossom Water* • *Castor Sugar* • *ground Cinnamon*
• *Cooking Oil.*

Mix together the rice, the orange blossom water, a teaspoon of castor sugar and a teaspoon of cinnamon. Cut the squares of pastry in two and fill them, folding them in triangular form. Fry the 16 briouats for 1 to 2 minutes in bubbling oil in a deep fryer. Sprinkle with sugar before serving.

199

Tajine with Duck and Wild Mushrooms

For 8 Guests

2 Whole Ducks cut into pieces, or 8 Large Drumsticks • *2 lb. Wild mushrooms* • *4 Onions* • *8 fl. oz. Cooking Oil* • *Salt and Pepper* • *2 pinches of Ginger* • *2 bunches Coriander* • *1 bunch Flat Parsley* • *A little Butter*

Prepare a mixture of puréed onions in the tajine platter. Then remove, in order to heat the oil and the platter for 10 minutes. Braise the duck in the platter, then add the onions and coriander mixed together. Add salt and pepper and mix in the ginger.
Cover with water and simmer for 2 hours over medium heat. During this time, prepare and wash the mushrooms, and sauté them in a frying pan with butter for 20 minutes, seasoning with salt and pepper. Add the parsley.
Arrange the duck and its cooking juices in a large tajine platter, garnish with mushrooms,

200

Pastilla with Almonds and Pigeon

For 8 Guests

• 24 Squares of puff pastry • 4 Pigeons, prepared for cooking and cut into pieces • 8 Beaten Whole Eggs and 1 Egg White left aside • 10 oz. chopped Onions • 8³/₄ oz. Shelled Almonds • 5³/₄ oz. Sugar • 5³/₄ oz. Butter • Cooking oil •several sprigs of Coriander • several sprigs of Flat Parsley • 1 tablespoon Saffron • 1 tablespoon ground Cinnamon • 1 teaspoon Ginger • A pinch of Salt • Castor sugar.

Cook the cut-up pigeons, the chopped onions, 3¹/₂ oz. of butter, the ginger, and the saffron with 1¹/₂ pints salted water in a glazed casserole for half an hour.

While the pigeons cook, fry the almonds in hot oil, then crush them in rough pieces.

Chop the parsley and the coriander. Take out the pieces of pigeon and turn the chopped herbs, the cinnamon and the sugar into the casserole. Reduce the liquid and add the beaten eggs when the liquid has cooled down, to avoid coagulating the eggs. Continue to cook over very low heat for 5 minutes, stirring constantly. Butter a pie mould. Place a first layer of pastry leaves on the bottom, doubling them to reinforce the base, so that they overlap each other and their edges go beyond the rim of the mould. Then cover with a layer of pigeon, then some of the cooled-down egg mixture, then sprinkle on some almonds. Generally flatten down and then repeat the process, layer by layer: pastry leaves, pigeon, egg mixture, almonds etc., remembering to reserve a layer of pastry leaves for covering the top. After the process is complete, coat the pastilla with egg white and delicately tuck down the edges of the leaves underneath. Cook the pastilla in the mould in a hot oven 450/500 °F (230/250 °C, Gas mark 8 or 9) for 30 minutes, turning it over once after 15 minutes, and spreading on pats of butter several times. Serve while still very hot, after quickly decorating the top with a latticework of ground cinnamon and castor

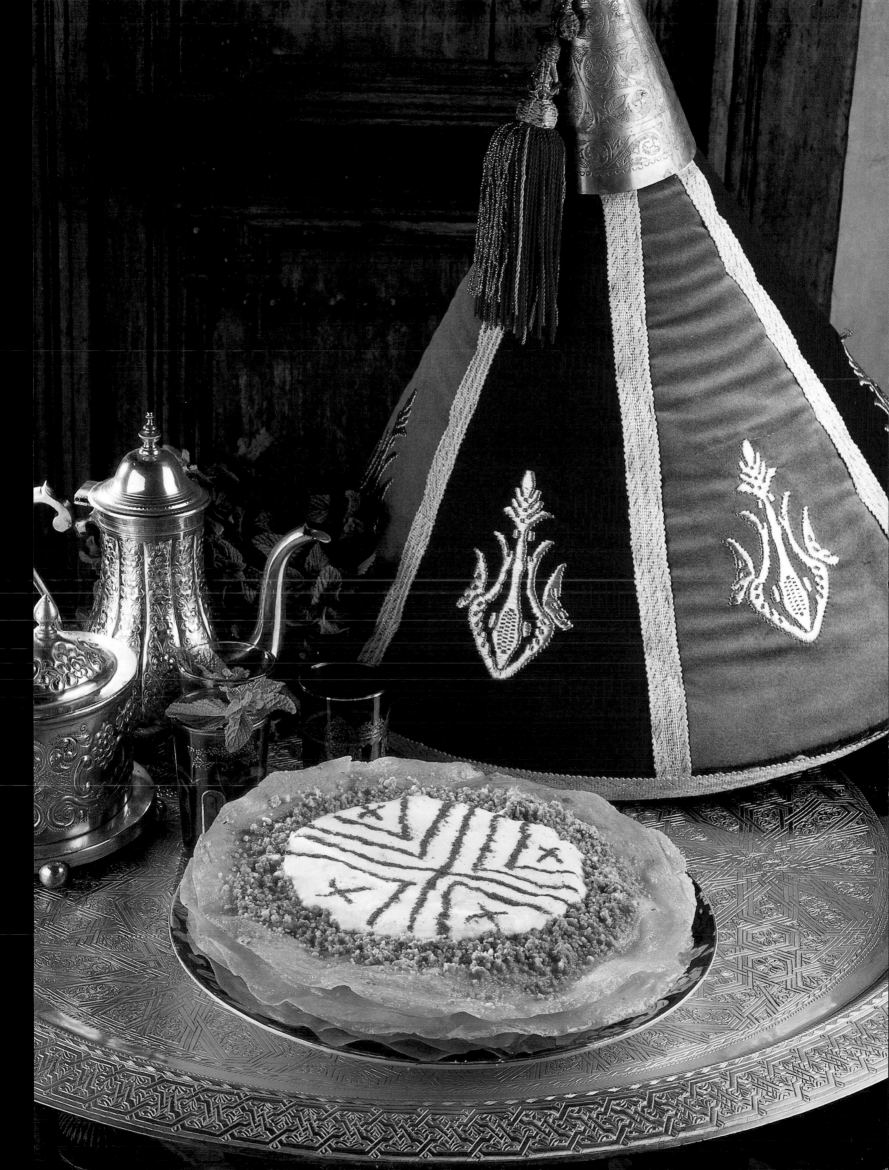

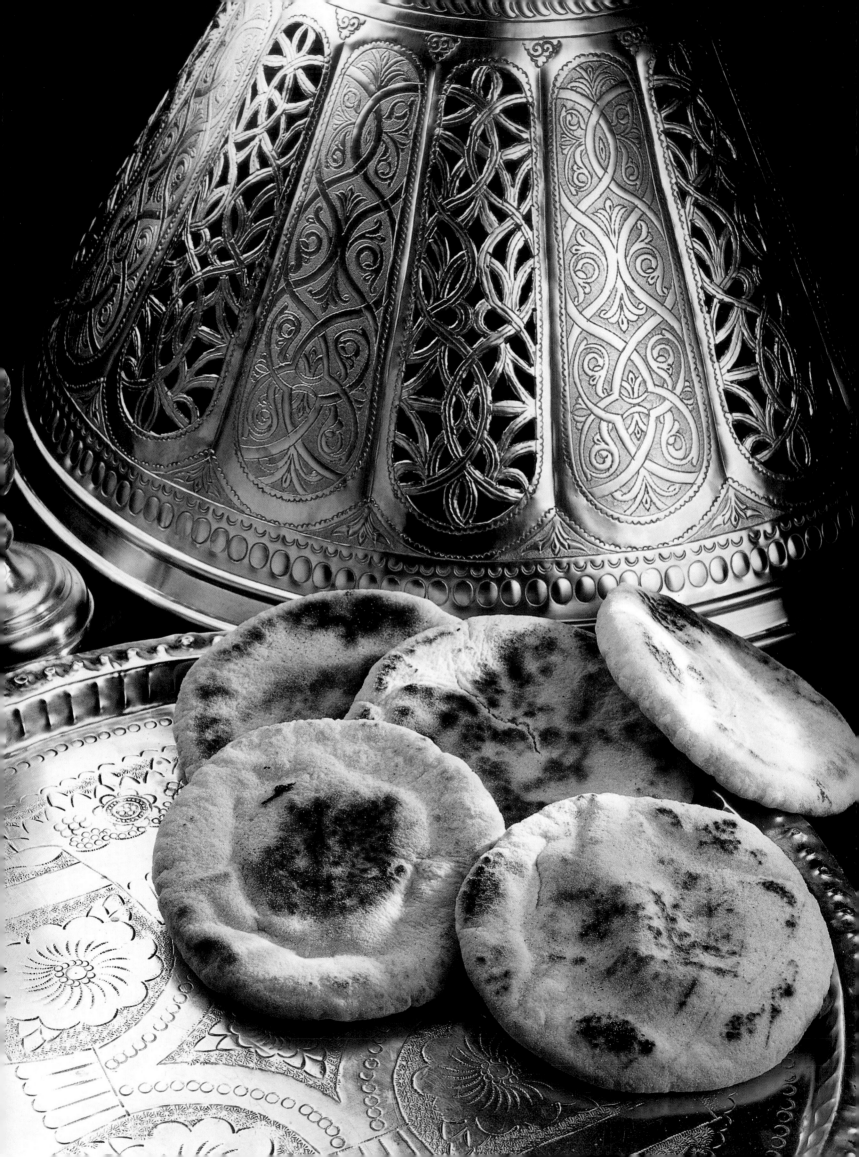

Bread (Kesra)

2 lbs. 4 oz. of Flour • 4 tablespoons of Oil • 1 teaspoon Salt • 5 oz. Melted Butter • 9 fl. oz. Water

Pour the flour into a large dish and make a crater on the top into which you pour the oil and the melted butter. Mix by rolling the liquid and flour together with your hands. Add the salt and water, then knead the dough into a ball.

Flatten to a thickness of approximately $1/3$ of an inch and place in a pre-heated tajine dish (or any flat crockery dish) Cook over low heat for several minutes on each side, until the two sides are nicely browned.

Brics with Kefta (Minced Steak)

For 8 Guests

205

• 12 leaves of puff pastry • 14 oz. Minced Steak • 2 bunches Coriander, finely chopped • 2 bunches Flat Leafed Parsley, finely chopped • 2 finely minced fresh Onions • 4 tablespoons Cooking Oil • 4 Whole Eggs • 1 teaspoon ground Cinnamon • Salt and Pepper.

Finely chop the onions, parsley and coriander and mix them in with the meat. Cut the pastry leaves into four long strips, place a small quantity of the meat stuffing at one end and fold into a triangle, folding down the pastry leaf at a right angle at each turn, until you

reach the end of the strip.
Close the triangle by sliding the end of the pastry leaf into the last fold.
Fry the stuffed triangles, drain, and serve while still hot.

Kefta (Meat Ball) Brochettes

For 8 Guests

2 lbs. 4 oz. Minced Meat • 2 Onions, chopped fine • 2 bunches Coriander, chopped • 2 tablespoons Cooking Oil • 1 teaspoon Cumin • Salt and Pepper

Chop the onions and the coriander. Knead them into the meat, together with the salt and pepper, the cumin and the oil. With damp

hands, form little cylinders and slip them on to the skewers. Grill on all sides.

Fig Briouats (Triangles)

For 4 Guests

10 leaves of puff pastry • 10 oz. Fresh Figs •5¹/₂ oz. Sugar • 2 teaspoons Orange Blossom Water • Ground Cinnamon • Almonds • A light Custard Cream: 1¹/₂ pints Milk • 5 Egg Yolks • 3¹/₂ oz. Sugar • Safflower oil or Peanut oil • A Wire Whisk • A blender, or similar food mixer

Place the figs, the 5¹/₂ oz. of sugar and water in a casserole and stew for 30 minutes.

Now prepare the custard cream: Heat the milk to boiling point in another casserole. In a saucepan, using a wire whisk, beat in the 3¹/₂ oz of sugar with the egg yolks, adding the sugar gradually. Keep beating until the yolks and the sugar are a pale yellow. Then beat in the 2 teaspoons of orange blossom water and 2 pinches of ground cinnamon. Very gradually, so that the yolks will not warm too fast, beat in the hot milk. Prepare a frying pan with hot oil and brown the almonds. Let the almonds and the custard cream cool. Using a blender, blend the almonds with the custard cream.

Place the stewed figs and their sauce onto the pastry leaves, fold into triangles, and fry them in safflower or peanut oil. (The oil you use should have as neutral a taste as possible because of the delicacy of the flavours.) Drain the Briouats and arrange them on a plate. Pour the custard cream over each triangle. Decorate each with a wisp of cinnamon and a mint leaf.

Halaouiet darcoum

For 4 Guests

• 4 leaves of puff pastry • 11 oz. Soft White Cheese of 40% Fat Content • 1 Banana • 1 Pear • 2 leaves of Gelatin • 3¹/₂ oz. Sugar • ²/₃ oz. Castor Sugar • 1 teaspoon ground Cinnamon • 1 tablespoon Orange Blossom Water • Frying Oil • Custard Cream: 18 fl. oz. Milk • 3¹/₂ oz. Sugar • 1 teaspoon ground Cinnamon • 1 teaspoon Orange Blossom Water • A Wire Whisk.

Finely dice the fruit. Place the soft white cheese in a bowl, add the sugar, the cinnamon, and the orange blossom water and mix well. Place the gelatin in a dish, wet it, and let it rest until it becomes soft. Place it in an oven for no more than 2 minutes and then incorporate it with the fruit mixture, mixing well. Then cool in the refrigerator.

Now prepare the custard cream: place the egg yolks in a saucepan. Using a wire whisk, gradually beat in the sugar. Keep beating, until the yolks and the sugar are a pale yellow. Then beat in the cinnamon, and the orange blossom water. Heat the milk to boiling point. Then, very slowly, to avoid coagulating the egg yolks, beat in the hot milk. Let it cool.

Fry the pastry leaves one by one in a deep frying pan. Place two pastry leaves on a large plate, pour on the custard cream, then a layer of the fruit mixture, and continue, with another leaf, custard cream layer, and the fruit mixture. Place a pastry leaf on top, and decorate with the castor sugar passed through a sieve, and with the cinnamon.

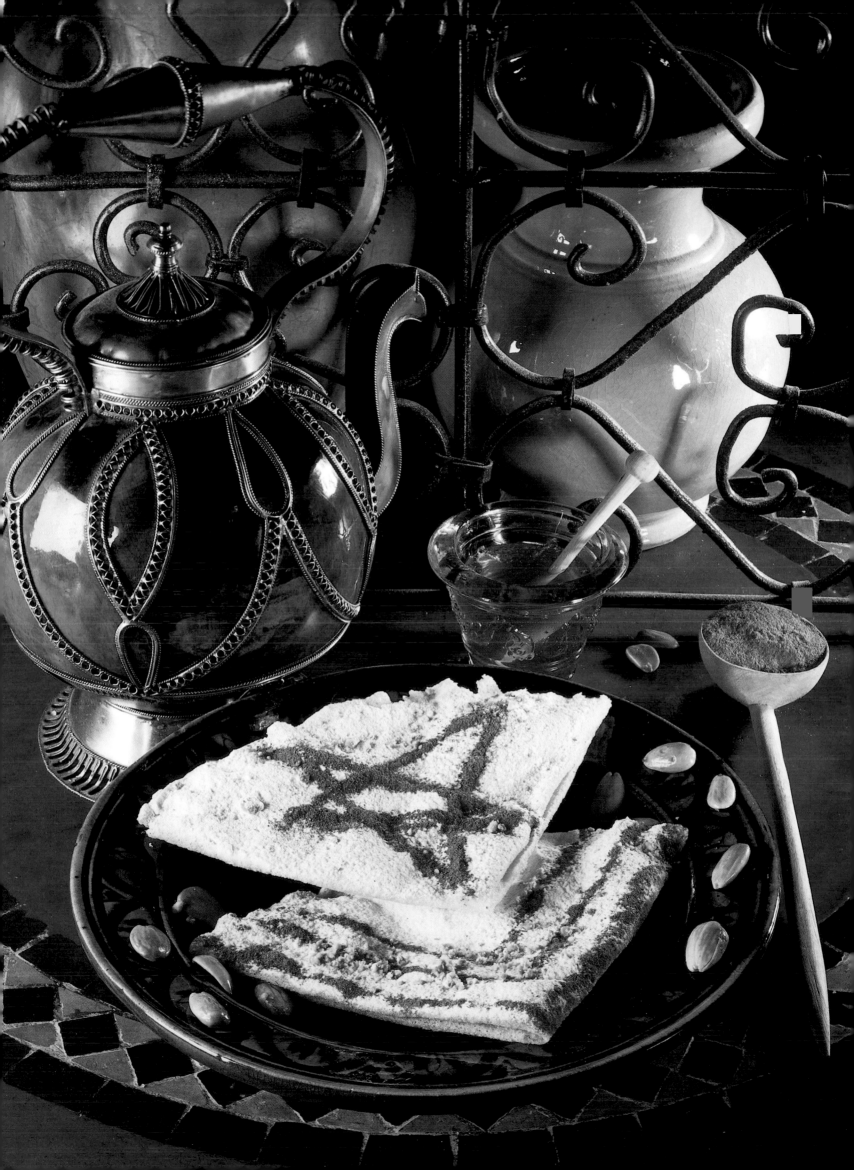

ANNEXES

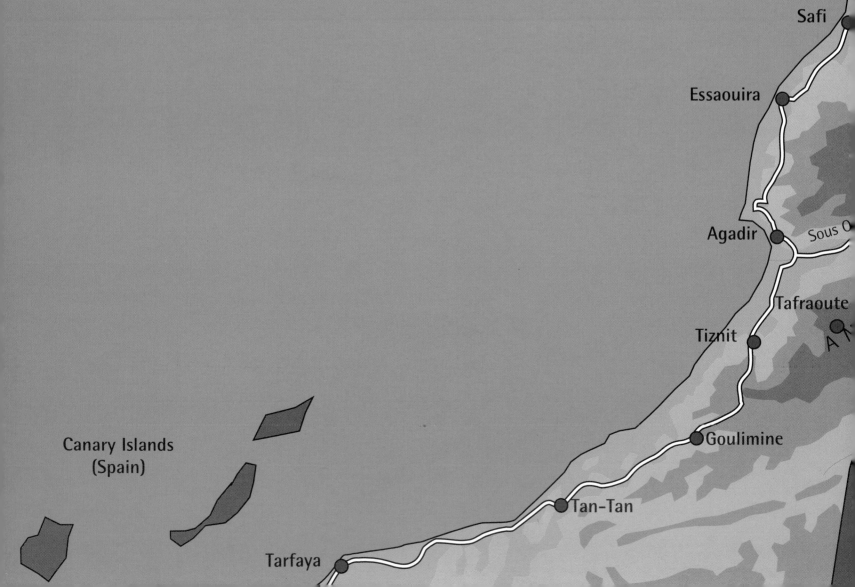

ATLANTIC
OCEAN

Safi

Essaouira

Agadir · Sous O

Tafraoute

Tiznit

A T

Canary Islands
(Spain)

Goulimine

Tan-Tan

Tarfaya

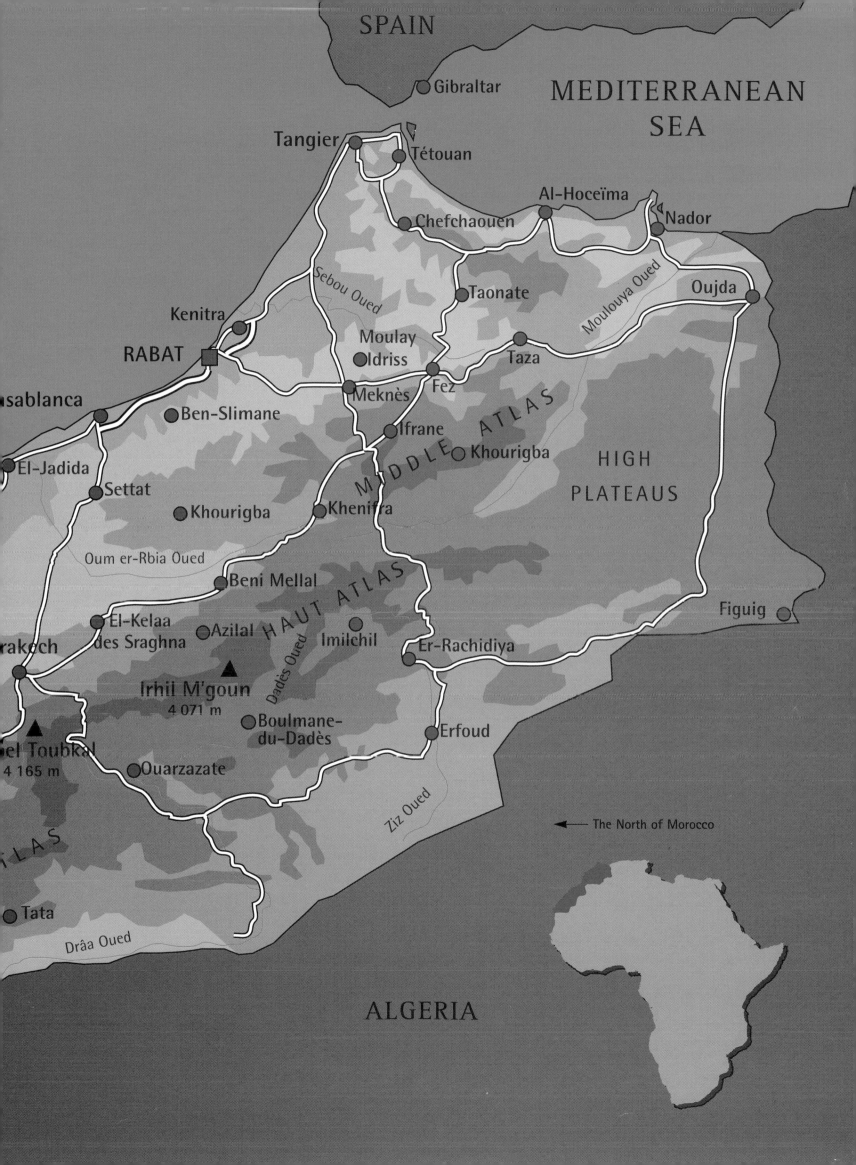

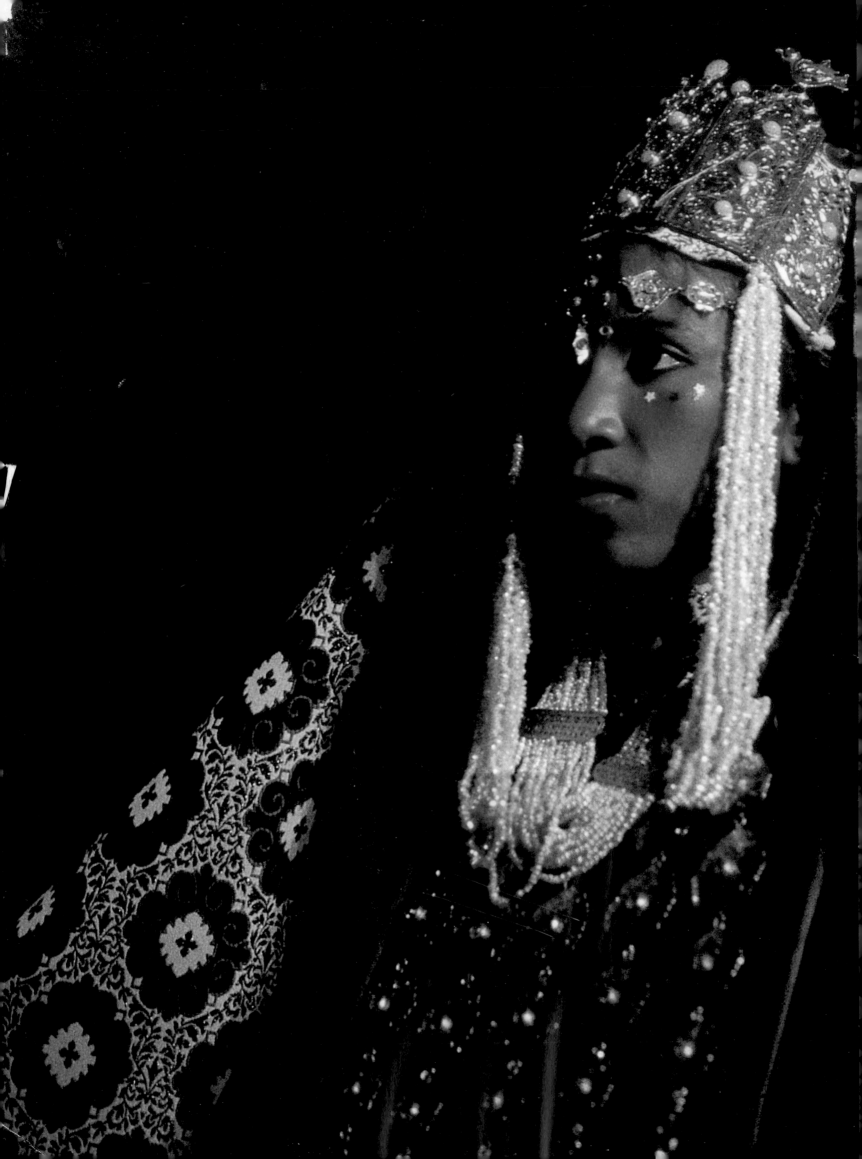